art and collectibles
Norman Rockwell

by
Carl F. Luckey

AN IDENTIFICATION AND VALUE GUIDE
FULLY ILLUSTRATED

D1498651

BOOKS AMERICANA

ISBN
0-89689-0-21-X

DEDICATION

To the founding and present staff and management of The Saturday Evening Post. Over the years they have done more to preserve the art and spirit of Norman Rockwell's works than all other combined efforts. It is good to see an old American tradition such as the Post carried on in an era that sometimes sees the old value compromised in the name of progress.

ACKNOWLEDGEMENTS

Books that deal with any sort of collectibles are rarely the work of a single mind and this one is certainly no exception. It is never possible to acknowledge all those who contribute. There are always so many helpful and cooperative people (some known, some not known) that it is just not practical to thank them all in print. My heartfelt thanks go to any of you who do not appear in this list. If you do not appear here, it is through oversight or ignorance of your aid.

Very special thanks to:
Bill Gardiner and Linda Stillabower of the Curtis Publishing Company for their kindness and friendship in helping to produce this book; the Norman Rockwell Estate; Ronald P. Gerwin, International Postal Collectors League; Dorothy and Irving Dunckelman, Coventry Collectibles; Mike and Gracie Neville, Middletown, Connecticut; and to Bob Wale, Albany, Georgia, a loud thanks for all your help and patience; and to Steve Weinreich of Dave Grossman Designs Inc., for preparing the most comprehensive package of information and photographs I have seen to date.

Others who contributed information or materials:
Stafford Calvin, Calhoun's Collectors Society; Robert P. Capria, The Danbury Mint; Stephen Clarke, CPS Industries; Michael J. P. Collings, The Rockwell Society of America; Suzanne DePee, Visalia, California; David P. Folds, Norman Rockwell National Convention; C. P., Gilmore, Popular Science Magazine; Melanie Hart, The

Hamilton Mint; Harry K. Hudson, Inverness, Florida; Philip F. Mooney, The Coporate Archives, The Coca-Cola Company; Majorie Nelson, Ladies' Home Journal; Bill Sanderson, Junke and Treasure Shop, Florence, Alabama; Paul A. Schmid III, Schmid Brothers, Inc.; C. Richard Speigel, River Shore, Ltd.; Robert P. Summers, Circle Gallery, Ltd.; David H. Wood, The Old Corner House, Stockbridge, Mass.

Author's Note

The value guides presented throughout the listings in this book are exactly that — **guides,** nothing more. Those values listed are presented in ranges and are derived from hundreds upon hundreds of price lists, collectors' lists and publications by the stacks. After all this data is gathered, a fair retail market value range must be determined at that particular point in time and considering the particular market influences at that time.

The complexities of buying and selling in the collectors market are myriad. There are factors affecting the value of each item too numerous to mention all but to name a few of the most important: condition, availability, age, current popularity of a particular type, current economic situation, dealer knowledge, collector knowledge, where found, ease of display or storage, etc.

It is incumbent upon any author who includes value guides in his work to point out that the values presented are all, without exception, out of date the day of publication. This phenomenon is unavoidable due to the inherent delays in manuscript preparation, typesetting, layout, proof reading, corrections, printing, binding and finally, distribution.

In the final analysis the values are only one man's opinion and must be recognized as such. It is not, and cannot be, the final unshakeable authority. The values are useful only when used in conjunction with other guides, price lists, etc., and the experience and knowledge of the user.

All items represented by photographs in this book are copyrighted. The photographs of various magazine covers,

advertising illustrations, three dimensional objects etc., are meant only to present the collector with a means to identify the various items. These very small photographs are representative of the actual objects, but because of space limitations they are not complete. They should however, give the collector a good idea of the physical characteristics of those collectibles available.

As has been my habit in seven previous books about collecting, I invite anyone with additional information, constructive criticisms, and especially suggestions as to how the book might be improved, to write me direct. Because the book is not a complete listing of all Rockwell pieces I particularly welcome any new information and photographs you may choose to send.

Don't hesitate to write, but please don't ask me to appraise anything. The dealers are more qualified than I.

I can't promise to reply to every single letter but will attempt to do so in time as the number of them allow. Do remember to enclose a stamped self-addressed envelope. That goes a long way toward helping to assure a response from any writer. Please do not telephone me. Schedules and workload do not allow me to accept any calls.

Happy Collecting

Carl F. Luckey
Lingerlost
Rt. 4, Box 301
Killen, Alabama 35645

NORMAN ROCKWELL ART AND COLLECTIBLES

CONTENTS

1

SECTION IV - China, Porcelain and Crystal Plates

SECTION V - Metal Plates, Plaques and Crystal Plates

SECTION VI - Bells

INTRODUCTION

Over the years there have been dozens of books written about the art of Norman Rockwell, one or two about the man himself, but precious few about his art **and** collectibles. There are millions of Americans who grew up with his work and love him through it. Long before his death in 1978, many of them had been collecting just about anything remotely connected with this remarkable man and his work. This was inevitable because of the very nature of the work. His barefoot farm boys and gangling adolescent school girls represented the childhood of most of those who saw his work. Just about every work accomplished by Rockwell showed us the best, the most pleasant side at the same time implying or suggesting a great deal more than he showed. He was a chronicler of his age. He was a master, but perhaps his greatest mastery was that unlike most old and modern masters (oh yes, he was that), Norman Rockwell was painter who meant most to those to whom a painting meant least.

His style, and indeed the man himself, lives on in the thousands of works he left us. It lives in his paintings, prints, and all the various two and three dimensional representations and interpretations of his work.

One of the largest groups of his work is represented by the Saturday Evening Post covers which he began illustrating in 1916. Over the years his work grew to tremendous popularity with many prints of his work being published. In 1971, one of the first serious attempts was made to place his work in collectors hands in a form other than fine print or painting. The famous Gorham Company issued a set of four porcelain plates bearing Rockwell's Four Seasons paintings. They were issued at sixty dollars the set and now are selling on the secondary market for about ten times that. This was the beginning of a phenomenal proliferation of all sorts of objects bearing his work or centered around the theme of one of his paintings. The Saturday Evening Post cover illustrations were then and now, the most popularly used images, for they are among the best known.

This book is an attempt to draw together for the collector as much information and photography representing all aspects of his work as possible in a finite time. It will not and cannot presently be completely comprehensive because of the sheer numbers of works and items to be listed. However subsequent editions will be improved and expanded as time goes by.

The book is divided into sections, each devoted to a certain type of work or object, and within each of these sections it is further broken down into alphabetical and/or chronological order. The Contents on page 1-3 should help you to select the particular area you wish to study for it represents a good outline of what is presented between the covers. That failing you might try the index in the final pages of the book. Each of the sections is introduced with an explanation of technique and/or history of the particular subject. So read on, enjoy, learn and understand more fully the magic of Norman Rockwell.

SECTION I

THE ARTIST

NORMAN ROCKWELL
February 3, 1894-November 9, 1978

When born his mother christened him Norman Percevel Rockwell. Percevel was the name of one of his mother's English ancestors. Rockwell said many years later that he "...never did like the name of Percevel." During his earliest years of illustrating he retained the use of the name to please his mother, but that he didn't like it much is obvious. While still living under the parental influence he variously signed his works "Norman P. Rockwell", "NPR", and even actually spelled it out, "Norman Persevel Rockwell".

Although Rockwell was born in New York City his family moved to a country suburb when he was nine or ten.

Even in those early years he was always drawing things. He quit high school during his sophomore year and enrolled in the National Academy School of Fine Arts. He was but sixteen years old. He soon tired of the stiff academic approach at the Academy and left it to enroll in the less staid Art Students League. By 1911, still not quite eighteen years old and still in art school, he got his first really professional assignment. He did ten or twelve illustrations for a children's book entitled **Tell Me Why Stories**. The book was published in 1912 and contains eight Rockwell Illustrations. He had done some less important (in his estimation) work prior to this but he considered the book illustrations his real beginning as a professional.

Soon after he began doing work for Boy's Life magazine. His first assignment was to do illustrations for a

Boy Scout camping handbook entitled **The Boy Scouts Hike Book** published in 1912. He began doing story illustrations for the magazine and in 1913, still only nineteen years old, he was made art director. His first ever magazine cover was for September 1913 issue of Boy's Life.

With that beginning he now had a presentable portfolio and started making the rounds of the offices of many other magazines of the day. He did many story illustrations and landed three more cover assignments in 1915.* He did at least sixteen covers** for other magazines before landing that famous May 20, 1916 Saturday Evening Post cover that launched him into the successful professional career that was to last for over sixty years.

He lived for a few years in New Rochelle, N.Y. In 1939 he moved to New England living first in West Arlington, Vermont and then in Stockbridge, Massachusetts from 1953 until his death. Some are fond of pointing out that this gentle countryman had his roots as a city boy and having a little fun with it. It should be pointed out that he lived, with a few short exceptions, almost his entire life in the country atmosphere of New York State and New England. It is from there that inspiration for the majority of his work came.

Whatever place Rockwell and his work will eventually occupy in the history of art is an academic question. Many of the professional critics were unkind, calling his work not art, but commercial illustration, photographic in nature. They used such words as corny and simplistic, but not even his meanest detractors could fault his craftsmanship, his insistence of authentic detail. What remains is his own sincere and assessment of himself by often saying "I consider myself an illustrator". That disarming statement must have been difficult for those critics to handle and indeed does make all those denigrations meaningless. Rockwell spoke of it once thus:

> "I paint what I like to paint, and somehow,
> for some reason, a good part of the time it

*Complete records are not yet available, but in present knowledge the first of these was a January 1915 issue of Recreation magazine and the other two were for St. Nicholas magazine.
**Including the Boy's Life covers.

coincides with what a lot of people like; it's popular. Which some (the art critics for instance) would say makes me a low type, mediocre, slightly despicable, etc., etc., and it may be true (when I'm depressed I think it is). After all, I'm not exactly in the mainstream of art in our time. But there's nothing really I can do about it. I paint the way I do because that's the way I'm made. I don't do it for money or fame or any of the other degrading motives which are thought to be the source of popular art. I paint what I do the way I do because that's how I feel about things".

Norman Percevel Rockwell died November 9, 1978. When the inquisitive press asked his wife Mary (Molly) about the cause of his death, she is quoted as having said simply, "He died of being 84 years old".

SECTION II

THE COLLECTORS GUIDE

WHAT ARE NORMAN ROCKWELL ART AND COLLECTIBLES?

The Art comprises two basic forms: original works and reproductions. The original works by Rockwell run the spectrum from pencil sketches to large oil paintings. The reproductions take many forms. There are the fine art reproductions and not so fine reproductions, and the largest group, the countless magazine covers, story illustrations, advertising illustrations, book jackets or covers, ad posters and showcards, and reproductions of many of these.

The Collectibles can be said to be three dimensional objects fashioned after or bearing Rockwell Art. There are at least hundreds of items to choose from. There are figurines, plates, thimbles, postage stamps and first day covers, serving trays, glass tumblers, gift wrapping paper, medal art and on and on.

Both the groups, art and collectibles, must be broken down into two divisions: (1) the limited edition or limited circulation items and, (2) the unlimited or mass circulation items.

There is a third catagory of collectible which must be considered also; that of Rockwell memorabilia such as autographs, personal snapshots, letters, related Rockwell art and collectibles, etc. Some have intrinsic value, but by for the most have only personal or sentimental value to the owner.

We shall take each of these three major catagories and expand the definition considerably. This should enable you

9

to more fully understand what is available. Then you will be better prepared to choose a place to begin your collecting or if you are already a Rockwell collector you may be able to organize your collection in a more logical manner. In doing so you may find that you can more easily define just exactly what sort of things you're missing or have duplicates of for possible sale or trade with another collector. With the sheer numbers of items available you may also gain some needed room by organizing. Call it if you will, "defining, refinings, and confining". More about this later.

NORMAN ROCKWELL ART

The Original Works

Rockwell's medium was oils. His paintings were meticulously accomplished after much study and preparation in the form of research, conceptual drawings, and study sketches in various media.

In his early days the printing industry was at a point where most of the artwork used in magazines and books was either black and white or at the most one or two color. Full four color process printing was in its infancy, expensive and rarely used. For this reason most of his early works, at least those illustrations he accomplished for printing, will be found to reflect this limited use of color.

We will not delve too deeply into listing and placing values on Rockwell's original paintings in this book. That is best left to the fine art dealers. Perhaps one day there will be a catalogue Raisonne listing all of his works. Many of his drawings and paintings of relatively lesser import will still fall into this catagory. However, don't lose sight of the fact that over the more than sixty years of his professional life he had to have accomplished thousands of sketches, drawings, etc., and that there have to be many floating around. These will be discussed a bit more in the where and how to find Rockwell art and collectibles pages.

The Reproductive Works

As was noted earlier there are two basic types of reproductions available. Those mass-produced photomechanically on high speed lithographic presses likely number in the tens of thousands.

For a few years Rockwell would autograph a number of these mass-produced prints especially for the Old Corner House* to help underwrite the cost of operating the museum. They always stamped each print so that there would be no doubt as to the fact that they were mass produced.

Beyond the mass-produced prints there are the limited edition prints, produced by two methods. One of these methods is a highly refined photomechanical procedure and the technical name for the resulting print is a collotype. They were printed in an edition of 295, all of which were hand-signed and numbered. Two hundred of the prints were numbered with Arabic number (e.g., 45/200). Sixty were marked A.P. (artist's proof) and thirty-five more were marked A.P. with Roman Numerals (e.g. XI/XXXV), which means that the last thirty-five were reserved for Rockwell himself. Those last thirty-five were always given by Rockwell to the Old Corner House for the same reason that he autographed some of the mass produced reproductions. That the collotype prints were photomechanically produced is beyond question; often the printing plate was used, with the printing of title and copyright added, to produce an unlimited edition as well.

Then there are the **stone lithographs.**** As above, there was an edition of 295, but never more than that. To use this very difficult hand production technique for printing a reproduction is extremely rare. Rockwell did not do the work on the stones; it was done by a professional, artist in an atelier*** but the work had to be personally

*The Old Corner House is a Stockbridge, Massachusetts museum that houses among other things, a large collection of Rockwell's original paintings.
**An old reproductive technique done by hand. Often used today to produce original prints.
***A studio where original prints are accomplished by an artist or a professional print maker under his supervision.

approved by Rockwell before printed or sold. After the edition was printed the stones were ground down to prevent any more from being printed.

So, in the final analysis both the collotype prints and the stone lithographs are limited edition reproductions, not originals, though the stone lithographs have by far the greater claim to being anything like an original work.

NORMAN ROCKWELL COLLECTIBLES

The Limited Edition Collectibles

The term limited is somewhat misleading as used here. Many of the items which are to be found in this catagory are not really limited according to the classic definition, at least not to the extent the prints are, and certainly some items are limited only by production planning and market analysis. Whether something in an edition of 1,000 or 20,000 is limited is arguable, but the argument is not to be dealt with here. The reason for the use of the terminology in this book is a need to make a distinction between those truly fine collectibles and those such as gift wrapping paper, **reproductions** of old advertising items, etc. This is not to say that the latter are not good to collect but to simply point out the inherent differences.

Most of the items in this catagory are quality products, not inexpensive to produce or buy. The figurines are a good example. They are three dimensional interpretations of Rockwell works and usually made of a procelain or other fine china material. Many other items in this catagory are made of the same substance, but metal and other materials are utilized also. They take many forms and there is a hazy line separating some from the unlimited catagory. The ultimate decision as to where an item should be placed is up to you, the collector.

The Unlimited Collectibles

Here it can be said with confidence that the items are truly unlimited. They are, like the unlimited prints, mass-produced items. A few good examples would be greeting cards, place mats, key chains, and especially any other unlimited reproductive item of recent issue. That most are useful is true; but collectible? That is an individual judgement.

ROCKWELL MEMORABILIA

Personal Mementos and Autographs

Many people visited Norman Rockwell over the years and as with any meeting or visit with a celebrity, there is likely to be a snapshot or two taken with that celebrity. Those are treasured by the individual of course, but likely not particularly desirable as a collectible for any others. Rockwell did on occasion give a visitor something. I know of one instance when he gave one of his ever present pipes to a man he particularly liked meeting. That man probably has enshrined the pipe but it likely isn't of much interest to anyone else.

Autographs are another matter. There has always been a large market for celebrity autographs. Whatever form they are found in, a letter, a show program, or a matchbook, they are relatively valuable and sought-after items. When Rockwell's autograph is associated with an item bearing a reproduction of his work, it elevates the item to much higher desirability hence, intrinsic value. Examples would be the autographed mass produced unlimited prints or the autograph on the base of a figurine.

Norman
Rockwell

Miscellaneous Rockwell Memorabilia

There are several things that qualify for this catagory. There have been several portraits of Rockwell painted and released in limited and unlimited editions and there is a sculptured bust on the market as well. A couple of particularly interesting things that belong here also are by a young artist named Robert Charles Howe.* His painting "A Tribute To Rockwell" was reproduced and released in 1972 in an edition of 2000 prints. The March/April 1973 Saturday Evening Post cover is by Howe and is a desirable adjunct to any Rockwell cover collection.

Occasionally one of Rockwell's models may autograph a print that they posed for. These are also nice to have in a collection.

Winner of the Saturday Evening Post Norman Rockwell Cover contest in 1973.

THE ART AND COLLECTIBLES
IDENTIFICATION GUIDE

In most instances the art is signed. As noted earlier Rockwell used a few different styles of signature ranging from simple initials to his full name (in the earliest days). Most of his work is readily identifiable by the familiar stylized signature reproduced here. Look for other styles however for he occasionally used them. Just about all can still be recognized for they were rendered legibly unlike some other artists' signatures. (See page 13).

Because of his infrequent ommission of the signature most of his works are easy to spot. That coupled with a study of his artistic style will prepare you fairly well in the recognition of his works. Most have been documented and listed; especially the magazine covers, advertising illustrations, etc., and lists are available. There is this book and a couple of others containing these lists. The others are more specialized in that they list only the magazine cover and advertising work. If you are into collecting the paper collectibles insofar as the ad and magazine cover illustration, *THE NORMAN ROCKWELL ENCYCLO-PEDIA, A Chronological Catalog of the Artist's Work by Molly Moline is highly recommended. It is the most comprehensive listing of these works to date.

As for the various limited and unlimited collectibles other than his art work, almost all are clearly identified as Rockwell related.

The real bonanza is the yet unfound original paintings and drawings for hundreds of magazine covers, story illustrations, and advertising art. Once again, do not lose sight of the fact that he was a prolific professional artist given to preparatory study works in the form of preliminary drawings and paintings. There must be several hundred, perhaps thousands of originals out there still to be discovered.

*The Curtis Publishing Company, Indianapolis, Indiana 46202. Copyright 1979 by Mary Moline. See page 42 for source information.

CARE, DISPLAY AND STORAGE

Because of the tremendous variety of Rockwellania, this subject will be broken down into three segments: Original Paintings, Paper Collectibles, and Other Than Paper.

Original Paintings

Remember that Rockwell considered himself first an illustrator, then an artist. The first order of business for an illustrator is to produce a work suitable for reproduction by a given deadline. They paint for reproduction, seldom thinking of their painting as a work of art that is to last down the ages. Their goal is the illustration, not a museum masterpiece.

Most of the old and modern masters worked slowly, methodically building up pigments, aware of the different drying times of each of them and letting various stages of their progress dry properly before going on. They are conscious that the work can literally destroy itself over the years if not properly executed. Many of the works Rockwell did for reproductive purposes were quickly done when compared to the other masters. He built up many layers quickly, varnishing each and letting it dry for a short period (only a few hours in some cases). The result was a painting with many layers and areas not properly dry. The various drying times and chemical reactions between different pigments and varnish can set up a great deal of internal stress that sometimes results in catastrophic changes. Fortunately he was aware of this and attempted to compensate when there was time, where possible. I know of only one case where extreme damage has manifested itself and even then it didn't destroy the picture. It only required extensive restoration.

There are a number of rules of care that must be adhered to when displaying or storing all fine paintings. Because of the instability of some of Rockwell's paintings, those of you who are lucky enough to own one should be acutely aware of them.

Never hang a painting over a fireplace that even on rare occasions has a lighted fire of any sort.

Never hang where heating or air conditioning vents or radiators will blow directly on the picture or expose it to sudden changes in temperature.

Never let sunlight shine directly on the picture; even for a few minutes each day. The ultraviolet portion of the light can fade the color not to mention the heat that can be generated.

Be sure to hang a painting in such a way as to allow ventilation to the back side. A thumb tack or pad at each lower corner should serve to hold the frame far enough away from the wall to allow air circulation and not be unsightly.

Never touch the surface of the painting and absolutely do not ever attempt to clean or restore a picture yourself. Do not even let a picture framer or artist touch it even if he says he knows how. Should you need such services, go to a museum and get a recommendation for a competent professional. Many well meaning individuals have literally destroyed a painting because they don't know enough about this highly complex craft to know better.

Last but not least, be sure of the frame. If it is framed when you obtain it, have a competent professional examine it for proper framing. If you have to have a frame for it, insist on strict adherence to conservation framing used by museums. Once again be

sure to go only to highly recommended
conservation framers with firmly established
reputations in the field. A beautiful frame
can hide a multitude of sins.

All of these precautions may seem extreme but
remember, your painting is worth thousands of dollars.

Paper Collectibles

This discussion will be based upon the assumption that all
Rockwell art on paper is valuable whether it be an original,
a magazine cover, a fine art print, or mass-production
print.

Every single precaution listed for original paintings
above applies to paper borne works of art-drawing or
print, if you are to insure its longevity. There are however
some added precautions peculiar to paper born art.

With so much of the Rockwell collectibles being paper
it is necessary for the collector to understand the nature of
the substance, and the "care and feeding" of it.

Paper has been around, in one form or another, for
about 2000 years. The very finest of papers are delicate
and hand made, but fine papers can also be machine-made.
Virtually all papers used by periodic publications are
machine-made and most are of inferior quality. The
majority of the Rockwell magazine covers, ads, etc., are
found on this inferior paper and have a tendency to "eat
themselves up". Among other factors, this is due to
incomplete washing out of the chemicals used in
production. Whether superior or inferior, paper is fragile
and almost never completely dry; all contain a certain
amount of moisture.

It has been said that a man is no better than the
company he keeps. The same is true for all paper-borne art
works, original or machine printed. Because of this, in
display or in storage, certain precautions must be taken. If
the paper is in direct contact with an inferior product, the
contaminants in that product will eventually contaminate
the picture. Most of these products, such as ordinary

picture matting, chipboard, cardboard, etc., are made of wood pulp and residues of chemicals remain in them. The same sort of problem is found in **some** clear plastic products.

Paper breathes, in its own way and is constantly being affected by atmospheric pressure, humidity, temperature, and most importantly, the pervasive presence of air pollution always with us in our time.

All acknowledged or potentially fine prints as well as any paper borne work you value must be protected from or fortified against these constant onslaughts, that they may have the best chance of survival.

Here again you must get recommendations for the best, most reliable professionals in the business. Listed in the sources section you will find address of firms that market storage and display materials for your particular need. If you have anything framed, be sure of your framer. Your neighborhood picture framer may be an excellent craftsman with good taste and impeccable reputation for honesty. That does not however, mean that he knows the intracacies of conservation framing.

One last word regarding **any** paper-borne artworks. There are many ways to attach it to a support backing in framing or display. Most are variations of these four: dry mounting, wet mounting, hinge mounting, and flange mounting. Of those four the first two are considered last resorts, to be used only when the art is so far gone that it would literally fall apart if not.

Collectibles Other Than Paper

Many of the things discussed concerning paper art in the previous pages will apply here also. In the long run common sense has a very good influence on how we take care of things. Because the remaining Rockwell collectibles take so many forms and common sense varies from one person to another there follows a list of general precautions and suggestions. It will either serve to remind or to educate.

Small objects should be held in the cupped hand when handling.

Large objects should be held with both hands when picked up.

Do not shove objects around on a shelf. If you are scraping across a surface, you damage both.

If an object has two or more parts, never assume they are firmly attached.

Never pick up objects by small protuberances.

Don't overcrowd your collection. The act of moving one may cause damage or breakage to another. In the case of figurines, this also helps to avoid the "Mob Scene" look.

Don't use any cleaning or chemical solution for cleaning unless you are certain that it will not harm the surface of the object. Never use abrasive cleaners.

All light must be considered a potential hazard and reasonable safeguards should be used. Direct sunlight is the worst offender.

Don't expose your collection to extreme changes in temperature or humidity.

Use strong picture hooks on sturdy walls when hanging pictures. Two hooks are recommended. That beautiful and valuable picture can be badly damaged if it falls from the wall.

Handle objects with clean hands. Finger prints furnish oils and moisture. The mixture

of the two are detrimental to paper and fine objects.

If you are moving objects or pictures from one location to another, take proper precautions such as wrapping each, sufficient to pad it from the others. Use several small containers rather than one large one.

After all of that, this: Concerned collectors can and usually do learn to be careful when handling and displaying objects, but are at the mercy of guests and visitors whose admiration can be destructive. Precautionary signs found in shops and stores are hardly suitable for the home; the warning buzzer that signals a museum guard or store keeper that a visitor has ventured too close to an exhibit is not only impractical for most collectors, but downright inhospitable; and the alarm that shrieks, rings, or whoops when exhibits are touched are meant to protect against thieves, not friends.

Yet the collector who makes no effort to defend his collection against the thoughtless, albeit innocent, guest may eventually find that "nice guys" end up with damage or breakage.

THE ANATOMY OF YOUR COLLECTION
Defining, Refining, and Confining

I have a collector friend (in another area of collecting) that started out modestly, trying to collect an example of each variation of a product manufactured by one old company. He became so intensely interested in similar products of other companies that in the past ten years his collection has expanded to an incredible size; over 7000 items. They are small, but still that prodigious number forced his family right out of their entire living room, later forcing an addition to the house to regain the lost square footage. Fortunately for him, his wife shared the same enthusiasm for his collection. Unfortunately, for most collectors, this is a rare circumstance.

Unless you are as fortunate as my friend you will have to formulate some sort of plan; even if only a loose one.

What do you want to collect? For most the answer is easy. One person may prefer figurines, another fine prints, or another, plates. Whatever the choice, specializing in one or two types, or forming eclectic collection, some will be self-limiting. How many $5,000.00 paintings can the average collector buy? That is an extreme example of course, but serves to illustrate the point. On the other hand you can "collect old magazine covers or ads for very modest cash outlay and hundreds can be stored or displayed in a very small area.

It is incumbent upon you to try aiming in one direction. It is probable that your tastes and desires will change as you learn more and in Rockwell collectibles, you have much to choose from.

A few suggestions to get your mind going follow here. None may appeal to you but one might spark another idea.

Collect objects of one type; plates for instance.

Concentrate on advertisements from only one company.

Confine your acquisitions to magazine covers only

Collect the illustrations that have only boys.

Collect only musical pieces.

How about collecting only those mass-produced reproductive prints?

There are many metal objects with Rockwell themes. You could confine your acquisition to metal only.

He did many illustrations that included a dog. Try to collect only those.

You could make a nice collection out of only those prints or objects that have a Christmas theme.

For you bell people there are at least forty different bells to find.

Matching figurines and plates would make an interesting collection.

For the philatelist there are a few postage stamps and lots of first day covers.

Collect Rockwell items pertaining only to Boy Scouting.

EXPLORING THE RESOURCES

There are so many things that have been and are being produced with Rockwell's work as the basis or decoration that the answer to the question where to find it, is just about anywhere. I took an afternoon not so long ago and made the round of the local antique, junk, and thrift shops, looking for Rockwell items. They all know me around here so the immediate question when I walk in is about what am I may be working on now. My answer — "Rockwell items", was met with various negative responses as far as their inventory was concerned. I bet all of them a soda or a candy bar that I could find something on their premises that was "Rockwell". To make a long story short; I didn't have much appetite at the dinner table that night.

Among the things I came up with were seven 1939 vintage Liberty magazines each with a Rockwell illustrated ad, a 1961 Saturday Evening Post with a Rockwell cover and an added bonus of one of his ad illustrations inside, a reproductive tin serving tray, and five mass-produced prints. Had I bought them all, the total outlay would have been $5.75.

As noted earlier there are several types of things that you will probably not find in such places. The fine art reproductions and figurines for instance. Improbable but not impossible, so keep your eyes peeled when attending events such as yard sales, estate sales and flea markets. You may be the only one in the crowd to recognize that treasure and pick it up for a song.

Some Specific Sources

Dealers are by far the best way to obtain the limited edition or limited circulation pieces. There are many who specialize in collectibles of all sorts and almost invariably offer one, two, or many Rockwell pieces and prints. Just about all the dealers who advertise widely in the various collectors periodicals are not only mail order but maintain retail shops and stores also. Some specialize in plates

and/or figurines; some prints; and some are eclectic in their offerings. Most of the prices I have noted in their ads and mailings are competitive with each other. Don't overlook your local sources, i.e. the jewelry stores, galleries, gift shops, department stores, etc. Collectors and dealers alike are becoming quite sophisticated in their knowledge of collecting. However it is still possible to find an item or two, bought many years ago at wholesale, marked up to standard retail and remains unsold at the original, old retail price. This would be especially true in smaller shops in the small towns of America.

There are some dealers in the U.S. that specialize in paper collectibles also. They are great sources for that hard to find last magazine cover to complete your collection.

You will find dealers of all sorts listed in the sources section.

Flea Markets, Yard Sales, etc. We've touched on this somewhat already. You know what you're looking for but the seller doesn't. Do not discount these possible sources. Remember the gee gaw your maiden Aunt Modelle brought you from her last annual sabbatical to 52 Flags over Yuma? It may not have been quite your cup of tea. A few years later you feel it's safe to get rid of it - for 25 cents at your garage sale. Imagine the delight you provide for that collector of gee gaws who knows yours is worth $25 instead! Put yourself in those shoes.

Friends, Neighbors, and Relatives also have good potential as sources or aids in collecting, they can be good detectives for you in their travels. You can let them know of your collecting interest and that may be a welcome solution to their problem on gift-giving occasions. One other thing, get in their attics or basements if you can. Offer to clean it out for contents or help to straighten out for an item or two. However you choose to do it they can be veritable treasure troves, especially for old magazines and the like.

SOME PITFALLS YOU MAY ENCOUNTER

In every area of collecting there are certain problems you must be aware of. Some are general to collecting and some are specific to your particular type of collectible.

The Prints and Paintings are quite vulnerable to that nefarious character, the forger. I know of no specific instance of a fake Rockwell painting as yet, but given the prices of paintings on todays market and the number of heretofore undiscovered originals, it is sure to eventually happen. Be ever mindful of the possibility.

The fine art prints are highly susceptible and in fact it has happened.

On page 11 there is a descriptio of how there are a number of the collotype prints that are printed from the plates after the small signed edition was printed. Remember that the title of the picture and copyright is added before the unlimited edition is printed. There has been trouble with some unscrupulous people buying these and forging the Rockwell signature to them. The only way I can suggest that you defend yourself against this is to be extremely cautious if you encounter a hand signed print with the machine printed title and copyright on it.

We also noted Rockwell's special favor to The Old Corner House of autographing some of the mass-produced reproductive prints. Remember that they stamped each one to indicate this. If you find a hand signed mass production print without the stamp, be suspect.

There is also the possibility of taking an old black and white advertising illustration or similar printing and adding light watercolor or acrylic paint so as to make it appear as an original work. It hasn't happened with a Rockwell work yet, to my knowledge; however it has been done in other areas of print collecting. A trusty magnifying glass should identify this for you with a little practice.

There is a characteristic of all old photomechanical

offset lithography*. Pick up any magazine and turn to a page with some advertising artwork on it. Choose an area that is only slightly colored or shaded and examine it under a magnifying glass. You will immediately discern a uniform dot pattern. Any time you see that, the picture you are examining is a reproduction, no matter if some of the work is actually hand colored and doesn't show the dot pattern.

Sounding a little negative here, I hasten to point out that there are many fine, legitimate limited edition reproductions on the market including some of Rockwell's work, and he may have autographed one for someone occasionally.

The Other Collectibles

Porcelain and pottery, wood, paper, glass, and metal can be bonded with new glues that leave almost no trace to the naked eye.

Concerning the value of damaged but expertly restored items: the porcelain pieces would be worth one-half or less than the going current retail market value unless the piece is a significantly rare one. Then it may be worth almost as much as a "mint" piece. The same is generally true of the other, more valuable items, made of wood, paper, glass, etc.

Detection of hidden repairs or legitimate restoration can be troublesome but there are a couple of methods not outside the means of most collectors. These are (1) examination by **long-wave** ultraviolet light, and (2) examination by X-ray. Until recently one could rely almost 100% on ultraviolet examination, but the latest restorative techniques (particularly with porcelain) that have been developed are undetectable except by X-ray examination.

When an undamaged piece is exposed to long-wave ultraviolet light, it will appear uniformly light in color (usually purple), the value of this color varying with the color on the item. A crack or fracture with glue in it will appear a lighter color than that adjacent to it (usually

This is the most common method of reproducing photos and pictures in periodicals.

orange or pink). Patches will show up almost white, and most new paint will appear a much, much darker purple.

An X-ray examination may prove a bit difficult unless you have access to the equipment. If you have a doctor or dentist friend, you might convince him to help you once in a while, for his expenses. A properly exposed X-ray film of a piece will show fracture lines much the same as it does your broken arm or leg.

The best way I know to avoid any of the pitfalls is to establish a working relationship with a trusted dealer. The ones I am familiar with are all just that. I don't know of a single bad apple in the barrel but alas, as in all collecting, one may rear his ugly head some day.

IT'S BROKEN, SCRATCHED, OR BADLY DETERIORATED

NOW WHAT?

For whatever reason let's say you have a less than mint condition item. If it is one of the original paintings, it goes without saying; restoration, if possible and economically feasible, is the only answer. For anything else the decision is subjective.

Before you get out the glue pot or scotch tape, stop and think about a few things.

It's true that many of us have the ability to do a neat job of mending with the result of showing little or no immediately discernible evidence of the operation. If you do it, it may turn out to be a classic case of "the operation was successful but the patient died".

If you elect to have a professional restore it, you must give some consideration to the economics of the situation. If it is worth a hundred or more dollars, is particularly rare, or has great sentimental value regardless of cost or worth, then your best alternative is a professional. If, on the other hand it is easily replaceable for less than the cost of restoration, then your decision is made for you. You may wish to repair it yourself, but bear in mind that what is valued low today may be a treasure tomorrow.

Collection Protection and Insurance

There are numerous ways to protect and safeguard your collection which you can accomplish with ease if you will take the time to do so. In the unfortunate circumstance of theft or destruction, the law enforcement authorities and/or insurance companies will be able to handle recovery, replacement or reimbursement, much more efficiently if you have done your homework before the fact. This "homework" can be rewarding in itself by increasing your knowledge of the very things you collect.

Write It Down

Inventory your collection. Put it on your "Things To Do Today" list. Get yourself some index cards and file box, a looseleaf notebook, or whatever may be easiest for you to use to catalog your collection. Some of the important things to record in your inventory are when, where, and how you obtained each piece. Record the price you paid or what you traded for it. Describe each with name, material, measurements, all signatures and other marks. It would be good even to assign each item a number in your collection and describe the location on the premises. The number may be your own or in the event there is a universal number you may prefer to use it.

Photograph It

Photographs are evidence, should something be damaged, of its original condition. They are a positive means of identification by which it may be traced if stolen and assurance for insurance purposes. They serve as a historical record and if the occasion to sell arrives, they can serve as an excellent tool in such process.

Many collectors find it convenient to use the back of each photo to record the description, etc., for their inventory. It is advisable to maintain duplicates of each, one set in a safe place at home so that you may use them when you wish, and the other set somewhere off the premises such as a safe deposit box.

Identification Marks

An additional safeguard is to mark each individually. If a piece is lost or stolen, the ability to point out a distinctive mark identifying it as your property is quite helpful.

If you are a purist, reluctant to permanently mark an object because it alters the original state, then there are other slightly more difficult ways.

You may want to use descriptions of unique properties of each item such as repairs, imperfections or areas of wear.

Should you choose to mark, do so in an unobtrusive

location such as an underside or back. However you mark, make sure it is permanent and very small.

In the case of prints or paintings be sure to mark on the back side, not on the image or margins. When marking, do so gently so as not to cause any trauma to the image on front. Certainly never use a ball point pen. They have a tendency to crease the paper, showing on the front.

Insure It

Many collectors feel safe and secure in the knowlege that they have a good homeowners' policy. They are living in a dream world. There are countless cases of collectors who received little or no compensation for their loss under a standard homeowners' policy. Most policies have clauses that limit or exclude coverage for collectibles. This book cannot delve into the intricacies of the insurance problem, but will serve to forewarn the collector. It behooves you to discuss your particular collecting situation with a trusted agent or to contact a specialist firm in fine art insurance.

SOURCES

The names and addresses in this section are placed here as an aid in locating a source for all sorts of help. Many items and services have been referred to in the text. Here is where to find them. The publications lists are there for your reading and research interests and many of them are great places to buy or sell through display and classified advertising. The clubs and organizations should be investigated by you. They can be wonderful sources of information and will put you in contact with collectors who share your interests.

There is no guarantee that any of the individuals or firms listed will respond to your request. A few are placed here because they requested to be listed; others are here because they have expressed interest through advertising. In either case it is ultimately up to you to assure yourself that any who appear in these lists meet your standards and requirements. Many of them do not maintain showrooms or stores for the public so it is strongly recommended that you contact them through the mail initially. Perhaps the lists can be expanded to include more names and other catagories. Any suggestions would be welcome.

DEALERS & ORGANIZATIONS

Those sources that deal primarily in prints are indicated. All others have various Rockwell collectibles available. It is always advisable to query the dealer by letter or telephone before visiting. Some sources are mail-order only and do not maintain a showroom to the public.

When writing, do remember to include a self-addressed stamped envelope. You will find a few toll-free (800) numbers. They are almost always provided for placing an order only.

Do not use the number to merely ask for information unless you intend to purchase whatever you may be asking about.

ALBATROSS ANTIQUES
73 West State St.
Oxford, N.Y. 13830
607 843-9191

ARMSTRONG'S
150 East Third Street
Pomona, Calif. 91766

ART'S
Box 1170
Temple City, Calif 91780

BENNIE E. BLAND (Prints)
P.O. Box 5579
Abilene, Texas 70605

THE BRADFORD
EXCHANGE
9333 Milwaukee Ave.
Niles, Ill. 60648

BROWN & BIGELOW,
INC.
1286 University Ave.
St. Paul, Minn. 55435

CALHOUN'S COLLECT-
OR'S SOCIETY
Calhoun Center
Minneapolis, Minn. 55435

CANDLELITE COL-
LECTOR'S SOCIETY
7 Norden Lane
Huntington Station, N.Y.
11746

CAROL'S GIFT SHOP
17601 S. Pioneer Blvd.
Artesia, Calif. 90701
213 924-6335

CERTIFIED RARITIES,
 INC.
202 York Rd.
P.O. Box 2069
Jenkintown, Penn. 19046

CIRCLE FINE ART
 CORP. (Prints)
232 East Ohio
Chicago, Ill. 60611
312 943-0664
 Also
8439 Warner Drive
Culver City, Calif. 90230
213 559-0330

COMMEMORATIVE
 IMPORTS
Box D
Bayport, MN.
800 328-1678
612 439-4918

CONTINENTAL
 COLLECTABLES
7 Norden Lane
Huntington Station, N.Y.
 11746

CONTINENTAL MINT
7 Norden Lane
Huntington Station, N.Y.
 11746

THE OLDER CORNER
 HOUSE (Prints)
Stockbridge, Mass. 01262

COVENTRY
 COLLECTABLES
P.O. Box 316
Bolton, Mass. 01740
617 779-5033

CREATIVE ART
 INVESTMENTS, INC.
 (Prints)
655 W. Irving Park Rd.
Chicago, Ill. 60613

CREATIVE WORLD LTD
39 Westmoreland Ave.
White Plains, N.Y. 10606

THE DANBURY MINT
47 Richards Ave.
Norwalk, CT 06856
203 853-2000

DOWNS COLLECTORS
 SHOWCASE
6048 West Bebit Ave.
Milwaukee, Wis. 63219

EDITIONS LIMITED
1280 Aberdeen Lane
Mundelein, Ill. 60060

JACK ENGEL LIMITED
 EDITIONS
Box 2254
La Mesa, Ca. 92041

FAIRMONT CHINA CO.
9854 Rush St.
South El Monte, Ca. 91733

FIDELITY ARTS (Prints)
9000 Beverly Blvd.
Los Angeles, Calif. 90048
213 278-6611

THE FRANKLIN MINT
Franklin Center, Pa. 19091

FRIVOLITE
North 9-520 Eighth Ave.
New York, N.Y. 10018
212 736-4422

THE GORHAM CO.
333 Adelaide Ave.
Providence, R.I. 02907

DAVE GROSSMAN
 DESIGNS, INC.
2383 Chafee Drive
St. Louis, Miss. 63141

THE HAMILTON
 COLLECTION
 (Hamilton Mint)
210 N. Main St.
Jacksonville, Fla. 32202

HAMPTON GALLERIES
P.O. Box 188
Cedarhurst, N.Y. 11516

HICKORY HOUSE
110 E. Main St.
Ottumwa, IA 52501
800 247-1075

HOLLYWOOD LIMITED
 EDITIONS
6990 N. Central Park Ave.
Lincolnwood, Ill. 60645

HOUSE OF GOEBEL
350 Fellowship Rd.
Moorestown, N.J. 08057

INTERNATIONAL
 POSTAL COLLECT-
 ORS LEAGUE
C/O Calhoun Collectors
 Society, Inc.
Calhoun Center
Minneapolis, Minn. 55435
612 835-0300

INTERNATIONAL
 SILVER CO.
500 South Broad St.
Meriden, Ct. 06450

JO JO'S COLLECTIBLES
P.O. Box 672
Rockville, Maryland 20851

JOY'S LIMITED
 EDITIONS
851 Seton Court
Wheeling, Illinois 60090

KNOWLES CHINA CO.
P.O. Box 296
Newell, W.V. 26050

KRUCKEMEYER and
COHN
309-311 Main Street
P.O. Box 967
Evansville, Ind. 47706
800 457-3536
812 464-9111

LYNELL STUDIOS
400 E. Street Rd., Suite
126
Feasterville, Pa. 19047

LEANIN' TREE
Box 9500-W
Boulder, Colorado 80301
800 525-0846
303 530-1442

LIMITED EDITION
COLLECTIBLES, INC.
18 East Ridgewood Ave.
Ridgewood, N.J. 07450
201 796-8300

LIMITED EDITIONS
CUSTOM GIFT SHOP
389 Jefferson Drive
East Windsor Township,
N.J. 08520
609 443-1253

EDWARD LONDON
9408 N. W. 70th St.
Tamarac, Florida 33321
305 721-8942

HARRY A. LUND
525 Hawthorne Place
Chicago, Ill. 60657

MADERS COLLECTOR'S
GIFT SHOP
1041 N. 3rd Street
Milwaukee, WI 53203
414 271-1911

McNAMARA'S
3305 N. Ocean Blvd.
Ft. Lauderdale, Fla. 33308
800 327-8854

METROPOLITAN ART
ASSOCIATES (prints)
3000 Marcus Avenue
Lake Success, N.Y. 11040
516 354-6600

MIKE & GRACIE
NEVILLE
12 Roberta Drive
Middletown, Conn. 06457
203 344-0062

MISTY'S GIFT GALLERY
228 Fry Blvd.
Sierra Vista, Arizona 85635
800 528-4846
602 458-7208

MAURICE NASSER
New London Shopping
Center
New London, Conn. 06320
203 443-6523

NEEDLEWORKS
COLLECTIBLES
1140 Ocean Ave.
Elberton, N.J. 07740
201 222-0292

NORDIC IMPORTS
5211 Hollywood Blvd.
Hollywood, Fla. 33021
305 981-5211

THE NUTMEG
COLLECTION
210 N. Main St.
Jacksonville, Fla. 32202

OXFORD HOUSE
Dept. 72
Southampton, Pa. 18966

THE PLATE
COLLECTOR'S STOCK
EXCHANGE
478 Ward St. Extension
Wallingford, Conn. 06492
203 265-1722

PORCELLANA LIMITED
1051 Eaton Avenue
Hamilton, Ohio 45013
513 869-8185

POSTAL COMMEMORA-
TIVE SOCIETY
47 Richards Avenue
Norwalk, Conn. 06856
203 853-2000

RICHARD'S LIMITED
EDITIONS
Box 35
Staten Island, N.Y. 10309
800 221-0966
212 356-6662

RIVER SHORE, LTD.
10185 River Shore, Dr.
S.E.
Caledonia, Mich. 49316

ROCKWELL
COLLECTOR'S
SOCIETY
201 West First St.
Dixon, Ill. 61021
815 284-6622

NORMAN ROCKWELL
MEMORIAL SOCIETY
12109 Wasatch Court
Tampa, Florida 33624
813 961-8834

THE NORMAN
ROCKWELL MUSEUM
INC.
425 Heuhl Road
Northbrook, Ill. 60062

THE NORMAN
ROCKWELL NATION-
AL CONVENTION
1061 Bimini Lane
Singer Island, Fla. 33404
305 845-1262

ROCKWELL SOCIETY
OF AMERICA
P.O. Box B
Stony Brook, N.Y. 11790

ROHN
Box 891
Mundelein, Ill. 60060
312 566-1471

ROSE MARIE'S
1024 Lincoln Ave.
Evansville, Ind. 47714
812 423-7557

RUMBLESEAT PRESS,
 INC.
Van Nuys, Calif. 91409

SANGO
212 Fifth Ave.
New York, N.Y. 10010

THE SATURDAY
 EVEING POST (Prints)
1100 Waterway Road
Indianapolis, Ind. 46202

SCHMID BROTHERS,
 INC.
55 Pacella Park Dr.
Randolph, Mass. 02368

THE STRATFORD
 GALLERY
114 Fifth Ave.
New York, N.Y. 10011
800 621-5199

TAMPA BAY GALLERY
12109 Wasatch Court
Tampa, Fla. 33624
813 961-8834

TREIN'S
201 West First St.
Dixon, Ill. 61021
815 284-6626

VIKING IMPORT
 HOUSE, INC.
412 SE 6th
Ft. Lauderdale, Fla. 33301
800 327-2297
305 763-3388

WATSON'S
135 East Michigan
New Carlisle, Ind. 46552

WESTPORT ART
SOCIETY
60 Wilton Road
Westport, Ct. 06880

PERIODICALS

The name, address, and a short description of each of these periodic publications is listed below. Most will send you a sample issue on request, it is recommended that you do exactly that so you may decide which of them is most interesting and useful to you.

AMERICAN COLLECTOR
P.O. Drawer C
Kermit, Texas

Has occasional articles about Rockwell collecting and ads for buying selling. Published monthly.

ANTIQUES JOURNAL
P.O. Box 1046
Dubuque, Iowa 52001

A monthly journal. Has ads for buying and selling.

ANTIQUE TRADER WEEKLY
P.O. Box 1050
Dubuque, Iowa 52001

A large circulation weekly newspaper about all sorts of collectibles. Has occasional articles about Rockwell collecting and extensive ads for buying and selling Rockwell collectibles.

COLLECT AMERICA INTERNATIONAL
P.O. Box 777
Waynesboro, Tennessee 38485

A national circulation monthly newspaper about all sorts of collecting. Has occasional articles about Rockwell collecting. Ads for buying and selling.

COLLECTOR EDITIONS QUARTERLY
170 Fifth Avenue
New York, N.Y. 10010

A very fine magazine for collectors of anything.

COLLECTORS JOURNAL
P.O. Box 60
Vinton, Iowa 52349

A weekly newspaper for collectors and antique auctions. Has ads for buying and selling.

COLLECTOR NEWS
606 8th Street
Grundy Center, Iowa 50638

A monthly newspaper for collectors. Has ads for buying and selling.

HOBBIES MAGAZINE
1006 South Michigan Avenue
Chicago, Illinois 60605

A monthly magazine for collectors and hobbiests. Has ads for buying and selling.

KOVELS ON ANTIQUES AND COLLECTIBLES
P.O. Box 22200
Beachwood, Ohio 44122

A good monthly newsletter on antiques and collectibles.

PLATE COLLECTOR MAGAZINE
P.O. Box 1041
Kermit, Texas 79745

A twice montly magazine for collectors. Has occasional articles about Rockwell collecting. Ads for buying and selling.

PRINT COLLECTORS NEWSLETTER
205 East 78th Street
New York, N.Y. 10021

A bimonthly newsletter for print collectors.

PRINT TRADER
6762 79th Street
Middle Village, New York 11379

A quarterly newsletter about prints and paper collectibles.

BOOKS AND SPECIAL EDITION PUBLICATIONS ABOUT ROCKWELL

THE ABC BOOK, George Mendoza

102 FAVORITE PRINTS BY NORMAN ROCKWELL, Christopher Finch. 1977, Artabras

HOMETOWN, Thomas Rockwell

LITTLE ROCKWELL BOOK, Mary Moline

MY ADVENTURES AS AN ILLUSTRATOR, by Norman Rockwell, c1960 Doubleday

NORMAN ROCKWELL, ARTIST AND ILLUSTRATOR, Thomas S. Beuchner, 1970 Abrams

NORMAN ROCKWELL: A SIXTY YEAR RETRO-SPECTIVE, Thomas S. Buechner. 1971 Abrams

NORMAN ROCKWELL COLLECTIBLES VALUE GUIDE, Mary Moline. Copyright 1979, Rumbleseat Press, Inc., San Francisco, Calif. 94123

THE NORMAN ROCKWELL CHRISTMAS BOOK, edited by Molly Rockwell, Fireside, 1977 Abrams

NORMAN ROCKWELL ENCYCOPEDIA, Mary Moline, Copyright 1979, Mary Moline, published by the Curtis Publishing Co., Indianapolis, Ind. 46202

NORMAN ROCKWELL, IN LOVING MEMORY, A special edition of the Saturday Evening Post, February, 1979. Copyright 1979, The SEP Co. Indianapolis, Ind. 46202

NORMAN ROCKWELL-332 MAGAZINE COVERS, Christopher Finch, Copyright 1979, Cross River Press, Ltd. Abbeville Press and Random House, New York

NORMAN ROCKWELL MEMORY ALBUM, Vol. 1, No. 1, Saturday Evening Post Staff, Copyright 1979, The Saturday Evening Post Company, Indianapolis, Ind.

THE NORMAN ROCKWELL STORY BOOK, Jan Wake

NORMAN ROCKWELL TREASURY 1979, David P. Folds, Jr., Copyright 1978, David P. Folds, Jr., NOROCO, Riviera Beach, Fla. 33404. Soon to be in 1980 edition

NORMAN ROCKWELL'S AMERICA, Christopher Finch, 1975

NORMAN ROCKWELL'S BOYS AND GIRLS AT PLAY, George Mendoza

NORMAN ROCKWELL'S COLORING BOOK, Gloria Taborin

NORMAN ROCKWELL'S WORLD OF SCOUTING, Green Bar Bill, William Hillcourt 1977 Abrams

A ROCKWELL PORTRAIT, Donald Walton, c1978 Sheed Andrews & McMeel

REMEMBERING NORMAN ROCKWELL, Dick Spiegel, 1975

SALUTE TO ROCKWELL, January 1979 edition of Plate Collector Magazine, copyright 1979, Collectors Media, Inc., Kermit, Texas 79745

CONSERVATORS

(1) Specializing in Repairs and Restoration of Fine Paintings
(2) Specialists in Paper Conservation
Listed by state in which they are found so that you may locate the one nearest you. The first thing to do however, is to check with your nearest museum for a recommendation. That failing, query any of these people or companies by letter first, to see if they can or will tackle your specific problem.

Some names will appear on both lists as many do both types of work.

The lists do not constitute a recommendation, but consist of names that have been mentioned in connection with the service in other writings.

(1) Specializing in Repair and Restoration of Fine Paintings
CALIFORNIA
Academy of Professional Art Conservation
165 W. Napa Street
Sonoma, California 95476

CANADA
Dr. Nathan Stolow
Director, National Conservation Research Laboratory
National Gallery of Art
Ottawa, Canada

CONNECTICUT
Roger Dennis
100 Mohegan Avenue
New London, Connecticut

DISTRICT OF COLUMBIA
Russell J. Quandt
3433 34th Street N.W.
Washington, D.C.

FLORIDA
Dorothy Baden Elliott
3655 Egerton Circle
Sarasota, Florida

ILLINOIS
Louis Pomerantz
1424 Elinor Place
Evanston, Illinois 60201

MARYLAND
Peter Michaels
The Walters Gallery
Baltimore, Maryland

Elizabeth Packard
Director of Conservation
The Walters Gallery
600 N. Charles Street
Baltimore, Maryland 21201

MASSACHUSETTS
Thornton Rockwell
Rt. 3, Box 216
Skeekonk Road
Great Barrington, Massachusetts

MISSOURI
Clements L. Robertson
City Art Museum of St. Louis
St. Louis, Missouri 63100

James Roth
William Rockhill Nelson Gallery of Art
Kansas City, Missouri 64111

NEW JERSEY
Bernard Rabin
38 Halsey Street
Newark, New Jersey 07012

NEW YORK
S. J. Fishburne
Rt. 1, Box 511
New Paltz, New York 12561

Felrath Hines
121 W. 88th Street
New York, N.Y. 10024

Paul Kiehart
50 Crest Road
New Hyde Park, L.I., New York

Anton J. Konrad
185 Hall Street
Brooklyn New York 11205

Suzanne P. Sack
125 Remsen Street
Brooklyn, N.Y. 11201

Jean Volkmer
Museum of Modern Art
11 W. 53rd Street
New York, N.Y. 10022

Margaret Watherston
44 W. 77th Street
New York, N.Y. 10021

Tosca Zagni
Museum of Modern Art
11 W. 53rd Street
New york, N.Y. 10022

PENNSYLVANIA
Theodore Siegl
The Pennsylvania Academy of Fine Arts
Philadelphia, Pennsylvania 19102

(2) Specialists in Paper Conservation

CALIFORNIA
Academy of Professional Art Conservation
3545 Mt. Diablo Boulevarde
Lafayette, California 94549

Gainesborough Products, Ltd.
P.O. Box 494
Morage, California 94556

Graphics International
P.O. Box 13292, Station E
Oakland, California 94661

ILLINOIS
Harold W. Tribolet
R. R. Donnelly and Sons Co.
350 East 22nd Street
Chicago, Illinois 60600

MASSACHUSETTS
Christa M. Gaehde
55 Falmouth Street
Arlington, Massachusetts

NEW YORK
Conservation Center of the Institute of Fine Arts
New York University
1 East 78th Street
New York, New York 10028

William J. Hanft
The Brooklyn Museum
Brooklyn, New York 11238

Carolyn Horton and Associates, Inc.
430 West 22nd Street
New York, N.Y. 10011

Mary Todd Glaser
270 Riverside Drive
New York, N.Y.

PENNSYLVANIA
Archival Restoration Associates, Inc.
510 School Road
Blue Bell, Pennsylvania 19422

Marilyn Kemp Weidner
612 Spruce Street
Philadelphia, Pennsylvania 19106

MISCELLANEOUS REPAIRS
AND RESTORATION

Cordier's Fine Arts
1619 South La Cienega Boulevarde
Los Angeles, California

Restores ceramics and other fine objects

Directory of Art and Antique Restoration
Arthur Porter
465 California Street
San Francisco, California 94104

Harry A. Eberhardt and Son
2010 Walnut Street
Philadelphia, Pennsylvania 19103

Restoration and repairs of ceramics and porcelain.

Hess Repairs
200 Park Avenue South
New York, N.Y. 10003

Restores china, ceramics, porcelain, etc.

Plate Collectors Exchange
478 Ward Street Extension
Wallingford, Connecticut 06492

Restores and repairs porcelains, china, etc.

Sierra Studios
P.O. Box 1005
Oak Park, Illinois 60304

Specializes in mail order repairs. Porcelain and china.

Simms and Associates
Art and Museum Consultants
18311 S. W. 95th Court
Miami, Florida 33157

Daniel Zalles
580 Sutter Street
San Francisco, California

Restores ceramics, china, porcelain, etc.

MISCELLANEOUS MATERIALS SOURCES

ACID-FREE FOLDERS
AND STORAGE SYSTEMS

The Hollinger Corporation
3810 S. Four Mile Run Dr.
Arlington, Virginia 22206

INSURANCE
INFORMATION

Insurance Information
 Institute
110 William Street
New York, N.Y. 10038

INVISIBLE MARKING
PEN KIT

Westminster Collectibles
6186 Skyline Drive
East Lansing, Mich. 48823

NAME PLATES
(CUSTOM)

Gilt-Craft Custom Name
 Plates
P.O. Box 62
Essex Falls, N.J. 07021

STORAGE SLEEVES &
ALBUMS PRINT
PROTECTORS &
ENVELOPES

Jordan Specialty Co., Inc.
95 University Place
New York, N.Y. 10003

ULTRA VIOLET LIGHTS

Simms and Associates
Art & Museum Consultants
18311 SW. 9th Court
Miami, Florida 33157

Ultra-Violet Products Inc.
Walnut Grove Ave. at
 Grand
San Gabriel, California

SECTION III

ROCKWELL FIGURINES

There have been many three dimensional renderings of Rockwell work over the years.

In present knowledge virtually all but one design have been produced in ceramic, porcelain, earthenware, or similar hard surface material that is formed by a mold process. There is one woodcarving of a figurine. There is also a hand carved music box series to be introduced by January 1981 by Schmid Brothers, Inc., of Randolph, Massachusetts. The latter will be carved in the famed Anri workshops in Italy.

The figurines are listed by company on the following pages.

CREATIVE WORLD, LTD

THE LITTLE LEAGUER
This is the first wooden Rockwell figurine to be issued. It is hand-carved and hand-painted in a world wide limited edition of 2,500 and is the first edition in a series. The wood carver is Anselmo Malsiner. The 8" figurine was released in July of 1979 at $175.00.

FIRST FORMAL
The second wooden figurine in the series, limited to 2,500 carvings and released at $190.00 in 1980.

DAVE GROSSMAN DESIGNS, INC.

See page 90 for notes about the company. Grossman has issued limited and unlimited editions of porcelain figurines and in 1980 they introduced a set of 2½" figurines made of pewter. From time to time the company retires a design thereby making an unlimited item somewhat limited. Production numbers in the retired unlimited editions are not generally disclosed.

Grossman collection pieces are easily identified by examining the base. They have the figurine style or mold number incised along with the Saturday Evening Post cover date from which the design was taken. Beginning with late 1978 production the company began including their "Creative hands" logo to the base. All are also plainly identified with the Grossman company name and copyright along with S.E.P. name and copyright as well.

The following pages list the full size (approx. 5"-6") figurines first then the special editions, the miniatures and others. The groups are listed in order of their release. Where the item has attained a value on the secondary market you will find that indicated. If it is still selling on the primary (retail) market the current recommended retail price is listed.

THE FULL SIZE FIGURINES

Some of these were issued in a limited edition and some designs have been retired. This will be indicated in the appropriate listings. All of these pieces are made of porcelain.

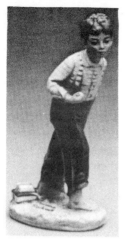

REDHEAD NR-1
September 16, 1916
Saturday Evening Post Cover
5½" Tall
Issued-1973
Retired-1978
Secondary Market Value-$150.00

Redhead, Dave Grossman Designs.

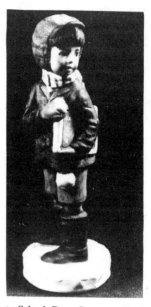

BACK TO SCHOOL NR-2
January 8, 1927
Saturday Evening Post Cover
6" Tall
Issued-1973
Current Retail Value-$28.

Back to School, Dave Grossman Designs.

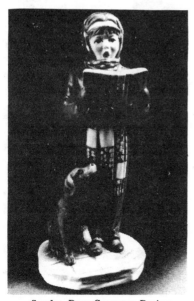

CAROLER NR-3
December 8, 1923
Saturday Evening Post Cover
5½" Tall
Issued-1973
Current Retail Value-$30.00

Caroler, Dave Grossman Designs.

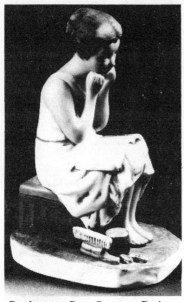

Daydreamer, Dave Grossman Designs.

DAYDREAMER NR-4
March 6, 1954
Saturday Evening Post Cover
5" Tall
Issued-1973
Current Retail Value-$36.00

NO SWIMMING NR-5
June 4, 1921
Saturday Evening Post Cover
5¼" Tall
Issued-1973
Current Retail Value-$36.00

No Swimming, Dave Grossman Designs.

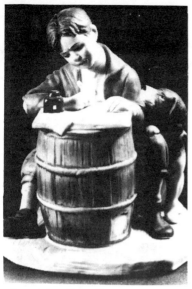

LOVE LETTER NR-6
January 17, 1920
Saturday Evening Post Cover
4½" Tall
Issued-1973
Current Retail Vaue-$426.00

Love Letter, Dave Grossman Designs.

LOVERS NR-7
August 30, 1924
Saturday Evening Post Cover
5" Tall
Issued-1973
Current Retail Value-$60.00

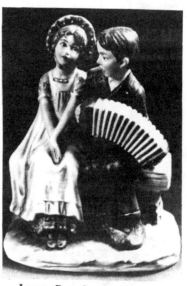

Lovers, Dave Grossman Designs.

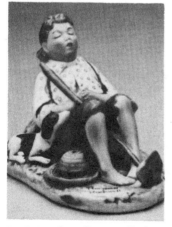

LAZYBONES NR-8
September 6, 1919
Saturday Evening Post Cover
3¼" Tall
Issued-1973
Retired-1977
Secondary Market Value-$300.00

Lazybones, Dave Grossman Designs.

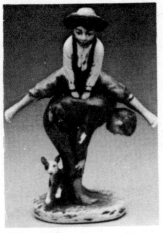

LEAPFROG NR-9
June 28, 1919
Saturday Evening Post Cover
6¼" Tall
Issued-1973
Retired-1976
Secondary Market Price-$600.00

Leapfrog. Dave Grossman Designs.

SCHOOLMASTER NR-10
June 26, 1926
Saturday Evening Post Cover
7½" Tall
Issued-1973
Retired-1978
Secondary Market Value-$250.00

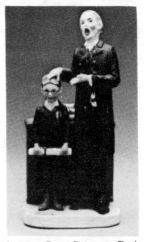

Schoolmaster, Dave Grossman Designs.

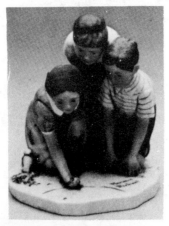

MARBLE PLAYERS NR-11
September 2, 1939
Saturday Evening Post Cover
4½" Tall
Issued-1973
Retired-1977
Secondary Market Value-$495.00

Marble Players, Dave Grossman Designs.

56

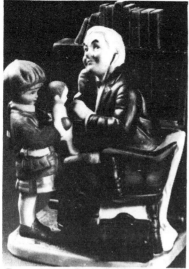

DOCTOR & DOLL NR-12
March 9, 1929
Saturday Evening Post Cover
6" Tall
Issued-1973
Current Retail Value-$100.00

Doctor & Doll, Dave Grossman Designs.

FRIENDS IN NEED NR-13
September 28, 1929
Saturday Evening Post Cover
5¼" Tall
Issued-1974
Current Retail Value-$86.00

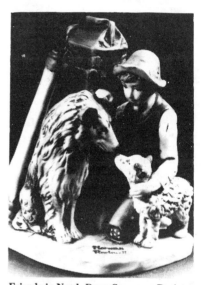

Friends in Need, Dave Grossman Designs.

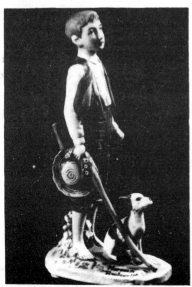

SPRINGTIME 1933 NR-14
April 8, 1933
Saturday Evening Post Cover
6" Tall
Issued-1974
Current Retail Value-$44.00

Springtime 1933, Dave Grossman Designs.

57

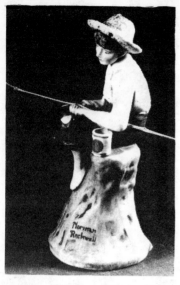

SUMMERTIME 1933 NR-15
August 5, 1933
Saturday Evening Post Cover
5¾" Tall
Issued-1974
Current Retail Value-$42.00

Summertime 1933, Dave Grossman Designs.

100th YEAR OF BASEBALL NR-16
July 8, 1939
Saturday Evening Post Cover
6" Tall
Issued-1974
Current Retail Value-$84.00

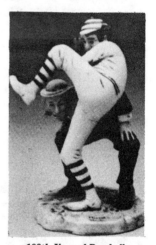

100th Year of Baseball,
Dave Grossman Designs.

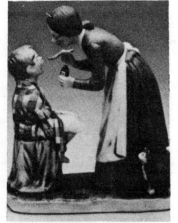

Take Your Medicine,
Dave Grossman Designs.

TAKE YOUR MEDICINE NR-18
May 30, 1936
Saturday Evening Post Cover
5¼" Tall
Issued-1974
Current Retail Value-$82.00

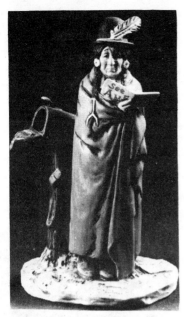

See America First, Dave Grossman Designs.

SEE AMERICA FIRST

Beyond the other two sizes of this figurine there is a very large and very rare version of it. The large figure is 21" high and was made in an extremely limited edition of only 6 pieces. They were produced for showroom display only and none are known to be in private collections. Each of these is valued at $10,000.00

SEE AMERICA FIRST NR-103
Limited Edition of 1,000
April 23, 1938 Saturday Evening Post Cover
9¾" Tall
Issued-1975
Edition Closed
Secondary Market Value-$250.00

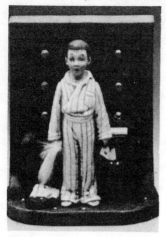

Discovery, Dave Grossman Designs.

DISCOVERY NR-20
December 29, 1956
Saturday Evening Post Cover
6" Tall
Issued-1975
Retired-1979
Secondary Market Value-$160.00

BIG MOMENT NR-21
January 25, 1936
Saturday Evening Post Cover
6½" Tall
Issued-1975
Current Retail Value-$100.00

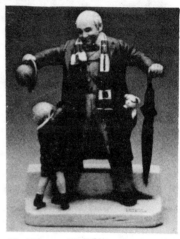

Big Moment, Dave Grossman Designs.

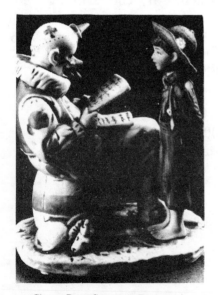

Circus, Dave Grossman Designs.

CIRCUS NR-22
May 18, 1918
Saturday Evening Post Cover
5¼" Tall
Issued-1975
Current Retail Value-$80.00

BARBERSHOP QUARTET NR-23
Limited Edition of 1,000
September 26, 1936
7" Tall
Issued-1975
Edition Closed
Secondary Market Value-$1,000.00

DRUM FOR TOMMY NRC-24
December 17, 1921
Country Gentleman Cover
6¾" Tall
Issued-1976
Current Retail Value-$62.00

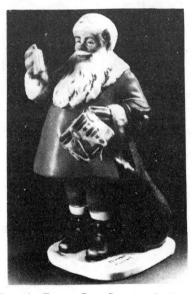

Drum for Tommy, Dave Grossman Designs.

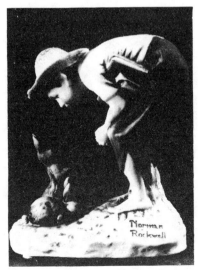

SPRINGTIME 1935 NR-19
April 27, 1935
Saturday Evening Post Cover
4¼" Tall
Issued-1977
Current Retail Value-$50.00

Springtime 1935, Dave Grossman Designs.

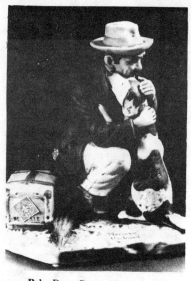

PALS NR-25
September 27, 1924
Saturday Evening Post Cover
5½" Tall
Issued-1977
Current Retail Value-$86.00

Pals, Dave Grossman Designs.

YOUNG DOCTOR NRD-26
Limited Edition of 5,000
5¾" Tall
Issued-1978
Current Retail Value-$106.00

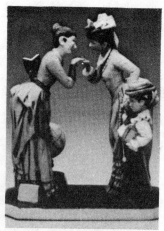

FIRST DAY OF SCHOOL NR-27
September 14, 1935
Saturday Evening Post Cover
6" Tall
Issued-1978
Current Retail Value-$110.00

First Day of School,
Dave Grossman Designs.

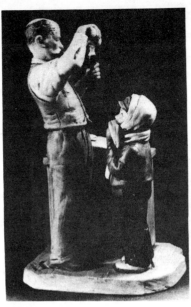

MAGIC POTION NR-28
March 18, 1939
Saturday Evening Post Cover
6½" Tall
Issued-1978
Current Retail Value-$94.00

Magic Potion, Dave Grossman Designs.

AT THE DOCTORS NR-29
March 15, 1958
Saturday Evening Post Cover
5½" Tall
Issued-1978
Current Retail Value-$112.00

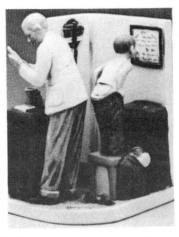

At The Doctors. Dave Grossman Designs.

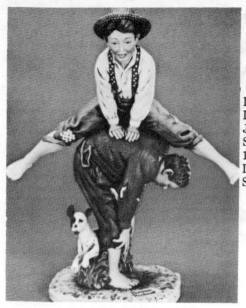

LEAPFROG NR-104
Limited Edition of 1,000
June 28, 1919
Saturday Evening Post Cover
10" Tall
Issued-1979
Secondary Market Value-$800.00

Leapfrog, Dave Grossman Designs.

TEACHER'S PET NRA-30
5¾" Tall
Issued-1979
Retired-1980
Secondary Market Value-$70.00

Teacher's Pet

DREAMS OF LONG AGO NR-31
August 13, 1927
Saturday Evening Post Cover
6" Tall
Issued-1979
Current Retail Value-$100.00

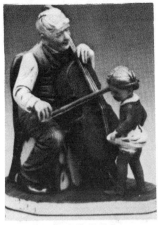

Grandpa's Ballerina,
Dave Grossman Designs.

GRANDPA'S BALLERINA NR-32
February 3, 1923
Saturday Evening Post Cover
5½" Tall
Issued-1979
Current Retail Value-$100.00

BACK FROM CAMP NR-33
August 24, 1940
Saturday Evening Post Cover
6¼" Tall
Issued-1979
Current Retail Value-$96.00

Back From Camp, Dave Grossman Designs.

THE TOSS NR-34
October 21, 1950
6½" Tall
Issued-1980
Current Retail Value-$110.00

The Toss, Dave Grossman Designs.

EXASPERATED NANNIE NR-35
October 24, 1936
6" Tall
Issued-1980
Current Retail Value-$96.00

Exasperated Nanny, Dave Grossman Designs.

HANDKERCHIEF NR-35
Saturday Evening Post
Inside Illustration May 11, 1940
7" Tall
Issued-1980
Current Retail Value-$110.00

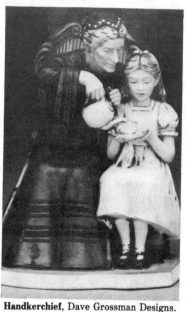

Handkerchief, Dave Grossman Designs.

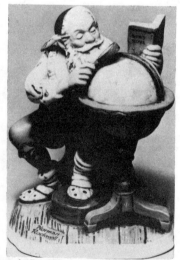

Santa's Good Boys, Dave Grossman Designs.

SANTA'S GOOD BOYS NR-37
December 4, 1926
Saturday Evening Post Cover
5½" Tall
Issued-1980
Current Retail Value-$90.00

DOCTOR & DOLL NR-100
Limited Edition of 1,000
March 9, 1929 Saturday Evening Post Cover
10" Tall
Issued-1974
Edition Closed
Issue Price-$300.00
Secondary Market Value-$1,200.00

NO SWIMMING NR-101
Limited Edition of 1,000
June 4, 1921
Saturday Evening Post Cover
9" Tall
Issued-1975
Edition Closed
Secondary Market Value-$300.00

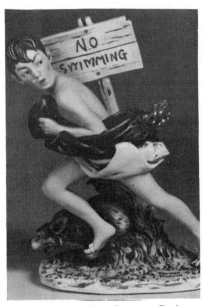

No Swimming, Dave Grossman Designs.

100th YEAR OF BASEBALL NR-102
Limited Edition of 1,000
July 8, 1939 Saturday Evening Post Cover
8" Tall
Issued-1975
Edition Closed
Secondary Market Value-$300.00

TOM SAWYER COLLECTOR SERIES

This is a series of four limited edition plates and matching figurines began in 1975 and ending in 1980. The plates are discussed in the plate section. The number of each in the now closed edition remains undisclosed See photos in the plate section, pages 88-124.

TOM SAWYER WHITEWASHING FENCE TS-1
Limited Edition Closed 5¾" Tall
Issued-1975
Secondary Market Value-$275.00

TOM SAWYER FIRST SMOKE TS-2
Limited Edition Closed
3½" Tall
Issued-1977
Porcelain
DAVE GROSSMAN DESIGNS, INC.
Secondary Market Value-$175.00

TOM SAWYER TAKE YOUR MEDICINE TS-3
Limited Edition Closed
5¼" Tall
Issued-1977
Secondary Market Value-$125.00

TOM SAWYER LOST IN THE CAVE TS-4
Limited Edition Closed
6" Tall
Issued-1978
Secondary Market Value-$125.00

HUCKLEBERRY FINN COLLECTOR SERIES

This is part of a series of four limited edition plates and matching figurines announced by Grossman in 1979. The plates are described in the plate section. The first two figurines in the series are listed below. They were issued in 1980 at $110.00 each.

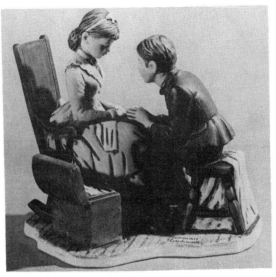

The Secret, Dave Grossman Designs.

HUCKLEBERRY FINN SECRET HF-1
Limited Edition of 10,000
5¼" Tall
Current Retail Value-$110.00

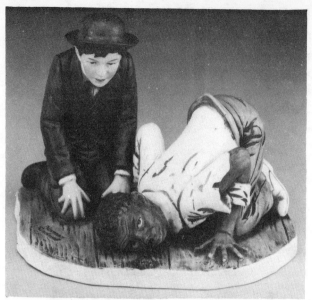

Listening, Dave Grossman Designs.

HUCKLEBERRY FINN LISTENING HF-2
Limited Edition of 10,000
4½" Tall
Current Retail Value-$110.00

THE MINIATURE FIGURINES

These are smaller pieces that are 4" tall at the most. Many of them are the same basic design as the larger figurines previously discussed. The series was initiated in 1979 with twelve different pieces being produced. The series continues.

REDHEAD NR-201
September 16, 1916 Saturday Evening Post Cover
3½" Tall
Issued-1979
Current Retail Value-$18.00

BACK TO SCHOOL NR-202
January 8, 1927 Saturday Evening Post Cover
3½" Tall
Issued-1979
Current Retail Value-$18.00

CAROLER NR-203
December 8, 1923 Saturday Evening Post Cover
3¾" Tall
Issued-1979
Current Retail Value-$20.00

DAYDREAMER NR-204
March 6, 1954 Saturday Evening Post Cover
2½" Tall
Issued-1979
Current Retail Value-$20.00

NO SWIMMING NR-205
June 4, 1921 Saturday Evening Post Cover
3½" Tall
Issued-1979
Current Retail Value-$22.00

LOVE LETTER NR-206
January 17, 1920 Saturday Evening Post Cover
3" Tall
Issued-1979
Current Retail Value-$26.00

LOVERS NR-207
August 30, 1924 Saturday Evening Post Cover
3" Tall
Issued-1979
Current Retail Value-$28.00

LAZYBONES NR-208
September 6, 1919 Saturday Evening Post Cover
1 ¾" Tall
Issued-1979
Current Retail Value-$22.00

LEAPFROG NR-209
June 28, 1919 Saturday Evening Post Cover
4" Tall
Issued-1979
Current Retail Value-$32.00

SCHOOLMASTER NR-210
June 26, 1926 Saturday Evening Post Cover
4" Tall
Issued-1979
Current Retail Value-$34.00

MARBLE PLAYERS NR-211
September 2, 1939 Saturday Evening Post Cover
3" Tall
Issued-1979
Current Retail Value-$36.00

DOCTOR & DOLL NR-212
March 9, 1929 Saturday Evening Post Cover
3½" Tall
Issued-1979
Current Retail Value-$40.00

FRIENDS IN NEED NR-213
September 28, 1929 Saturday Evening Post Cover
3" Tall
Issued-1980
Current Retail Value-$30.00

SPRINGTIME 1933 NR-214
April 8, 1933 Saturday Evening Post Cover
3¾" Tall
Issued-1980
Current Retail Value-$24.00

SUMMERTIME 1933 NR-215
August 5, 1933 Saturday Evening Post Cover
3¾" Tall
Issued-1980
Current Retail Value-$22.00

100th YEAR OF BASEBALL NR-216
July 8, 1939 Saturday Evening Post Cover
4" Tall
Issued-1980
Current Retail Value-$40.00

SEE AMERICA FIRST NR-217
April 23, 1938 Saturday Evening Post Cover
4" Tall
Issued-1980
Current Retail Value-$28.00

TAKE YOUR MEDICINE NR-218
May 30, 1936 Saturday Evening Post Cover
4½" Tall
Issued-1980
Current Retail Value-$36.00

PEWTER MINIATURE FIGURINES

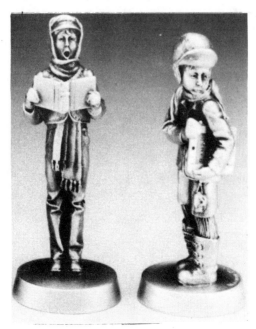

Two of the 12 **pewter miniatures.** Dave Grossman
Designs.

Current Retail Value-$25.00/each
Each Figurine 2½" Tall
Set of 12 figurines inspired by these Norman Rockwell
Saturday Evening Post Covers:

FP-2	Back to School	1/8/27
FP-3	Caroler	12/8/23
FP-5	No Swimming	6/4/21
FP-7	Lovers	8/30/24
FP-12	Doctor & Doll	3/9/29
FP-17	See America First	4/23/38
FP-18	Take Your Medicine	5/30/36
FP-21	Big Moment	1/25/36
FP-22	Circus	5/18/18
FP-23	Barbershop Quartet	9/26/36
FP-28	Magic Potion	3/18/39
FP-32	Grandpa's Ballerina	2/3/23

DISPLAY PLAQUES

Display Plaque NRP-1, Dave Grossman Designs.

NORMAN ROCKWELL DISPLAY PLAQUE NRP-1
February 13, 1960 Saturday Evening Post Cover
5½" Tall
Issued-1973
Retired-1979
Secondary Market Value-$30.00

DISPLAY PLAQUES

Display Plaques. Right NRP 3; Left: NRP 4. Dave Grossman Designs.

SMALL NORMAN ROCKWELL DISPLAY PLAQUE (4¾" Tall) NRP-3

LARGE NORMAN ROCKWELL DISPLAY PLAQUE (3" Tall) NRP-4

January 8, 1927 Saturday Evening Post Cover
Issued-1980
Current Retail Value-$20.00 (small)
Current Retail Value-$30.00 (large)

FRANKLIN PORCELAIN

JOYS OF CHILDHOOD SERIES

The Franklin Mint announced this series in 1976 to be a limited edition available by subscription only. They were limited to the extent of the number of subscribers to the series before the closing date of December 31st, 1976. The

final number in the edition is reported to be 3,700. It is not known whether these are complete sets of the ten figurines or a mixture of sets and individual prices. What makes them rather unique is that the company commissioned Rockwell to design them for rendition in bisque porcelain. In present knowledge this is the first time Rockwell ever accomplished paintings for the purpose of a three-dimensional interpretation in porcelain. The issue price for the set of ten was $1200 and each figurine is presently valued at $140-$150. They are listed below.

Hopscotch	The Stilt-Walker
Coasting Along	The Fishing Hole
Dressing up	Trick or Treat
Ride 'Em Cowboy	Time Out
The Nurse	The Marble Champ

GOEBEL ART, INC.

It is not widely known that this famous West German manufacturer of Hummel figurines and other fine collectables also produced a series of figurines inspired by Rockwell works. They were the first to do so.

They produced a series of twelve known figurines, and a dealer display plaque in 1963. They are said to have been produced in a limited edition of 500 pieces each.

This printed mark will be found with the inscription "W. Germany" associated. It is also possible to find a similar mark incised into the figurine. The marks are found on the underside of the base. In addition to the trade mark, there will be an incised mold number of three numerical digits. These mold numbers begin with 201 and ascend numerically ending with 218. The thirteen known pieces are listed on the following page.

There were 18 pieces originally planned but 5 of them are not yet known to be in collectors hands. The missing pieces are mold numbers 205, 206, 207, 209, and 210. These should be considered extremely rare. The company records show that sample figurines were produced, but never offered for sale. However collectors of their Hummel pieces have found that many items "never offered for sale" have indeed been found in the U.S. It is likely the result of a no longer used policy of delivering a few pre-production samples to gauge response from the dealers. Each is valued at $200 to $300. Rare.

Mold Number	Name	Height
201	Little Veterinarian	6"
202	Boyhood Dreams	6"
203	Mother's Helper	5½"
204	My New Pal	5"
208	His First Smoke	4½"
211	The Home Cure	6"
212	Timely Assistance	6"
213	She Loves, Me, She Loves Me Not	4"
214	Buttercup Test	5"
215	First Love	5½"
216	Canine Solo	5"
217	Patient Anglers	4½"
218	Dealer Plaque	3"

THE GORHAM COLLECTION

The Gorham company began producing figurines depicting Rockwell works in 1972 with the same four illustrations used for their first Four Seasons plates in 1971. Both the plates and figurine series followed the calendars of the famous Four Seasons annual release by the Brown and Bigelow company. There are of course other figurines. The Four Seasons sets will be described first, then the others. The figurines are listed in chronological order of release.

THE FOUR SEASONS SERIES
1972 BOY AND HIS DOG
Value Range $350 to $390 each piece
Limited Edition of 5000 Sets.

Winter	A Boy Meets his Dog
Spring	Adventurers Between Adventures
Summer	The Mysterious Malady
Fall	Pride of Parenthood

1973 YOUNG LOVE
Value Range $240 to $265 each piece
Limited Edition of 5000 Sets.

Spring	Beguiling Buttercup
Summer	Soaring Spirits
Fall	Scholarly Pace
Winter	Downhill Daring

1974 FOUR AGES OF LOVE
Value Range $280 to $300 each piece
Edition Unknown

Spring	Sweet Song So Young
Summer	Flowers in Tender Bloom
Fall	Fondly Do We Remember
Winter	Gaily Sharing Vintage Times

1975 GRANDPA AND ME
Value Range $200 to $230 each piece
Limited Edition of 2500 Set.

Spring	Day Dreams
Summer	Goin' Fishin'
Fall	Pensive Pals
Winter	Gay Blades

1976 ME AND MY PAL
Value Range $195 to $230 each piece
Limited Edition of 2500 Sets.

Spring	Young Man's Fancy
Summer	Fisherman's Paradise
Fall	Disastrous Daring
Winter	A Lickin' Good Bath

1977 GRAND PALS
Value Range $145 to $165 each piece
Limited Edition of 2500 sets.

Spring	Soaring Spirits
Summer	Fish Finders
Fall	Ghostly Gourds
Winter	Snow Sculpture

1978 GOING ON SIXTEEN
Value Range $145 to $170 each piece
Limited Edition of 2500 Sets.

Spring	Sweet Seranade
Summer	Shear Agony
Fall	Chilling Chore
Winter	Pilgrimage

1979 THE TENDER YEARS
Value Range $135 to $160 each piece
Limited Edition 2500 Sets.

Spring	Spring Tonic
Summer	Cook Aid
Fall	Chilly Reception
Winter	New Year Look

1980 A HELPING HAND
Value Range $165 to $180 each piece
Limited Edition of 2500 Sets.

Spring	Closed For Business
Summer	Swatler's Rights
Fall	The Coal Season's Coming
Winter	Year End Count

1981 Likely To Be The Same as the 1980 Four Seasons Plate Series.

The following list is of miscellaneous figurines that have been released by Gorham to date. They are listed in order of their model number. This is also the most likely order of release chronologically. Where possible the earliest year of issue is listed. When the year information

was not available, the corresponding space is left blank. The first twenty five were issued in 1977 or before.

Some of the pieces have been retired. The first molds were broken up by the company and the figurines will not be reissued. You may note that the model #13 was not utilized. Model numbers 15, 16, 22 and 23 have been retired so far.

Model Number	Name	Height	Date of Issue	Date of Illustration	Value Range
1	Weighing In	6¾ "		1958	65-75
2	Missing Tooth	6"		1957	40-60
3	Tiny Tim	6½ "		1934	45-65
4	At The Vet	6"		1952	40-55
5	Fishing	6"		1930	60-90
6	Batter Up	6¼ "		1916	60-80
7	Skating	5¾ "		1920	50-75
8	Captain	5½ "		1922	60-85
9	Boy and His Dog	5"		1923	50-75
10	No Swimming	6"		1929	50-70
11	Old Mill Pond	5½ "		1929	60-85
12	Saying Grace	5½ "		1951	90-130
14	Tackled	6½ "		1951	90-130
15	Independence	6½ "		1925	45-65
16	The Marriage License	6¼ "		1926	65-85
17	The Oculist	6¼ "		1955	70-90
18	Pride of Parenthood	5"		1956	40-60
19	Beguiling Buttercup	6¼ "		1958	65-90
20	Vintage Times	5½ "		1949	60-90
21	Gay Blades	6¼ "		1927	65-100
22	Choosing Up	6½ "		1948	60-90
23	Missed	6½ "		1951	80-95
24	Oh Yeah	6¾ "		1951	80-120
25	Big Decision	6½ "		1951	80-120
26	The Runaway	6"		1962	60-85
27	Triple Self Portrait	7½ "	1979	1920	70-100
27	Triple Self Portrait	7½ "	1979	1960	60-90
28	Day in the Life of a Girl	6"	1980	1952	50-75
29	Day in the Life of a Boy	6"	1980	1952	50-75
30	After the Prom		1980	1957	100-125
31	The Annual Visit	3¾ "	1980	1947	130-160
32	*Triple Self Portrait	10¼"	1980	1960	250-300
33	**The Jolly Coachman	8"	1980	1929	60-80
8002	Dealer Plaque	6"	1979	1925	40-60
8255	Santa Plans His Trip	3½ "	1980	1939	10-15

*Limited to 5,000 in the edition.
**Limited to 7,500 in the edition.

The Gorham Pewter Collection

So far in 1980 there have been at least three pewter figurines produced. They are limited to an edition of 3000 each. They are fastened to wood-like bases. The three are listed below at release price.

Name	Height	S.E.P. Cover Date	Release
Fall	4"	Nov. 21, 1925	$85
Spring	3½"	Apr. 27, 1935	$75
Summer	4½"	June 23, 1923	$75

RIVER SHORE, LTD.

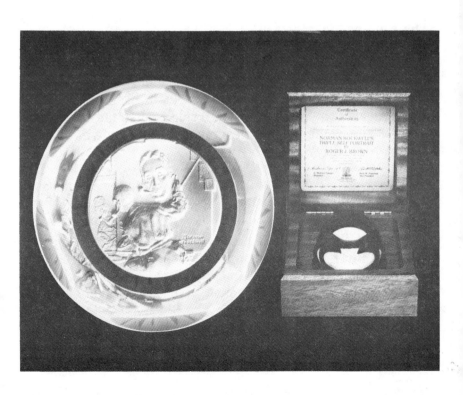

River Shore is well known for their quality collectibles. The figurines pictures here are the "Norman Rockwell-River Shore Collection". The collection consists of eight figurines. Each is approximately 4" high. They are the same figures as used on the River Shore Bell Series I and II. The figurines were released in 1980 at $25 each in unlimited edition. They are listed below.

Set I	Set II
Flowers For Mother	Future All-American
School Play	5-Cents a Glass
First Day of School	Garden Girl
Football Hero	Dressing Up

THE NORMAN ROCKWELL MUSEUM

The Family Figurine Collection

This is a collection of twelve figurines commissioned by the Norman Rockwell Museum. They are each issued in an edition of 22,500 pieces. They are hand cast and hand painted and rendered in bisque porcelain. Each bears the official seal of the Museum. The 6 released so far are listed below. The remaining 6 designs are not known to the author presently.

Name	Height	Release Price
Baby's First Step	4"	90
The First Haircut	6 ¾"	90
Happy 'Birthday' Dear Mother	4"	90
The First Prom	4"	90
Wrapping Christmas Presents	7"	90
Sweet Sixteen	6½ "	90

*The release price of the figurines and the first 6 in the series was advanced to $110 recently.

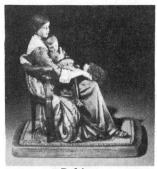
Bedtime.

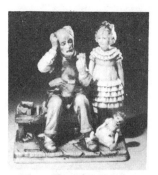
The Cobbler.

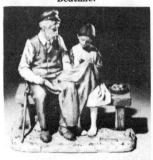
The Lighthouse Keeper's Daughter.

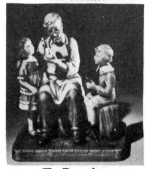
The Toymaker.

The Heirloom Collection

A set of four figurines. The same notes from the Family Figurine collection apply to these except that the edition is not known.

NAME	ISSUE PRICE*
THE TOY MAKER	$50
THE COBBLER	$50
LIGHTHOUSE KEEPER'S DAUGHTER	$50
BEDTIME	$50

Other Norman Rockwell Museum Figurines-Classic Series

Name	Height	Issue Price
For A Good Boy	5"	$65
Memories	5¼"	$65
The Music Lesson	4¾"	$65

Insufficient market data to establish secondary market value.

| The Music Master | 4¾" | $65 |
| Puppy Love | 4¾" | $65 |

THE DANBURY MINT

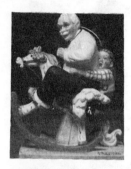

Gramps at the Reins

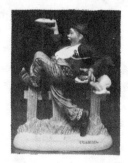

Caught in the Act

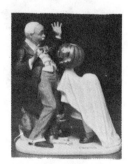

Trick or Treat

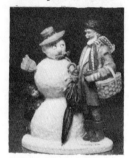

Granpa Snowman

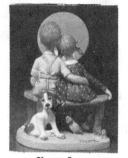

Young Love

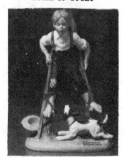

Boy on Stilts

THE NORMAN ROCKWELL FIGURINES

This is a series of twelve porcelain figurines sold by subscription and the initial offering required reservations by the collector by May 31, 1980. Each of the designs is taken from Rockwell's illustrations for the Saturday Evening Post. The pieces are individually hand-painted. There has not been sufficient time for any of them to have established values on the secondary market. The original subscribers' price was $55 for each figurine. The company has begun issuing the figurines but the collection is not yet complete. The first six designs are listed below. The final six are not yet disclosed.

Gramps at the Reins	6"
Grampa Snowman	6 1/2"
Trick or Treat	6 1/2"
Caught in the Act	6 1/8"
Boy on Stilts	7"
Young Love	5 7/8"

MUSICAL FIGURES
by Schmid Brothers, Inc.
and Anri/Ferrandiz

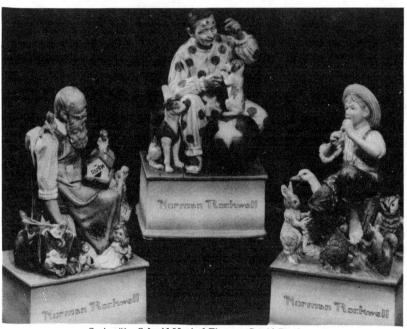

Series #1 - **Schmid Musical Figures**, Scmid Brothers, Inc.

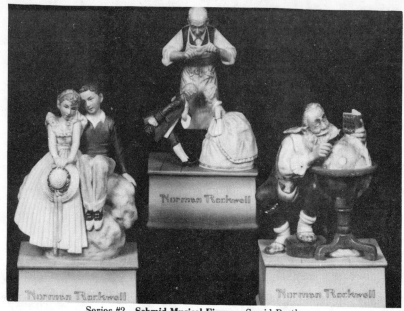

Series #2 - **Schmid Musical Figures**, Scmid Brothers, Inc.

Schmid Brothers, Inc. are producers and distributors of many fine collectibles. Among the Schmid products are two series of three, figural musical pieces rendered in porcelain. They are also the exclusive U.S. distributors of the hand-carved wooden pieces made in the famed Anri workshops in Italy. Schmid and Anri have collaborated in the production of a series of hand-carved wooden, bas-relief musical pieces to be issued late in 1980. As far as can be determined Schmid and Anri are the only producers of musical figures based upon Rockwell's works.

NORMAN ROCKWELL MUSICAL FIGURES

The two three-piece series are hand painted porcelain. They are each produced in a sequentially numbered limited edition. Each piece is between 7" and 8" high.

First Series
Limited to 4000* each
SANTA'S HELPERS
 Saturday Evening Post, Dec. 2, 1922
 Tune: We Wish You a Merry Christmas

*Edition completely exhausted. Mold has been destroyed.

BETWEEN THE ACTS
 Saturday Evening Post, May 26, 1923
 Tune: Send in the Clowns

SPRINGTIME OF '27
 Saturday Evening Post, April 16, 1927
 Tune: Talk To The Animals

Value Range: $120 to $150 each.

Second Series
Limited to 2500 each
MARIONETTE
 Saturday Evening Post, Oct. 22, 1932
 Tune: The Emporer's Waltz

ON TOP OF THE WORLD
 Saturday Evening Post, July 11, 1936
 Tune: People Will Say We're In Love

SANTA'S GOOD BOYS
 Saturday Evening Post, Dec. 4, 1926
 Tune: Santa Clause Is Coming To Town

Issue Price: $135 each.

ANRI ROCKWELL MUSICAL BOXES.
 Scheduled for release in January of 1981, this box is the first in a Series, Schmid Brothers, Inc. and the famous ANRI workshops in Italy have collaborated to produce a series of carved bas-relief wood music boxes. The designs in the carvings are taken from Rockwell illustrations. Release price is not yet known. The edition is to be limited to 2,500 each.

SECTION IV

CHINA/PORCELAIN AND CRYSTAL PLATES

BRANTWOOD COLLECTION

HOMECOMING-1979

This 8½" diameter plate is the first in a series of Mother's Day theme plates. The plate is limited to an issue of 20,000 and made by the Gorham company. Value range $35 to $40.

CANDLELITE COLLECTORS SOCIETY

Toymaker - Bas Relief.

THE TOYMAKER-1980

This is a new bas-relief plate released in late 1979. It is endorsed by the Norman Rockwell Collector's Club and limited by year of issue. Actual manufacturers is unknown

at present. It was issued at $65. There has not been sufficient time for its secondary market value to be established.

CERTIFIED RARITIES, INC.

April Fool - 1978.

APRIL FOOL PLATES
The four April Fool covers Rockwell illustrated are the designs for their four plate series. The Gorham Company produced the plates for them. Issued in an edition limited to *10,000 each they are valued at between $30 to $40.

April Fool-1978	April 3, 1943 Post cover
April Fool-1979	April 3, 1948 Post cover
April Fool-1980	Unknown

CONTINENTAL MINT

DOCTOR AND DOLL-1977
This plate is seldom seen in any lists as being for sale. It was issued by the mint with the "Royal Wood" backstamp. It has been offered for as little as $12.50 and as

One reference found stated 7,500; may have been in error.

much as $40. It has also been offered as a gift when joining the Rockwell Collectors Club. The plate illustration is from the cover of the January 13, 1923 Literary Digest magazine.

THE DANBURY MINT

THE NORMAN ROCKWELL FINE CHINA PLATE COLLECTION-1978

This company initiated this series of twelve plates and commissioned the Gorham Company to produce them. Each plate is 8½" in diameter. The series was limited to those subscribed to in a specified period of time but the number of each actually produced has not been disclosed. Value range $25 to $35 each.

Ship Ahoy	Plumbers
Back to School	Dear Diary
Grandpa's Girl	Circus Clown
Saturday's Heroes	Man Threading a Needle
Pals	End of Christmas
Tea For Two	Catching the Big One

DAVE GROSSMAN DESIGNS COLLECTION

It was the recognition of the intense feelings that first attracted Dave Grossman to Rockwell's works. Grossman, a talented artist and sculptor who had been commissioned for art works for presidents and dignitaries world-wide, contacted the Saturday Evening Post in 1970. He suggested the creation of three-dimensional figurines of Rockwell's covers securing an agreement to do so after about two years of discussions. This beginning has evolved to include many other types of objects bearing or inspired by Rockwell works.

The plates are covered here. The others will be discussed in the appropriate sections of the book.

TOM SAWYER SERIES

The first of the Grossman plates was released in 1975 as the beginning of a series of plates depicting Mark Twain's "Adventures of Tom Sawyer". There were matching figurines created also. They are covered in the section on figurines.

There are four 7¾" diameter porcelain plates in all, each produced in a limited edition of 10,000. The editions are all closed and they are available on the secondary market only.

Title	Year Of Issue	Secondary Market Value
White Washing Fence	1976	$80.00
First Smoke	1977	$40.00
Take Your Medicine	1977	$40.00
Lost in the Cave	1978	$40.00

HUCKLEBERRY FINN SERIES

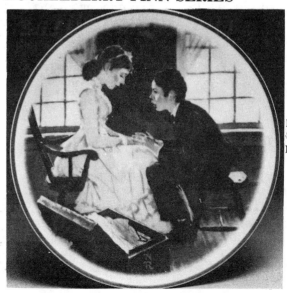

Huckleberry Finn Series-Secret,
Dave Grossman Designs.

91

Huckleberry Finn-Listening, Dave Grossman
Designs.

A new series inspired by Rockwell's illustrations of
Mark Twain's Huckleberry Finn character. The series was
initiated in 1980 and so far there are two plates and
matching figurines. They are too new to have been
established on the secondary market. The 8" porcelain
plates produced in a limited edition of 10,000. The edition is
still open.

Title	Year Of Issue	Issue Price
Secret	1980	$40.00
Listening	1980	$110.00

OTHER PLATES BY
DAVE GROSSMAN DESIGNS

YOUNG DOCTOR-1978
This plate, inspired by an unpublished Rockwell
painting, was produced in an edition limited to 5000. The
edition is sold out and selling for about $65 on the
secondary market.

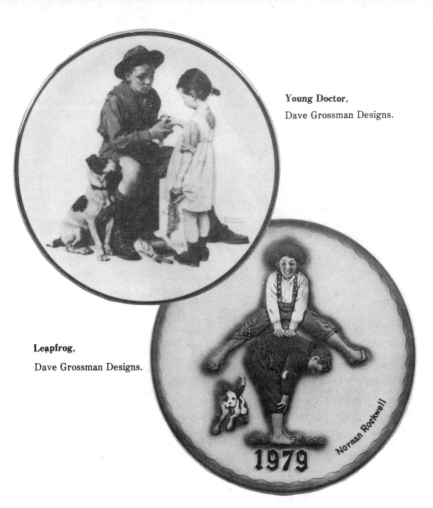

Young Doctor,
Dave Grossman Designs.

Leapfrog,
Dave Grossman Designs.

LEAPFROG-1979
Announced in 1978 for an early 1979 release this 7½"
plate is the first Rockwell plate to be produced in
bas-relief. The number in the edition is not known but it is
sold out and selling for $65 on the secondary market
presently. The design is from the June 28, 1919 Saturday
Evening Post Cover.

BUTTER BOY-1979
Produced in an edition limited to 5000, this 8"
porcelain plate is now sold out. The secondary market
value is $40-$45 presently.

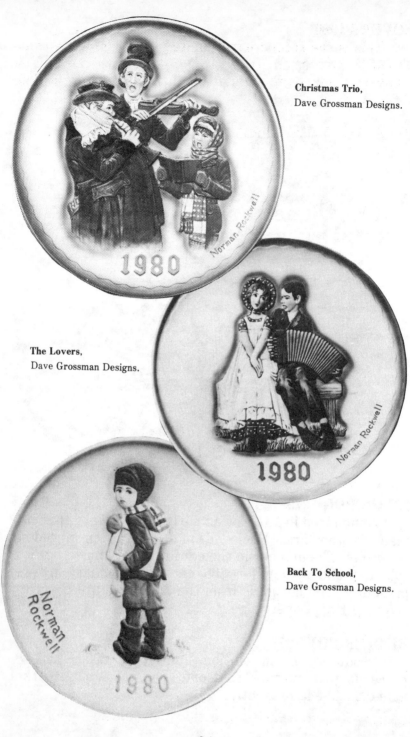

Christmas Trio,
Dave Grossman Designs.

The Lovers,
Dave Grossman Designs.

Back To School,
Dave Grossman Designs.

94

LOVERS-1980

This is the second hand-painted bas-relief plate to be issued by Grossman. It is 7½" in diameter. The edition number is unknown. Design taken from the August 30, 1924 Saturday Evening Post cover. Issue price: $60.00

BACK TO SCHOOL-1980

The first bas-relief miniature plate to be produced by Grossman, it measures 4¼" in diameter. It was inspired by the January 8, 1927 cover of the Post. The edition is limited to 1000 plates total and issued at $24.00.

CHRISTMAS TRIO-1980

The 1980 Grossman Christmas plate. Presumably it will be limited to the number sold in the year of issue. It is a bas-relief plate, 7½" in diameter and issued at $75. The design is taken from the cover of the December 8, 1923 Saturday Evening Post.

FAIRMONT

OLD MAN WINTER-1979
THE INVENTOR-1979
READY FOR SCHOOL-1980

All three plates were made by Fairmont China and released at $19.95. Edition limited in each of the three 7½" plates but the number remains unknown. The value range is $20-$25.

THE GORHAM COLLECTION

Gorham Fine China is an old American company that was established about 150 years ago. They are now known as Gorham-Textron.

Gorham has been making commemorative plates bearing Rockwell designs since 1970 producing about sixty

different plates to date. They have produced figurines and other Rockwell items as well but they will be covered in another section.

FAMILY TREE-1970
This was the first commemorative plate inspired by a Rockwell ever, to be produced. It depicts Rockwell's "Family Tree". The plate is 10½" in diameter and was produced in a limited edition of 5000. The issue price was only $17 and it has risen to about $220-$245 on the secondary market today.

THE FOUR SEASONS SERIES
Gorham began producing sets of four plates depicting the Brown and Bigelow Company's famous Four Seasons Calendars by Rockwell in 1971. They have released a set of four each year since then for a total of forty plates. They are limited editions to the extent that they are sold only during the year of issue. The actual numbers are not available. They are all 10½ inches in diameter and have a gold rim.

1971 BOY AND HIS DOG
Value Range $140 to $145 each
Winter A Boy Meets His Dog
Spring Adventurers between Adventures
Summer The Mysterious Malady
Fall Pride of Parenthood

1972 YOUNG LOVE
Value Range $60 to $70 each
Winter Downhill Daring
Spring Beguiling Butter Cup
Summer Flying High
Fall A Scholarly Pace

1973 FOUR AGES OF LOVE
Value Range $90 to $100 each
Spring Sweet Song So Young
Summer Flowers in Tender Bloom

96

| Fall | Fondly Do We Remember |
| Winter | Gaily Sharing Vintage Times |

1974 GRANDPA AND ME
Value Range $45 to $50 each
Spring	Day Dreamers
Summer	Goin' Fishin'
Fall	Pensive Pals
Winter	Gay Blades

1975 ME AND MY PAL
Value Range $50 to $55 each
Spring	Young Man's Fancy
Summer	Fisherman's Paradise
Fall	Disastrous Daring
Winter	A Lickin' Good Bath

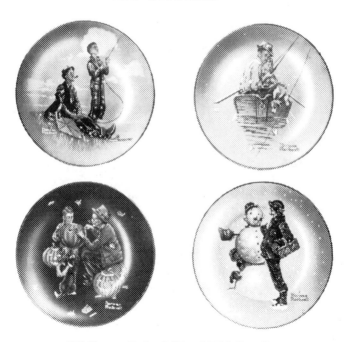

1976 Norman Rockwell **"Grand Pals"** Four Seasons Plates. Spring-"Soaring Spirits", Summer-"Fish Finders, Fall-"Ghostly Gourds", Winter-"Snow Sculpture". Gorham Collection.

1976 GRAND PALS
Value Range $60 to $65 each
Spring Soaring Spirits
Summer Fish Finders
Fall Ghostly Gourds
Winter Snow Sculpture

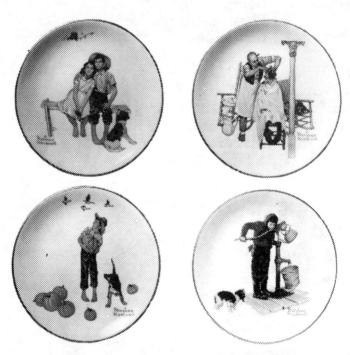

1977 Norman Rockwell **"Going On Sixteen"** Four
Seasons Plates. Spring-"Sweet Serenade", Summer-
"Shear Agony", Fall-"Pilgrimage", Winter-"Chilling
Chore". Gorham Collection.

1977 GOING ON SIXTEEN
Value Range $40 to $50 each
Spring Sweet Serenade
Summer Shear Agony
Fall Chilling Chore
Winter Pilgrimage

1978 THE TENDER YEARS
Value Range $20 to $30 each
Spring Spring Tonic

Summer	Cool Aid
Fall	Chilly Reception
Winter	New Year Look

1979 A HELPING HAND
Value Range $20 to $25 each

Spring	Closed for Business
Summer	Swatter's Rights
Fall	Coal Season's Coming
Winter	Year End Count

*1980 DAD'S BOY
Value Range $30 to $35 each

Spring	In His Spirit
Summer	Trout Dinner
Fall	Careful Aim
Winter	Ski Skills

THE STREAKERS-1974
This is an 8½" diameter plate originally issued at $14.50. Edition information unknown. The plate depicts the cover illustration from the June 4, 1921 issue of Post. Value Range $20 to $25.

BUTTER GIRL-1974
This plate may or may not exist. There was only a single reference to it in over a thousand pages of research materials. The reference was dated 1974 and stated the release price as $15.00. It could have been planned but not released or, it could simply be an obscure plate. Insufficient data to establish value.

THE GOLDEN RULE-1974
An unlimited production 8½" plate with a reproduction of Rockwell's Saturday Evening Post cover of April 1, 1961. Value range $35 to $45.

*The last of the series. This tenth set of four ends the sets with a total of forty plates.

TINY TIM-1974

This is the first Rockwell Christmas plate produced by Gorham. It is 8½" in diameter and is limited to the extent of the number sold in 1974. The actual number is unknown. Value Range $60 to $70.

WEIGHING IN-1974

This plate measures 8½" in diameter and was issued at $12.50 in 1974. The edition number is unknown. Value range $15 to $25.

BENJAMIN FRANKLIN-1975

This 8½" plate was produced in a serially numbered edition limited to 18,500. It is the illustration for the Post cover of May 29, 1926; "Ben Franklins Sesqui-Centennial". Value Range $30 to $35.

GOOD DEED-1975

The second plate in the annual Gorham Christmas series. The illustration is from the Post cover of December 6, 1924. Limited to the year of issue. Value range $50 to $65.

OUR HERITAGE-1975

This is the first in a series of four plates with a Boy Scout theme. It was produced in a serially numbered edition of 18,500 plates. It is taken from a 1950 Boy Scout calendar. Value range $50 to $60.

A SCOUT IS LOYAL-1976

The second in the Boy Scout series of four plates. It is a serially numbered limited edition of 18,500. The illustration is from a 1932 Boy Scout calendar. Value range $50 to $65.

CHRISTMAS TRIO-1976

The third plate in the annual Christmas plate series. The illustration is from the Post cover of December 8, 1923. Value range $50 to $60.

THE MARRIAGE LICENSE-1976

This is an unlimited plate still being offered by Gorham. The well known illustration is from the Post cover of June 11, 1955. Current Suggested Retail Price $32.50*.

1976 Norman Rockwell **Presidential Plates,** John F. Kennedy, Dwight D. Eisenhower. Numbered limited edition 9,800 each. Gorham Fine China.

THE PRESIDENTIAL PLATES-1976

Gorham produced two plates each serially number in an edition limited to 9,800. The plates are 10½" in diameter and bear portraits of John F. Kennedy and Dwight D. Eisenhower. Value range:

Eisenhower $25 to $35
Kennedy $40 to $50

FOUR FREEDOMS-1976

Gorham/American Express

This set of four mini-plates (1½" diameter) bear the famous "Four Freedoms". They were commissioned by American Express as a Bicentennial offer to their card holders. They were made by Gorham. Edition unknown. Current value: $45-$50.

A GOOD SIGN ALL OVER THE WORLD-1977

The third in a series of four Boy Scout theme plates. The edition is serially numbered and limited to 18,500. The illustration is taken from a 1963 Boy Scout Calendar. The original title of the painting is "A Good Turn All Over the World". Value range $25 to $35.

March 1, 1980 price list.

THE SCOUTMASTER-1977

This is the final plate in the four plate series. Also limited to 18,500 plates. The illustration is from a 1956 Boy Scout calendar. Value range $25 to $35.

YULETIDE RECKONING-1977

The fourth in the series of annual Christmas plates by Gorham. The edition is limited to 18,500 plates. The illustration is from the Post cover of December 4, 1920. The original title was simply "Santa". Value range $25 to $30.

THE RUNAWAY-1977

Gorham and Brown & Bigelow collaborated to produce a series of plates with a clown theme. This is the first in the series. It is 10½" in diameter and the issue is limited to 7,500 plates. Value range $60 to $70.

IT'S YOUR MOVE-1978

The second in the Clown series by Gorham/Brown & Bigelow. Limited to 7,500 plates, the illustration is from an oil painted in 1935. The title of the original is "Playing Checkers". Value range $45 to $50.

CAMP FIRE STORY-1979

Boy Scouts of America/Gorham

There are at least six in this series so far. Made for the Boy Scouts of America by Gorham and distributed by the Boy Scout Supply Division. They are limited to 18,500 plates. All are valued at between $25 and $65. It began as a four plate series but has been extended.

PLANNING CHRISTMAS VISITS-1978

This is the 1978 edition of the annual Gorham Christmas plate. It is limited to the year of issue. The illustration is from the Post cover of December 4, 1926. Value range $25 to $30.

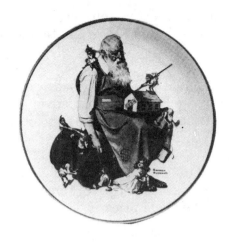

Santa's Helpers - 1979 Christmas plate. Gorham.

SANTA'S HELPERS-1979
This is the 1979 of the annual Gorham Christmas plate. It is limited to the year of issue. The illustration is from the Post cover of December 2, 1922. Value range $25 to $30.

TRIPLE SELF-PORTRAIT-1979
This is a 10½" diameter plate that Gorham calls the "Norman Rockwell Memorial Plate". It bears the illustration done for the Post cover of February 13, 1960. The production numbers are not presently known. Value range $40 to $45.

THE UNDERSTUDY-1979
This is the third plate in the Clown theme series. The number is the edition is 7,500. Value range $40 to $45.

THE ANNUAL VISIT-1978
A 10½" plate bearing the left one-half of an illustration in the April 12, 1947 issue of the Saturday Evening Post. Edition unknown. Issued at $32.50.

BOY SCOUT TRIBUTE-1980
This is a plate limited to 18,500 in the edition. The plate is 10¾" in diameter and the illustration is from the 1969 Boy Scout calendar. The title of the original painting

is "Beyond the Easel" and includes a self-portrait of Rockwell in a Boy Scout uniform. Value range $40 to $50.

A LETTER TO SANTA-1980
The 1980 edition of the annual Christmas plate. The illustration is from the Saturday Evening Post cover of December 21, 1935. Edition limited to the number sold in the year of issue. Issue price: $27.50.

THE COUNTRY DOCTOR-1980
This is the 1980 Birthday plate issued by Gorham. It is limited by the year of issue. The issue price is $32.50.

LAKE SHORE PLATES

The Lake Shore Prints company among other things, issued plates made by Gorham and Ridgewood, they initiated a Rockwell series in 1973 and ended it four plates later in 1976. No illustrations were found but the plates are listed below:

Name	Year of Issue	Number in Edition	Current Value
Butter Girl	1973	9,433	115-135
Truth About Santa	1974	15,141	50-75
Home From the Fields	1975	8,500	40-60
A Presidents Wife	1976	*2,500	65-80

*This figure may be in error for one reference states that there may have been less than 1000 in the edition.

LYNELL

LAST MINUTE CHANGES-1979
All American Soap Box Derby Collection
This is an 8½" diameter sequentially numbered plate limited by the year of issue. It is the first of a series but the only one in the series by Rockwell. Value range $25 to $35.

SNOW QUEEN-1979
The Norman Rockwell Collection of Legendary Art
This is the first edition of their Christmas annuals series. Limited to a sixty day production period the edition is not known. Release price is $24.50.

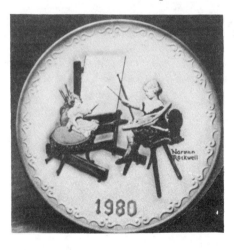

The Artist's Daughter.

THE ARTIST'S DAUGHTER-1980
The Norman Rockwell Collection of Legendary Art
This is a bas-relief porcelain plate. It is the first in an annual series. Limited to the year of issue the release price is $65.00. There is a matching figurine

CRADLE OF LOVE-1980
The Norman Rockwell Collection of Legendary Art
The first in a series of Mother's Day plates. It is a serially numbered edition limited to the number produced in 60 days. The actual number is undisclosed. Initial release price is $29.50.

NORMAN ROCKWELL COLLECTORS CLUB (TREIN'S)

THE DOCTOR AND THE DOLL-1978
There is some confusion about this plate. References were vague when researching it and the Continental Mint Doctor and Doll plate. There is a possibility that they are the same plate (see page 89). This plate is 8" and limited to the number manufactured in a 90 day period. The number in the edition is unknown. It is the first edition in a series.

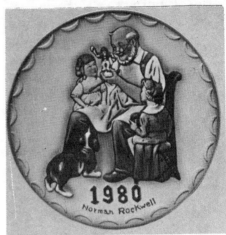

The Toymaker.

THE TOYMAKER-1980
Available for purchase in late 1979 this plate is a 7½" bas-relief issued in a limited edition. The number in the edition is unknown. Value range $65-$75.

NORMAN ROCKWELL MUSEUM

This is a large permanent collection of the art of Norman Rockwell located in Philadelphia. They have commissioned several plates bearing Rockwell illustrations under the name "The Norman Rockwell Museum Plate Program, Ltd."

THE AMERICAN FAMILY

A series of twelve plates issued in 1978 and 1979 in a serially numbered edition limited to 9,900 plates of each design. The museum commissioned Fairmont China to produce the plates. Each plate bears the museum seal and the Fairmont backstamp.

Name	Current Value
Baby's First Step	45-55
Happy Birthday Dear Mother	35-40
Sweet Sixteen	30-35
First Haircut	30-35
First Prom	30-35
The Student	30-35
Wrapping Christmas Presents	30-35
Birthday Party	30-35
Little Mother	30-35
Washing Our Dog	30-35
Mother's Little Helper	30-35
Bride and Groom	30-35

NORMAN ROCKWELL REMEMBERED-1979

The portrait of Rockwell on this plate was not painted by him. However the background is a montage made up of details from about twelve of his paintings. The plate is 10¼" in diameter and produced in limited but undisclosed edition. Value range $25 to $30.

THE DAY AFTER CHRISTMAS-1979

Issued in an edition of 25,000 this is the first edition in a second series of commissioned by the Rockwell Museum. Value range $70 to $80.

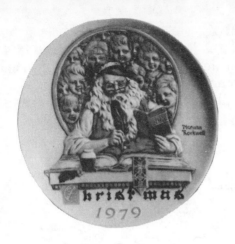

Santa's Children.

SANTA'S CHILDREN-1979

This plate was produced but never issued. It was to be the first in a series of bas-relief annual Christmas plates. The actual production number is not known but is quite low. They are not available on the collector's market due to some difficulties encountered with regard to ownership of the copyright to the art depicted. It is extremely unlikely that the collector will ever find one.

CHECKING HIS LIST-1980

The second in the annual series of bas-relief Christmas series. Value range $55 to $65.

THE AMERICAN FAMILY II

A second series of *twelve 8½" plates depicting American family themes by Rockwell. Manufactured by Fairmont China and limited to 22,500. Value range $35 to $40 each.
New Arrival
Sweet Dreams
Little Shaver
We Missed You Daddy
Home Run Slugger
Giving Thanks

*Only the first six plate illustrations have been announced.

*RIDGEWOOD INDUSTRIES, INC.

TOM SAWYER Plate Series-1974

This is a series of four plates bearing Rockwell illustrations of Mark Twain's Tom Sawyer character. The illustrations are rendered in Sepia tones. They were produced in an edition limited to 3000 plates. Current value: $130-$150.

RIVER SHORE, LTD.

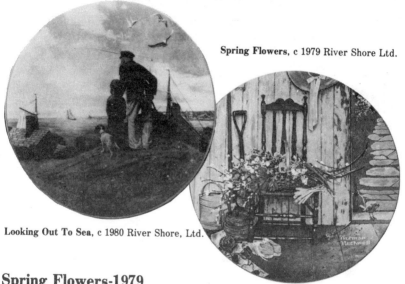

Spring Flowers, c 1979 River Shore Ltd.

Looking Out To Sea, c 1980 River Shore, Ltd.

Spring Flowers-1979

This is a 10¼" diameter plate issued in a single issue edition of 17,000. The illustration is reported to be the only known Rockwell painting to be a still-life. Value range $75 to $80.

Looking Out to Sea-1980

The second single issue collector plate to be issued. The plate is 10¼" in diameter and bears a Rockwell illustration that originally appeared in the October 1927 issue of Ladies Home Journal. It is limited to 17,000 and issued at $75.

Ridgewood is no longer active.

ROCKWELL SOCIETY OF AMERICA PLATES/KNOWLES

The Rockwell Society of America is a non-profit organization that is devoted to the appreciation of the art of Norman Rockwell. They are not engaged in production or distribution of Rockwell items but do sanction certain objects that meet with their approval, for distribution through The Bradford Exchange, Ltd. They indicate this approval by allowing the manufacturer to place the official Society seal on the object and in advertising materials. Presently the Edwin M. Knowles China Corporation is producing Society approved objects. There are presently three series of Rockwell plates produced by Knowles. All are limited by year of issue only.

The Toy Shop Window.

THE CHRISTMAS SERIES

Name	Year of Issue	Value Range
Scotty Gets His Tree	1974	115-150
Angel With A Black Eye	1975	80-95
Golden Shop Window	1976	40-50
Toy Shop Window	1977	50-60
Christmas Dream	1978	25-35
Somebody's Up There	1979	25-30

THE HERITAGE COLLECTION

Name	Year of Issue	Value Range
The Toy Maker	1977	125-155
The Cobbler	1978	75-85
Lighthouse Keeper's Daughter	1979	20-30
The Ship Builder	1980	20-25

THE MOTHER'S DAY SERIES

Name	Year of Issue	Secondary Market Value Range
A Mother's Love	1976	75-90
Faith	1977	60-70
Bedtime	1978	60-75
Reflections	1979	25-30
A Mother's Pride	1980	25-30

ROYAL DEVON PLATES

The Royal Devon company is owned by Gorham/Textron. The company is used for some of their contract production. There have been two different on-going series of porcelain Rockwell plates since 1975; a Christmas series and a Mother's Day series. There is one other plate possibly produced in 1976.

THE CHRISTMAS SERIES

Name	Year of Issue	Number in Edition	Secondary Market Value
Downhill Racing	1975	*	60-70
The Christmas Gift	1976	*	50-60
The Big Moment	1977	*	30-40
Puppets for Christmas	1978	7,500	30-35
One Present Too Many	1979	*	35-40

Limited by the year of issue. The actual figure is unknown.

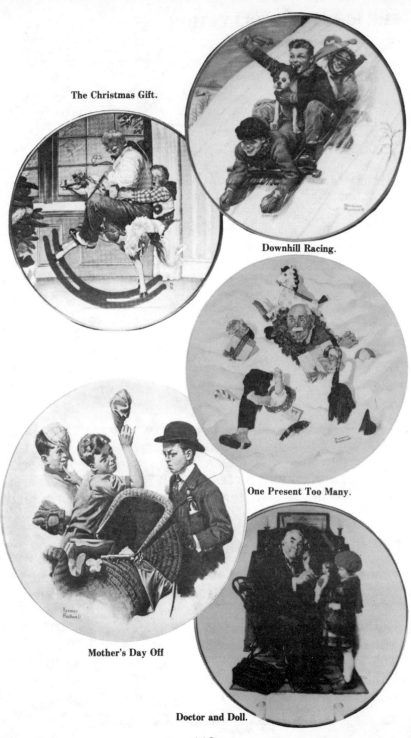

The Christmas Gift.

Downhill Racing.

One Present Too Many.

Mother's Day Off

Doctor and Doll.

112

THE MOTHER'S DAY SERIES

Name	Year of Issue	Number in Edition	Secondary Market Value
Doctor and Doll	1975	*	65-80
Puppy Love	1976	*	50-65
The Family	1977	*	30-35
Mother's Day Off	1978	7,500	30-40
Mother's Evening Out	1980	*	30-35

TOM SAWYER-1976

There is little information regarding this plate. It is reported to have been issued in an edition of 10,000. Only one reference book mentioned the plate and virtually no advertising information was uncovered by the author. Existence at this time is questionable. It could be that this is a part of the Ridgewood Industries Tom Sawyer series of four. See page 109.

SANGO

SWEETHEARTS-1976

This is the first edition of a series of plates initiated by Commemorative Imports by Sango. Entitled "Living American Artist Series Number 1" the first artists work to be represented was Rockwell. The plate issue was limited to 10,000. Value range $45 to $55.

Limited by the year of issue. The actual figure is unknown.

STANCRAFT PRODUCTS, INC. (BROWN & BIGELOW)

THE TRAVELING SALESMAN-1978

THE COUNTRY PEDDLER-1979

THE HORSE TRADER-1980

Stancraft Products, Inc. (Brown & Bigelow)

These are three of the plates in a series depicting traveling salesmen. It is 10½" in diameter and limited to 7,500 in the issue and were manufactured by the Gorham Company. Value range $35-$45 each.

SECTION V

METAL PLATES

CONTINENTAL MINT

Tom Sawyer-Lost In The Cave,
Continental Mint.

TOM SAWYER SERIES
This plate series is gold-plated copper. It was issued in an edition less than 10,000. The actual number is not presently known. Value range $35 to $60.

TOM SAWYER-TAKING THE MEDICINE*-1976

TOM SAWYER-PAINTING THE FENCE-1977

TOM SAWYER-LOST IN THE CAVE-1978

TOM SAWYER-SMOKING THE PIPE-1979

One reference illustrates and lists this Continental Mint plate as being gold-plated pewter, not copper and the illustration shows a plate with the design etched into the metal and not in bas-relief. No other reference to this plate was found anywhere.

SANTA'S ARRIVAL-1976

A gold-plated pewter plate. Edition number unknown. Value range is $40 to $50.

Butter Girl, Continental Mint.

BUTTER GIRL-1979

This is an 8" diameter gold-plated copper plate. The design is struck in bas-relief and the edition is limited to 10,000 plates. Value range $75 to $95.

See page

CREATIVE WORLD, LTD.

Looking Out To Sea, Creative World, Ltd.

LOOKING OUT TO SEA-1977

This is a bas-relief 8" plate struck in copper. It was designed by Roger Brown for Creative World, Ltd. It was issued in 1977 in an edition of 15,000; the first of a series of six. There was also a miniature issued in ⅔" diameter copper. Value Range 8" $55 to $65.

YANKEE DOODLE DANDY-1978

This is a bas-relief 8" plate struck in copper. It was designed by Roger Brown for Creative World, Ltd. It was issued in 1978 in an edition of 15,000; the second of a series of six. There was also a miniature issued in ⅔" diameter copper. Value range 8" $40 to $50.

GIRL AT MIRROR-1979

This is a bas-relief 8" plate struck in copper. It was designed by Roger Brown for Creative World, Ltd. It was issued in 1979 in an edition of 15,000; the third of a series of six. There was also a miniature issued n ⅔" diameter copper. Value range 8" $55 to $60.

THE FRANKLIN MINT

CHRISTMAS PLATE SERIES

This is a series of 8" sterling silver plates that was begun in 1970. The series is typical of the Franklin offerings in that they were issued on a subscriber basis and limited only by the number of subscribers. They depict various Rockwell Christmas scenes etched into the surface. They range from $100 to $275 on the secondary market today.

YEAR	THEME	NUMBER ISSUED
1970	BRINGING HOME THE TREE	18,321
1971	UNDER THE MISTLETOE	24,792
1972	THE CAROLERS	29,074
1973	TRIMMING THE TREE	18,010
1974	HANGING THE WREATH	12,822
1975	HOME FOR CHRISTMAS	11,059

THANKSGIVING PLATE-1977

This plate is made of sterling silver with the design etched in. 8" in diameter. It was produced in a limited number of 6,361 in the U.S. It is not known if there were others. Value Range $180 to $210.

AMERICAN SWEETHEARTS SERIES

The Franklin Mint initiated a series of crystal plates with the design etched into the surface. Beginning in 1977 the series of 6 was completed in 1979. The issue price was $120.

Name	Issue Year	Number in Edition	Collector Value
Youngsters at Play	1977	1004	$160
Teenagers Together	1977	1004	$160
Bride and Groom	1978	1004	$160
Proud Parents	1978	1004	$160
Graduation Day	1978	1004	$160
Retirement Kiss	1979	1004	$120

THE HAMILTON COLLECTION

MAN'S BEST FRIEND SERIES
This is a series of six copper plates executed in bas-relief. The plate designs were interpreted from Rockwell's work by David Stapleford and struck in 8" diameter solid copper plates. The edition is limited to 9500. There is not sufficient market data to determine a value range as yet. The original issue price is $40.00 for each.

1979 THE HOBO	1979 GONE FISHING
1979 THE DOCTOR	1980 PUPPY LOVE
1979 MAKING FRIENDS	1980 THE THIEF

ROCKWELL COPPER CHRISTMAS PLATE SERIES
The Metal Arts Company and The Hamilton Collection
This series of 8" solid copper Christmas theme plates began with the 1978 issue. The designs are intepreted by Daniel Stapleford and executed in bas-relief. The edition is limited by the number of subscribers in the year of issue. Specific numbers produced are not known presently.

YEAR	NAME	VALUE RANGE
1978	THE CHRISTMAS GIFT	$40 to $50
1979	THE BIG MOMENT	$40 to $50

THE CHILDREN OF NORMAN ROCKWELL SERIES
As far as can be determined all in this series are 1979 releases. There are six in the series. These plates are smaller than the normal sizes. They were struck in bas-relief copper in a 3¾" diameter size. Billed as a "Demi-Plate", they are limited to an edition of 19,750 for each. There is insufficient market data to establish a secondary market value as yet. They were issued at $21.50 each.

Knuckles Down, Hamilton Collection.

Name	From Saturday Evening Post Cover
Doctor and Doll (FE)	March 9, 1929
Knuckles Down	September 2, 1939
Grandpa's Girl	February 3, 1923
Leapfrog	June 28, 1919
Dog Gone It	October 4, 1919
Look Out Below	January 9, 1926
Batter Up	August 5, 1916
No Peeking	June 15, 1929

THE CHRISTMAS HOME COMING
The Hamilton Mint

This is a plate made of pewter. Only one reference to it was turned up and no photos. Issued in 1976 it is now valued at between $40 and $55. Size unknown but probably about 8".

THE LINCOLN MINT

SANTAS HELPERS-1975
As far as the author can find this was the only Rockwell plate produced by this company. It was issued in 1975 in two versions. One was in sterling silver and the other was in pewter. The design was etched into this 9 inch plate. Value Range: Sterling $140 to $170.
Pewter $40 to $60.

THE NUTMEG COLLECTION
(Hamilton Mint)

SANTA'S MAILBAG-1979
This is a ¾" miniature plate struck in copper. The Rockwell illustration is rendered in bas-relief and the edition is limited to those sold in 1979. It is the first in a series of Rockwell Christmas theme miniatures to be released annually. Issue price was $9.95 and they came packaged in a crystalline presentation case. Data insufficient to determine a secondary market value.

RIVER SHORE, LTD.

ROCKWELL'S LINCOLN-1976
A pure copper* commemorative plate designed and adapted from Rockwell's work by Roger Brown. First issued in 1976 by River Shore in an edition limited to 9500. The plate is 8" in diameter and contains 16 ounces of copper. It is the first plate in River Shore's Famous Americans Series. Value Range: $290 to $425.

*This was the first commemorative plate ever to be made from copper.

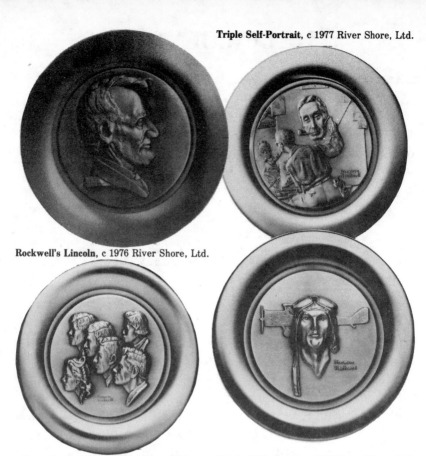

Rockwell's Lincoln, c 1976 River Shore, Ltd.

Peace Corps, c 1978 River Shore, Ltd. Spirit of Lindbergh, c 1978 River Shore, Ltd.

TRIPLE SELF-PORTRAIT-1977

Sometimes called Rockwell's Rockwell. This well known art work is reproduced in bas-relief. The relief was executed by Roger Brown for River Shore as the second plate in their Famous American Series. The plate is struck in pure copper. The diameter is 8", plate weighs almost a full pound and was first issued in 1977. Edition limited to 9500. Value Range: $90 to $140.

PEACE CORPS-1978

This is the third in the River Shore, Ltd. Famous Americans Series. Issued in 15 ounces of pure copper in an edition limited to 9500 plates. It is an 8" plate adapted to

bas-relief by Roger Brown. First issued in 1978. Value Range: $75 to $90.

SPIRIT OF LINDBERGH
This is the fourth and final in the Famous Americans Series copper commemorative plates issued by River Shore. The edition was limited to 9500 and issued in 1979. It is struck in pure copper, 8 inches in diameter. Value Range: $50 to $60.

STANCRAFT PRODUCTS INC. (BROWN & BIGELOW)

ADVENTURERS BETWEEN ADVENTURES
[Metal Plates]
Struck in bronze, this is the first in a series. Issued in 1979 in 8" diameter at $55.00 and still selling at that price. Future releases unknown.

STRATFORD GALLERY

FOUR FREEDOMS
Offered in 1980 at invitational subscriber price of $35 per item. They were struck by the Metal Arts Company in bronze bas-relief. They were issued in a frame. The plaques measure 5¾"x7¼" and overall (framed) 9"x10½". The literature states they are limited editions but does not disclose the edition number.* Value range not established as yet but in excess of $40.00 each.

Will be limited by number of subscribers.

BRONZE MEDALLION of a Norman Rockwell Self Portrait

This solid bronze medallion was commissioned by the Stratford Gallery and struck by the Metal Arts Company. It is 1 15/16" in diameter with a provision for hanging on a wall or as a pendant on a chain. It was used as a promotional gift to purchasers of the Stratford Gallery 1980 offerying of their framed bronze bas-reliefs of the Four Freedoms. Value range: $10-20.00.

WILTON

This company produced a plate in commemorative of Norman Rockwell day in Stockbridge, Masschusetts, May 23, 1976. The plate is made of porcelain and "Armetale". The ceramic portion is the center and the metal is a special alloy called "Armetale" by Wilton. It looks much like pewter but stronger and tarnish resistant. Value range $18-$30.

ZELDA'S OF APPLE VALLEY

ALMOST GROWN UP-1979

This is a crystal plate 8" in diameter with the design out into the surface. Issued in 1979 at about $10 there is insufficient data to establish current collector value.

FREEDOM FROM WANT
Manufacturer Unknown

This is a toleware plate bearing a color reproduction of the "Freedom From Want" painting. Only one advertising reference (1980) was found. It stated that the plate is 10" in diameter and was priced at $9.95.

LOOKING OUT TO SEA
Manufacturer Unknown

This is an attractive toleware plate bearing a full color reproduction of the famous "Looking Out To Sea" painting. 1979 advertising material states in part "...made in a very limited issue". No other information was found. The issue price was $19.50.

SECTION VI

BELLS

DAVE GROSSMAN DESIGNS, INC.

FACES OF CHRISTMAS-1975
This is the first Rockwell collector bell to be produced by Grossman. It was issued at $12.50 in an edition limited to 9,500 pieces. The design was taken from the December 20, 1920 issue of the Saturday Evening Post. Value range $15-$20.

DRUM FOR TOMMY-1976
This bell is identical in shape to the 1975 limited bell but the research materials and records available to the author do not make it clear whether this is a part of a series. There is no indication of the edition other than probably being limited to the year of issue. As far as can be determined there have been no further issues of Christmas bells after this one. Released at $12, the design is from the December 17, 1921 issue of Country Gentlemen Magazine. Value range $12-$15.

LEAPFROG-1980
This is the first bas-relief design bell produced by Grossman. It is the first in an annual series. 6½" tall and limited to the year of issue, the design is from the June 28, 1919 cover of the Saturday Evening Post. Issue price: $50.

BEN FRANKLIN BICENTENNIAL BELL-1976
A porcelain bell issued in commemoration of the U. S. Bicentennial. The design is from the May 29, 1926 issue of the Saturday Evening Post. The edition was limited to 10,000 pieces. Value range $12-$20.

Leapfrog, limited edition 1980 Norman Rockwell Bas Relief Bell. Dave Grossman Designs.

THE DANBURY MINT

This well-known company as produced many collector bells bearing Norman Rockwell art. Their first issue of a collection óf Rockwell bells was begun in 1975. The Doctor and Doll was the first bell in the series and it ended with The Remedy bell in early 1978.

THE NORMAN ROCKWELL BELL SERIES-1975-1978
This is a collection of twelve Bavarian porcelain bells sold by subscription and limited to the number of those subscribed to with each individual issue. They are listed below by design name and subscriber cutoff date. The actual numbers of each edition is not known. Each bell is identical in shape and measures 7" in overall height. Each sells for about $40-$60.

Name	Subscriber Cutoff Date
Doctor and Doll	Dec. 31, 1975
Grandpa Snowman	Feb. 28, 1976
Freedom From Want	May 31, 1976
No Swimming	Aug. 15, 1976

Saying Grace	Oct. 22, 1976
The Discovery	Dec. 31, 1976
The Runaway	Mar. 15, 1977
Knuckles Down	May 23, 1977
Tom Sawyer	Aug. 1, 1977
Puppy Love	1977
Santa's Mail	Dec. 31, 1977
The Remedy	* 1978

TRIPLE SELF PORTRAIT-1979

This is a wood handle porcelain bell measuring 7 9/16" overall height. It was issued as a memorial tribute to Rockwell. Edition unknown. Value range $30 to $40.

THE WONDERFUL WORLD OF NORMAN ROCKWELL BELL COLLECTION-1979-1980

This is a series of twelve Bavarian porcelain collector bells began in 1979. The edition is limited to the number of subscriptions to the series. The closing date for subscribing was April 30, 1979. Each bell bears a design taken from well known illustrations from the Saturday Evening Post. They are each 5 3/8" high overall with an

Exact date unknown.

open loop handle. The series was not complete as of this writing. The nine known designs are listed below. There has not been sufficient time for a secondary market to develop. Release price for each was $27.50.

Grandpa's Girl Baby Sitter
Friend in Need Back To School
Puppy in the Pocket A Boy Meets His Dog
Batter-up Gramps at the Reins
Leapfrog

THE GORHAM COLLECTION

1980 Love's Harmony Bell, **Flying High**.

Gorham began producing Rockwell collector bells in 1974 with the first edition in an annual limited edition. They have continuously produced collector bells since adding others. They are listed here by year of issue. All Gorham bells have a wooden handle. Unless otherwise noted each is limited by year of issue.

Year of Issue	Name	Height	Value Range
1974	SWEET SONG SO YOUNG	9"	70 to 85
1975	SANTA'S HELPERS	9"	25 to 40
1975	YOUNG LOVE	9"	30 to 50
1975	*THE TAVERN SIGN PAINTER	9"	35 to 50
1976	SNOW SCULPTURE	10½"	30 to 50
1976	FLOWERS IN TENDER BLOOM	10½"	30 to 50
1977	FONDLY DO WE REMEMBER	8½"	30 to 40
1977	CHILLING CHORE	8½"	40 to 50
1978	GAILY SHARING VINTAGE TIMES	8½"	20 to 30
1978	GAY BLADES	8½"	25 to 35
1979	BEGUILING BUTTERCUP	8½"	25 to 35
1979	A BOY MEETS HIS DOG	8½"	25 to 35
1980	FLYING HIGH	8½"	30 to 35
1980	CHILLY RECEPTION	8½"	30 to 35

THE HAMILTON COLLECTION

FOUR SEASONS BELL COLLECTION-1979-1980

This is the only set of four silver plated metal collector bells to be issued to present. The House of Gorham, bell makers and precious metal craftsmen, was commissioned to produce the bells. They are cast in bas-relief and silver plated. They have walnut handles topped off with a silver plated crown. The set is limited to 9,800. Value range $60 to $65.

*Limited Edition of 18,500 pieces.

RIVER SHORE LTD.

River shore has released two sets of collector bells to date. The collections are entitled "The Norman Rockwell Children Series". The first series of four were released in 1977 and the second in 1978. Both sets included a wooded display rack in the issue price.

Series I-1977
Limited Edition 7,500 Sets
 First Day of School
 School Play
 Football Hero
 Flowers For Mother
Value range 150 to 200.

Series II-1978
Limited Edition 15,000 Sets
 Five Cents a Glass
 Garden Girl
 Dressing Up
 Future All-American
Value range 150 to 200.

ROYAL DEVON

BUTTER GIRL-1976
As far as could be determined this is the only Rockwell collector bell to bear the Royal Devon Stamp.
Value range $25 to $35.

SECTION VII

MEDALS AND INGOTS

Over the years there have been many medals and ingots produced. The famous Franklin Mint has produced the greatest number of these, with the Hamilton Mint close behind. Others have struck or had commissioned a few more. The latter is well represented by the various pieces that the Ford Motor Company commissioned in celebration of assorted occasions. The majority of them have been struck in silver with some use of gold, bronze and other metals. In todays incredible gold and silver market the material from which some of them are made is in itself valuable. Coupled with the fine work that most represent they are inherantly valuable. Actual metal value was not considered in deriving the values quoted here in because of the great state of flux the market is in at this time.

THE FRANKLIN MINT ISSUES

Although the Ford Motor Company beat the Franklin Mint to commissioning Rockwell works in metal by almost twenty years this company is the real pioneer in the area. To date there are dozens of Franklin Mint issues of Rockwell works rendered in a metal form. They began doing these in 1972. The following is a chronological listing of the various medals and ingots they have produced so far.

SPIRIT OF SCOUTING-Medal Series, 1972
Made of sterling silver this series of twelve medals depicts the twelve tenets of the Boy Scout Pledge. In 1972 the series cost $9.75 per metal (total-$117). A complete set of 12 is valued in excess of $250 currently. These were a total of 26,971 minted. It is not known how many are in complete sets.

131

NORMAN ROCKWELL'S FONDEST MEMORIES-Ingot Series-1973, 1976

In 1973 there were 23,532 serially numbered sets of ten 2"x2½" ingots struck in sterling silver. In 1976 there was another issue, un-numbered, of 1,282 sets of ten produced. The current value of either set is now between $300 and $400 with the earlier set falling in the higher side of the range. The ingots are:

At The Barber
Holiday Dinner
The Checker Game
Fun on the Hill
The First Date

The Knitting Lesson
The Patient
Playing Hookey
Day Off
The Big Parade

TRIBUTE TO ROBERT FROST-Medal Series, 1974

This series was struck in sterling silver in sets of twelve. There were a total of 12,544 sets minted. The current value for a set ranges from $360 to $400. The medals are from the following Rockwell paintings:

After Apple Picking
The Road Not Taken
Dust of Snow
Stopping by The Woods on a
 Snowy Evening
Going for Water
Mending Wall

The Gift Outright
Birches
A Mood Apart
The Pasture

A Time To Talk
The Grindstone

FAVORITE MOMENTS FROM MARK TWAIN-Ingot Series 1975

This series of ten 2"x1-5/8" ingots was struck in a sterling silver edition of 4,544 and in a bronze edition of 1,220. The current values are $155-$180 for the bronze set and $350-$400 for the sterling silver set. The paintings from which the designs were taken are as follows:

The Adventures of Tom Sawyer
The Adventures of Huck Finn
Life on the Mississippi

Roughing It
Connecticut Yankee in King Arthur's Court
The Prince and the Pauper
The Celebrated Jumping Frog
Innocents Abroad
Pudd'n Head Wilson
Tom Sawyer, Detective

THE OFFICIAL GIRL SCOUT MEDALS-1977

This is a set of 12 medals depicting the Girl Scout Promise "On My Honor", the motto "Be Prepared" and the ten laws. The sets of twelve medals were minted in a *bronze edition of 1,996 sets, a sterling silver edition of 2,182 sets, and a 24K solid gold edition of 20 sets. The value of them are: bronze, $215-$235; the sterling silver and gold medals are not priced due to the rapidly changing world market.

HAMILTON MINT ISSUES

The Hamilton Mint Company started minting metal ingots depicting Rockwell paintings in 1974 with two separate issues: The Four Season and the first of their fine Christmas theme ingots.

THE FOUR FREEDOMS-Ingots, 1974

These four 1¾"x2½" ingots were struck in a solid (.999 pure) silver edition and another edition where the silver ingots were gold plated. The edition number struck of each was limited to the number subscribing. The actual number is unavailable at present. Current value for the silver set is $185 to $240 with the gold-plated edition not significantly higher at this time.

There were 560 extra medals of the "Considerate" law minted with the wrong number on the obverse. The error reads #10 when it should read #11. Value of this mint error medal is unknown.

THE CHRISTMAS THEME INGOTS

Beginning in 1974 the Hamilton Mint began producing an ingot bearing an image taken from various early Saturday Evening Post Christmas covers by Rockwell. They were not really a series as much as they were simply annual releases. Each is described for you here. Edition numbers are unknown.

CHRISTMAS TRIO-1974

Made of solid (.999 pure) silver and another of the same silver, but gold-plated. The ingot depicts the 1923 S.E.P. Christmas cover. The value is about $25-$30.

SLUMBERING SANTA-1975

Made of solid (.999 pure) silver and another of the same silver, but gold-plated. The ingot depicts the 1922 S.E.P. Christmas cover. Value range is about $30-$40.

TINY TIM-1976

Made of solid (.999 pure) silver and another of the same silver, but gold-plated. The ingot depicts the 1934 S.E.P. Christmas cover. The value range is about $25-$35.

CHARLES DICKENS-1977

Made of solid (.999 pure) silver and another of the same silver, but gold-plated. The ingot depicts the 1928 S.E.P. Christmas cover. The value is about $35-$50.

SANTA PLANNING A VISIT-1978

Made of solid (.999 pure) silver and another of the same silver, but gold-plated. The ingot depicts the 1926 S.E.P. Christmas cover. The value is about $35-$45.

BEST LOVED SATURDAY EVENING POST COVERS-Series of 12, 1975

Once again the mint issued the ingots in the .999 silver and the silver/gold plate editions. The value for a complete set of twelve ranges from $130 to $200.

Best Loved Saturday Evening Post Covers Series.
Hamilton Mint.

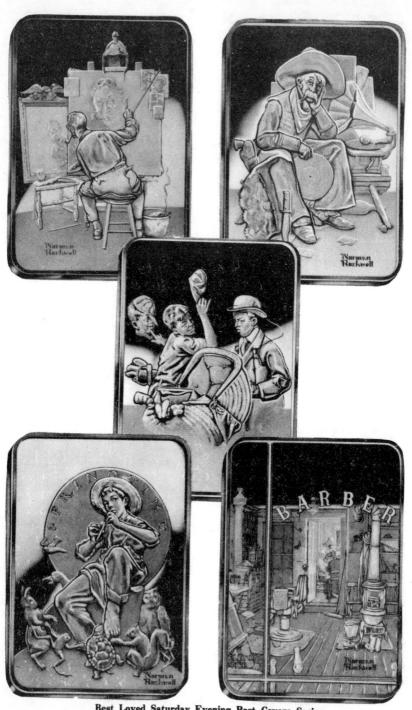

Best Loved Saturday Evening Post Covers Series.
Hamilton Mint.

Best Loved Saturday Evening Post Covers Series.
Hamilton Mint.

COVER DATE

Mother's Day Off	May 20, 1916
Meeting The Clown	May 18, 1918
Threading The Needle	April 8, 1922
The Wonders of Radio	May 20, 1922
Springtime	April 16, 1927
Dreams of Long Ago	August 13, 1927
Doctor and Doll	March 9, 1929
The Tatoo Artist	March 4, 1944
Shuffleton's Barber Shop	April 29, 1950
Saying Grace	November 24, 1951
Breaking Home Ties	September 25, 1954
Triple Self-Portrait	February 13, 1960

THE FOUR SEASONS-Medals, 1976

Four sterling silver medals struck as a set. Current value is $60-$65.

PORTRAITS OF AMERICA-1977

This is another series of ingots depicting Saturday Evening Post Rockwell covers. They were struck in a solid (.999 pure) silver edition and another edition of the same

silver but gold plated. There are 24 in the series and currently valued at $600-$700 for a complete set.

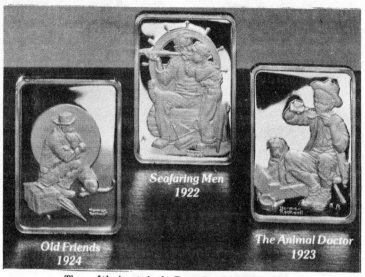

Three of the ingots in the **Portraits of America Series.**
Hamilton Mint.

Pee Wee Liberation 1939	The Wave Of The Future 1949
The Animal Doctor 1923	The Undercover Man 1921
Old Friends 1924	Voting 1944
The Pro 1916	Vacation 1930
Seafaring Men 1922	The First Haircut 1918
Jockey Weighing In 1958	After The Prom 1957
The Ride Home 1925	Barbershop Quartet 1936
The New Pupil 1935	Summer Afternoon 1930
Thanksgiving 1942	The Tossup 1950
Rainout 1949	Road To Miami 1940
At The Depot 1927	Adventure 1924
Barbershop 1940	Debutante 1933

SATURDAY EVENING POST 250th ANNIVERSARY MEDAL

Struck in solid (.999 pure) silver, this medal is 2 inches across. It was issued at $30 in 1977 and currently brings up to $50.

SECTION VIII

MISCELLANEOUS COLLECTIBLES

This section is devoted to the many other types of Rockwell collectibles not covered by catagory so far. They are arranged alphabetically according to type of item. The manufacturer or sponsoring agency or company will be identified where possible. Many of the items listed here are fine products, limited and unlimited, worthy of collecting. Others may be of special interest to some collectors to obtain but some of them are also presented only as a matter of general interest.

Of the many hundreds in the latter, general interest catagory, are not particularly valuable or hard to obtain but who knows what status they may attain in future years. There is only a sampling of them represented here. An example would be the gift wrapping paper, or the jigsaw puzzles. These are not assigned a collector value.

BOTTLES

BEAM'S 1976 BICENTENNIAL LIMITED EDITION SERIES

The James B. Beam Distilling Corporation of Clermont-Beam, Kentucky is well known for its various commemorative bottles. In 1976 they issued a series of 6 bottles, each bearing a reproduction of a Norman Rockwell Saturday Evening Post cover illustration. The "one fifth" bottle, with the bourbon whisky in it sold for about $7.00 depending upon the part of the U. S. it was offered. Today the bottles, whisky or no, sell for around $10-$15 each. The S.E.P. covers represented are listed on the following page. Edition numbers unknown.

The Colonial Sign Painter	Feb. 6, 1926
Ben Franklin	May 29, 1926
Charles Lindbergh	July 23, 1927
The Homecoming	May 26, 1945
Game Called Because of Rain	April 23, 1949
Vote For Casey	Nov. 8, 1958

BOWLS & CACHEPOTS

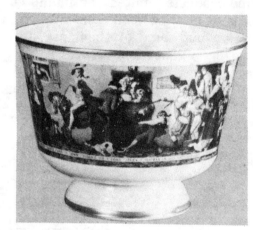

Gorham Fine China.

YANKEE DOODLE BOWL-1975

This fine porcelain bowl is 8½" in diameter and was issued by Gorham Fine China in a limited edition of 9,800* as a U. S. Bicentennial commemorative. The design is a reproduction of the Rockwell mural commissioned in 1937 by the Nassau Tavern of Princeton, New Jersey. Value range $80 to $100.

BEN FRANKLIN BOWL-1976

This is another fine china bowl, 5½" in height and 8½" diameter. Issued by the Danbury Mint as a U. S. Bicentennial commemorative. Limited by year of issue it bears a design taken from the Saturday Evening Post cover of May 29, 1926. Value range $105 to $125.

It has been reported that production may have been cut short of this number due to technical problems.

FOUR SEASONS CACHEPOTS Series #1 1979
Series #2 1980

These are small covered china bowls from Gorham Fine China. Each is 5" in diameter and 6½" high with the china lid. Each cachepot dipicts the four illustrations from the given Brown and Bigelow Four Seasons Calendars. Each is limited to 9,800 numbered pieces.

Series #1 From the 1958 calendar year. Value range $60 to $70.

Series #2 From the 1948 calendar year. Value range $60 to $65.

FOUR FREEDOMS CACHEPOT-1979

This is the same size cachepot as the Four Seasons but this one has a metal lid. All four illustrations appear on the body of the bowl. They are not limited production items. Also from Gorham Fine China. 1980 price-$85.00.

CHRISTMAS WRAP

C.P.S. INDUSTRIES of Franklin, Tennessee markets a large line of Christmas and other gift wrap and tags bearing Rockwell art from the Saturday Evening Post. A perfect selection for Rockwell collectors to use on gift giving occasions. Retail prices range from $.29 to $3.50.

CALENDARS

Photos courtesy of The Corporate Archives. Copyright by The Coca-Cola Company.

There were almost 100 different calendars produced between 1918 and 1978 that bear illustrations by Norman Rockwell. Some of the more famous are the Boy Scout Calendars and the Four Seasons Calendars. No attempt to list all the calendars will be made here, but the major issuers are listed with the approximate number of calendars they issued.

Boy Scouts of America 50*
Brown and Bigelow 33
The Coca Cola Company 4

*Rockwell painted illustrations for the Boy Scout Calendar every year from 1926 to 1976 inclusive with the exception of 1928 and 1930.

CUPS, MUGS, and STEINS

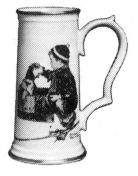

1976 **"Pride of Parenthood"** Four Seasons Stein, edition of 9,800 pieces. Gorham Fine China.

1977 **"A Boy Meets His Dog"** Four Seaons Stein, edition of 9,800 pieces. Gorham Fine China.

FOUR SEASONS STEINS

The Gorham Fine China Company began issuing a series of annual china steins in 1976. The designs are all from the various Rockwell Four Seasons calendars by Brown and Bigelow. Each is 8" high and limited to an edition of 9,800 pieces each year. The steins are listed below.

ISSUE YEAR	NAME	VALUE RANGE
1976	Pride of Parenthood	$65 to $75
1977	A Boy Meets His Dad	$50 to $60
1978	The Mysterious Malady	$35 to $40
1979	Adventurers Between Adventures	$35 to $40
1980	Goin' Fishin'	$35 to $40

FOUR SEASONS ROYAL CUP SET-1980

This is the first in a series of limited edition sets of four cups issued annually by Gorham Fine China. The first set of four depict one scene each from the 1958 Rockwell Four Seasons calendar, "Boy and His Dog", by Brown and Bigelow. Each cup is 4-5/8" high, 3½" diameter and they are limited to 9,800 sets of four. 1980 recommended retail price: $100 the set.

Two of the **Norman Rockwell toby mugs**. From Dave Grossman designs.

TOBY MUGS

Dave Grossman Designs, Inc. began issuing these 4" high porcelain mugs in 1979 with six and so far has produced a seventh in 1980. Each design is in the traditional "toby mug" style with the heads taken from characters depicted on various Saturday Evening Post covers. All are still selling at the original retail price of $35.

Name	S.E.P. Cover Date
See America First	April 23, 1938
Dreams of Long Ago	August 13, 1927
Merry Christmas	December 3, 1921
Jester	February 11, 1939
The Hobo	October 18, 1924
Catching the Big One	August 3, 1929
Faces of Christmas	December 4, 1920

NORMAN ROCKWELL COLLECTORS' MUG SERIES

Issued in 1979 by American Treasury and billed as the "...first in a series", it is expected they will issue future sets of four. The four mugs are porcelain, 4" tall and depict various Saturday Evening Post Covers. Original issue price was $5 each or a set of four for $15.97. Sold by subscription only.

NORMAN ROCKWELL COLLECTORS MUGS

A 1979 issue of four porcelain mugs from The

Westport Art Society depicting illustrations from the advertisements of the Massachusetts Mutual Life Insurance Company of Springfield, Mass. There apparently are to be future issues of the sets. Available by subscription at $5 each or $15.98 for a set of four.

CLOCKS

At least one clock design was found advertised. This clock is 12" wide by 15" high. It has a mirror face decorated with Rockwell work in one of four designs. They are "Flowers in Tender Bloom", "Flying High", "Young Man's Fancy", & "Puppy Love". It is a cordless, battery operated clock that was advertised in 1979 for $75. There have been some clocks with plate faces issued in recent months.

DOLLS

Rumbleseat Press, Inc. announced the introduction of a 20 doll series based on Rockwell characters in 1980. The face and body are made of hand crafted and hand painted bisque porcelain. Each is sequentially numbered in limited edition. The clothes are hand stitched and removable. Made in Germany by the Royal Porcelain Works, the first edition in the series is "Mimi", a character from one of the "Doctor and Doll" illustrations. Release price for this first edition in the series is $125.

The known future releases of the twenty are listed below.

MIMI	From "Doctor and Doll"
DAWN	From "No Swimming"
WILMA	From a Look magazine illustration
SUZY	From a Crest Toothpaste ad
DAVEY	From "The Truth About Santa"
PERCY	From a Life magazine cover
BILLY	From the first Saturday Evening Post cover

GREETING CARDS

When the holiday
hustle and bustle
has passed...

Hallmark Christmas card 1978.

There have been at least 60 different greeting cards, post cards, etc. produced bearing Rockwell work. Most have been commercially produced, but a few were privately produced. Some of the commercially produced cards, such as some by Hallmark can stil be found in stores occasionally. The rarest of them are of course the private cards. Among the latter are Christmas cards for the Massachusetts State Police (date unknown) and the Peter Lind Hayes post card of 1964 for example. No value has been established for the cards. There are some greeting cards being produced for sale now.

MIRRORS

There have been a number of Rockwell illustrations printed on mirrors, framed and available in specialty and gift shops. Interesting and decorative but not expected to be significant to collectors other than for decoration.

MUSIC BOXES and Other Boxes

The musical figures are covered on page 147. These are the typical small to medium size boxes with and without musical movements.

Those that were found in the course of research were all produced by Schmid Brothers, Inc. Two sets of music boxes by Schmid bear illustrations from the Four Seasons calendars. There are in addition, several other non-musical boxes by Schmid; sets of twelve Gozinta Boxes and twelve not boxes each having a different Saturday Evening Post cover.

Music Boxes, Value Range-$5-$25 each
Other Boxes, Value Range-$3-$10 each

ORNAMENTS

There are several different types of ornaments to be found, all being of recent issue; some limited and some unlimited. They are listed here according to manufacturer.

DAVE GROSSMAN DESIGNS, INC.
Grossman has produced three different types of Christmas ornaments. They are listed here by type and in order of relase.

Christmas Tree Balls

These are typical glass balls, 3¼" in diameter. All are limited to the year of issue and bearing an illustration from Saturday Evening Post covers. Numbers in each edition unknown.

Year Date	Cover Date	Secondary Market Value
*1975	Dec. 4, 1920	$25-$30
1976	Dec. 4, 1926	$10-$12

*Edition sold out - closed.

1977	Dec. 6, 1933	$10-$12
1978	Dec. 16, 1939	$10-$15
1979	Dec. 21, 1935	$5 issue price
1980	Dec. 2, 1922	$5 issue price

Charles Dickens Series, Dave Grossman Designs.

Charles Dickens Series

These are the same as the Christmas balls above except they bear illustrations from Rockwell's illustrations of Charles Dicken's characters on various Saturday Evening Post covers. They are available as a set of four only at $12 retail for the set in 1980. Unlimited edition.

Tiny Tim	Dec. 15, 1934
Christmas Dance	Dec. 8, 1928
Christmas Ride	Dec. 5, 1925
Christmas Trio	Dec. 8, 1923

FACES OF CHRISTMAS 1980

This is a limited edition ornament made of Lucite. The design, from the December 4, 1920 Saturday Evening Post cover, is etched into the surface. It is 3" in diameter and limited to the year of issue. 1980 issue price is $5. First in a series.

1980 Rockwell **Lucite Ornament.**

FIGURINE ORNAMENTS

Grossman began a series of hanging figural ornaments in 1978. They are each limited by the year of issue. Made of porcelain and 3" to 3½" tall they each can stand alone if you do not wish to hang them.

Year	Name	S.E.P. Cover Date	Secondary Market Value
1978*	Caroler	Dec. 8, 1923	$30-$40
1979*	Drum For Tommy	Dec. 17, 1921	$25-$35
1980	Santa's Good Boys	Dec. 4, 1926	$20 issue price

Edition sold out - closed.

150

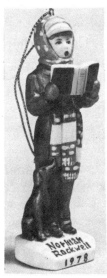
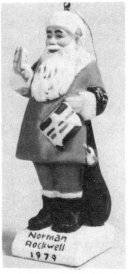
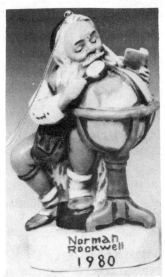

| Caroler | Drum For Tommy | Santa's Good Boys |

GORHAM FINE CHINA

The Gorham company has produced one figurine ornament to date. It is "Tiny Tim", stands, 3" in height and is made of porcelain. There is a provision for hanging if you wish. The issue price was $15.00 in 1979.

HALLMARK CARDS, INC.

This well known greeting card company has produced at least three Christmas tree balls. Each is valued from $5 to $10 and are readily identifiable by the Hallmark name imprinted on them.

OTHER ORNAMENTS

There are a few other companies that have offered Rockwell ornaments over the years. Among them are Vesta Glass and Schmit. Little information was found about their products.

151

PAINT SETS

The Craft House Corporation of Toledo, Ohio has produced at least four paint by number sets. Each of them recreates a Rockwell work in 12"x16" size.

PAPER WEIGHTS
NORMAN ROCKWELL TRIPLE SELF-PORTRAIT
River Shore Ltd.

This is a beautiful sculpted sulfide crystal paper weight designed by Roger Brown. The paper weight comes in a wooden presentation box and is limited to 2500 pieces. Issued in 1980 at $250.

CHRISTMAS TRIP PAPERWEIGHT
Manufacturer unknown

This is a leaded crystal paperweight that has been produced in a limited edition of 1000 pieces. The paperweight was released in late 1979 at $125.00 and is still selling at release price. It is the first of a series to be released once a year.

PUZZLES [Jigsaw]

The Jaymar Specialty Company of New York and Parker Brothers of Salem, Massachusetts have both produced a number of Jigsaw puzzles of Saturday Evening Post covers. There are between 40 and 50 different designs to be found. They retail for between $2 and $12.

SOUVENIR SPOONS

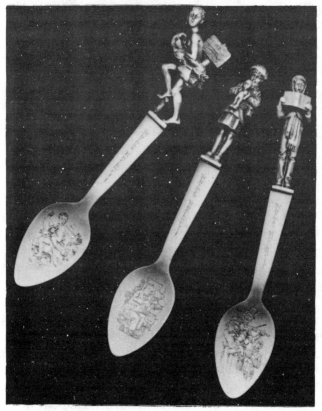

Norman Rockwell collector spoons of fine pewter.
Dave Grossman Designs.

The only spoons with Rockwell designs so far have been produced by Dave Grossman Designs, Inc. and introduced in 1980. They are rendered in pewter and available at $35 each. Each spoon is 6¾" long and inspired by one of Rockwell's Saturday Evening Post covers. The Post cover scene is etched into the spoon bowl and one of the characters from that scene is reproduced as a three-dimensional figure mounted on the spoon handle. The illustration shows six of the twelve designs. The full collection is listed below.

NAME	COVER DATE
Back to School	Jan. 8, 1927
Caroler	Dec. 8, 1923

No Swimming	June 4, 1921
Lovers	Aug. 30, 1924
Doctor and Doll	Mar. 9, 1929
See America First	Apr. 23, 1938
Take Your Medicine	May 30, 1936
Big Moment	Jan. 25, 1936
Circus	May 18, 1918
Barbershop Quartet	Sept. 26, 1936
Magic Potion	Mar. 18, 1939
Grandpa's Ballerina	Feb. 3, 1923

THIMBLES

Thimbles with Rockwell illustrations have been issued by three companies so far, all in limited editions. There are 31 thimbles to be found.

THE DANBURY MINT THIMBLES

One set of six thimbles and have been issued by Danbury. Offered by subscription in 1980 they were available singlely at $7.50 each or as a complete set for $39.50. The six designs were taken from Rockwell works in the Saturday Evening Post archives. The thimbles are made of china. The list of thimbles follows.

Going Steady
Personal Touch
Falling In Love

Puppy Love
Three's a Crowd
Defeated Suitor

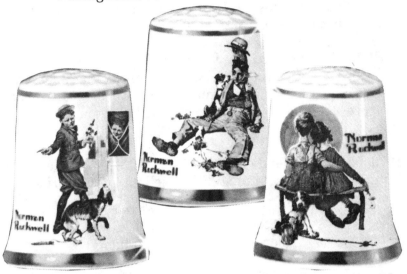

The Danbury Mint thimbles - **"Young Love"**.

"Day In The Life of a Boy". Dave Grossman Designs.

DAVE GROSSMAN DESIGNS THIMBLES

This company has issued two sets of thimbles so far. The sets are six each, all 1" tall, made of porcelain and limited to the year of issue. Both sets are still selling at $72

the set

1979 Set-Six designs taken from the Day in the Life of a Boy, Post cover of May 24, 1952.

1980 Set-Six designs taken from the Day in the Life of a Girl, Post cover of August 30, 1952.

GORHAM FINE CHINA THIMBLES

Gorham has produced two sets of six thimbles each and a 1980 Christmas thimble. The two sets are called "Nature Friends" and depict various animals from Rockwell's works.

1979 Nature Friends-issued at $14.50 ($87.00 Set) and Limited to 9,800 sets of six. Still selling at that price.

Turtles	Foxes
Raccoons	Ducks
Deer	Rabbits

1980 Canine Friends-issued at $14.50 ($87.00 Set) and limited to 9,800 sets of six different Rockwell dogs from Four Season's calendars illustrations.

1980 Christmas Thimble-Tiny Tim-issued at $15 from the Post cover illustration of December 15, 1934.

STAMPS and FIRST DAY COVERS, CACHETS

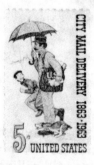

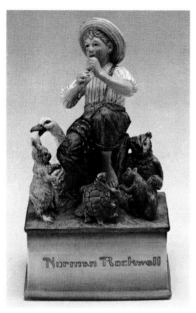

Talk To The Animals. Schmid Brothers, Inc.

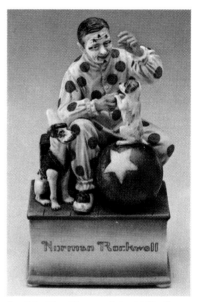

Send In The Clowns. Schmid Brothers, Inc.

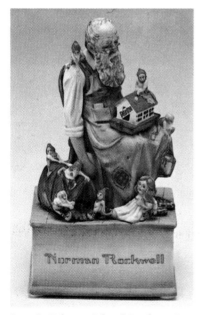

Santa's Helpers. Schmid Brothers, Inc.

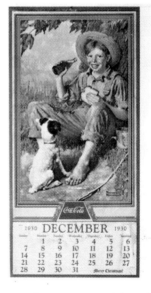

December 1930 Coca-Cola Calendar. © The Coca-Cola Company. Courtesy The Corporate Archives.

Knuckles Down, Hamilton Collection.

Butter Boy. Dave Grossman Designs.

1978 Puppets For Christmas. Royal Devon Company.

1979 Mother's Evening Out. Royal Devon Company.

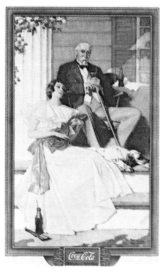

Above: One of the six Norman Rockwell Toby Mugs. From Dave Grossman Designs.

Above: A 1934 Coca-Cola Calendar illustration by Rockwell. Courtesy The Archives. © The Coca-Cola Company.

Right: Can't Wait. Illustration from one of fifty first day covers bearing Liberian Stamps, Rockwell illustrations. International Postal Collectors League.

Below: Colonial Sign Painter. Color lithograph on Arches, hand signed by Norman Rockwell. Limited to 260 impressions, 35 reserved for the artist, 36-1/8 by 23-3/8 inches. Hand proofed and printed at Atelier Ettinger, Oct. 1975.

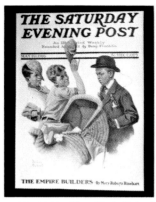

May 20, 1916. The First Saturday Evening Post cover to carry a Norman Rockwell illustration.

February 6, 1926. The first full color Rockwell cover for the Saturday Evening Post cover.

April, 1932. Ladies Home Journal cover.

April, 1928. Ladies Home Journal Cover.

A circa 1919 Post Grape-Nuts Cereal ad.

A circa 1937 Beech-Nut Gum ad.

Piso's Cough Syrup ad from 1921.

Sun-Maid Raisins ad. C 1926.

A 1924 Fisk Rubber Company ad.

Circa 1921. Two ads. Lime Crush and Lemon Crush soft drinks.

The March, 1923 cover for American Magazine.

The June, 1918 cover for Red Cross Magazine.

The April, 1921 cover for Popular Science.

The October, 1920 cover for Popular Science.

An Edison-Mazda ad from the 1920's.

A circa 1943 Upjohn ad.

An Interwoven Socks ad. Circa 1927.

The famous Watchmakers of Switzerland ad from the late 1940's.

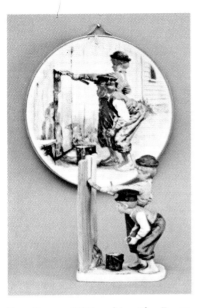

Tom Sawyer-Whitwashing The Fence.
Dave Grossman Designs.

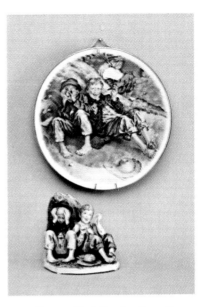

Tom Sawyer-First Smoke. Dave Gross-
man Designs.

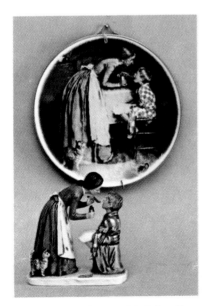

Tom Sawyer-Take Your Medicine. Dave
Grossman Designs.

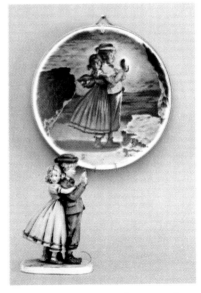

Tom Sawyer-Lost In The Cave. Dave
Grossman Designs.

Left: The May 8, 1920 cover for The Literary Digest.

Right: The March 20, 1918 cover for Leslie's.

Left: The October, 1919 cover for Farm and Fireside.

Right: The April, 1934 cover for Boys' Life.

The first Rockwell cover for Country Gentleman. August, 1925 issue.

The March 29, 1919 cover for Collier's.

A print of the only known published still-life by Rockwell; "Molly's Potting Shed".

U.S. COMMEMORATIVE STAMPS-(Rockwell Designs)
Boy Scouts Of America-50th Anniversary
4 cent stamp issued February 8, 1960. Scott catalog number 1145. Collector Value, 28 cents unused.

City Mail Delivery-100th Anniversary
5 cent stamp issued October 26, 1963. Scott catalog number 1238. Collector Value, 15 cents unused.

Tom Sawyer-American Folklore
8 cent stamp issued October 13, 1972. Scott catalog number 1470. Collector Value, 28 cents unused.

FIRST DAY COVERS-U.S. (Cachets designed by Rockwell)
Brotherhood and Human Rights-United Nations Cachet Bears Rockwell's illustration, the Golden Rule, from the Saturday Evening Post cover of April 1, 1961. Limited edition of 2500.

The Spirit of '76-Postmasters of America cachet. Bears an illustration by Rockwell of two boys and a girl emulating the stamp design reproduced from the famous "Spirit of '76" painting by A.M. Willard around 1880. Issued January 1, 1976.

Triple Self-Portrait
Little Spooners [Puppy Love]
Friends in Need
First Day of School
Batter Up
Doctor and Doll
Weighing In

Going To Church-Postal Commemorative Society a series of eight cachets each bearing one of the above illustrations. The cachets were issued February 3, 1978 in commemoration of Rockwell's birthday.

Summer Olympic Games-Issued by the Franklin Mint

for the Postmasters of America in commemoration of
the 1976 Summer Olympics at Lake Placid. Issue date
was July 16, 1976.

George Washington's Victory at Princeton-Issued by
the Franklin Mint for the Postmasters of America.
Issue date was January 3, 1977.

FOREIGN STAMPS & CACHETS (Rockwell Designs)

**The Norman Rockwell Tribute To The Youth Of
America**-This series of stamps and matching cachets was
issued by Liberia under the sponsorship of the Internation-
al Postal Collectors League*. The art on the stamps and
cachets is from the archives of Brown and Bigelow, Inc.
The series was issued in Liberia and bears the postal
cancellation "First Day of Issue, 1 Sept., 1979, Monrovia,
Liberia". They were sold by subscription and limited to
20,000 first day covers. The League provided subscribers
with an album in which to preserve the covers. The issue
price was $4.75 each (total $237.50) and are reportedly
selling for $6 to $7 each now. The list of the 50 covers and
the date of the original painting follows.

A GOOD SCOUT-1925
A GOOD TURN-1926
GOOD FRIENDS-1927
SPIRIT OF AMERICA-1929
SCOUT MEMORIES-1931
A SCOUT IS LOYAL-1932
AN ARMY OF FRIENDSHIP-1933
CARRY ON-1934
A GOOD SCOUT-1935
THE CAMPFIRE STORY-1936
SCOUTS OF MANY TRAILS-1937
AMERICA BUILDS FOR TOMORROW-1938
THE SCOUTING TRAIL-1939
A SCOUT IS REVERENT-1940
A SCOUT IS HELPFUL-1941
A SCOUT IS LOYAL-1942

A wholly owned subsidiary of Calhoun's Collectors Society, Inc.

A SCOUT IS FRIENDLY-1943
WE, TOO, HAVE A JOB TO DO-1944
I WILL DO MY BEST-1945
A GUIDING HAND-1946
ALL TOGETHER-1947
MEN OF TOMORROW-1948
FRIEND IN NEED-1949
OUR HERITAGE-1950
FORWARD AMERICA-1951
THE ADVENTURE TRAIL-1952
ON MY HONOR-1953
A SCOUT IS REVERENT-1954
THE RIGHT WAY-1955
THE SCOUTMASTER-1956
HIGH ADVENTURE-1957
MIGHTY PROUD-1958
TOMORROW'S LEADER-1959
EVER ONWARD-1960
HOMECOMING-1961
POINTING THE WAY-1962
A GOOD SIGN ALL OVER THE WORLD-1963
TO KEEP MYSELF PHYSICALLY STRONG-1964
A GREAT MOMENT-1965
GROWTH OF A LEADER-1966
BREAKTHROUGH FOR FREEDOM-1967
SCOUTING IS OUTING-1968
BEYOND THE EASEL-1969
COME AND GET IT-1970
AMERICA'S MANPOWER BEGINS WITH BOY POWER
 -1971
CAN'T WAIT-1972
FROM CONCORD TO TRANQUILITY-1973
WE THANK THEE-1974
SO MUCH CONCERN-1975
SPIRIT OF '76-1976

TRAYS

There are some very old trays, reproductions of old trays and new issues.

THE OLD TRAYS
Only two are presently known but there may be more to be found.

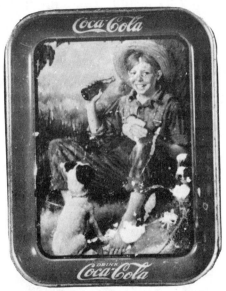

THE COCA-COLA COMPANY
The accompanying photograph represents the only advertising tray from the Coca-Cola Company that bears Norman Rockwell art. Although not visible in the photo it is inscribed "(c) Coca-Cola Co., 1931", "American Art Works, Inc..." The photo is from their Corporate Archives and used with their permission. The value of $175.00 is taken from **The Official Coca-Cola Collectibles Price Guide.** The tray measures 10½"x13".

GREEN GIANT [NIBLETS CORN)
This advertising tray depicts a little boy and girl eating corn on the cob. It has a title label on the bottom edge that states "Who's Having More Fun?" It measures 17½"x12¾" and dates in the early 1940's. Value range **$40-$50.**

THE NEW TRAYS

With the general interest in Americana and the widespread special interest in Rockwell collectibles, there have come reproductions of old trays and new issues of metal trays produced in a similar style to the old. There have been 15 or 16 of these new trays to be produced so far. They are listed by issuing company here.

FAIRCHILD INDUSTRIES

Issue Year	Name	Number Produced	Size	Value Range
1977	Tattoo Artist	10,000	14x16	$10-$15

DAVE GROSSMAN DESIGNS, INC.

Issue Year	Name	Number Produced	Size	Value Range
1975	Ben Franklin	5,000	12x14	$10-$15
1975	Santa's Helpers	Unknown	12x14	$10-$15
1976	Santa Planning Visit	Unknown	11x13	$12-$15

1978 April Fool Tray.

HEIRLOOM PRODUCTS, INC.

Issue Year	Name	Number Produced	Size	Value Range
1975	April Fool	Unknown	12x14	$10-$15
1976	Butter Girl	10,000	12x14	$12-$15
1977	April Fool	20,000	11x13	$15-$18
1978	April Fool	Unknown	Unknown	$15-$18

162

RIVER SHORE, LTD.

Issue Year	Name	Number Produced	Size	Value Range
1975	Two Boys with Hound Dogs	5,000	10½x13½	$10-$15
1976	Looking Out To Sea	1,000	10½x13½	$15-$20
1976	Triple Self-Portrait	4,000	10½x13½	$15-$18
1976	Doctor and Doll	1,000	10½x13½	$15-$20

UNITED STATES POSTAL CREDIT UNION

Issue Year	Name	Number Produced	Size	Value Range
1976	The Country Postman	Unknown	11" round	$8-$12

SECTION IX

NORMAN ROCKWELL PRINTS

This section will list the prints of Rockwell art. Be sure to refer back to pages 10 to 12 and review the discussion of definitions and precautions.

There are millions of unlimited reproductions of Rockwell works on the market today. The following pages will list and discuss only those limited (in some manner), and the signed and limited ones. Almost all the others can give you pleasure when properly framed and hung in your home but they are not likely to ever be particularly valuable.

HARRY ABRAMS PRINTS

THE HARRY ABRAMS PORTFOLIO

This is a set of fifteen prints. They were not numbered but they were hand-signed by Rockwell. The individual signed prints sell for about $500 each. Their signed prints sell for about $500 each. There are also some unsigned prints of the same series that sell for $15-$20. Each print is 19"x25".

Marriage License	Homecoming
Weigh In	Tired but Happy
Walking to Church	Truth About Santa
Shuffleton's Barber Shop	Family Tree
Tough Call	Only Skin Deep
Roadblock	No Swimming
Before and After	The Art Critic
The Runaway	

THE ABRAMS LIMITED EDITION COLLOTYPES

In 1970 the Abrams company published the famous book **Norman Rockwell, Artist and Illustrator. Over**

100,000 copies were printed. Later the company published 1100 more copies with an extra page bearing the author's signature (Thomas S. Buechner) and that of Norman Rockwell. The page also bore a sequential number in the edition. Along with the book the purchaser also received a signed and numbered limited edition collotype especially printed for distribution with the book. There were ten subjects each printed in an edition of 110 for a total of 1100. The combination print and book sell in excess of $4000. The subjects of the prints are listed here.

Breaking Home Ties	Weighing In
Christmas Trio	Spring
Courting Couple Surprise	Summer
Self-Portrait	Fall
Time For Greatness	Winter

THE A-T-O PRINT COLLECTION

You've Got To Be Kidding! A-T-O, Inc.

A-T-O, Inc. is an Ohio based company that produces among other related things, the American LaFrance fire engines. Over the years they commissioned Rockwell to do a number of paintings for the company. They have had five reproduced and have offered them to the public through their advertising beginning around 1971. They are valued at around $5-$10 each.

GEE THANKS, BROOKS
THE NEW AMERICAN LAFRANCE IS HERE!
ADIRONDACK WINTER
YOU'VE GOT TO BE KIDDING!
IN SAFE HANDS

THE CIRCLE GALLERY PRINT COLLECTION

This company has published over 100 different prints that were numbered limited editions and hand-signed by Rockwell. Plus many unsigned prints and posters.

The signed limited prints listed on the following pages have an edition number listed with each. The number 200 appears more often than any other and this is slightly misleading. The number 200 represents the portion of the printing that is marked in the traditional manner; i.e. 105/200. This is the portion of the edition that you would normally be buying. Most of those printings actually number more than 200. There are usually a few artist's proofs and sometimes a small "deluxe edition" printed on a special paper called Japon paper rather than the Arches or Rives paper normally used.

A good example would be "The Lobsterman" listing. If you look at the edition number listed with the print you will note that it says 330 rather than 200. The "print documentation", (Circle Gallery furnishes this with each of their prints) states in part as follows:

Number of Impressions	330
Numbered	1/200-200/200
Roman Numbered	35 Designated I/XXXV-XXXV/XXXV
Artist's Proofs	70 on Arches designated "Ap"
Deluxe Edition	25 on Japon designated "Ap"

The documentation states further, "No unsigned or unnumbered impressions in the edition. No artist, publishers or printers proofs other than stated herein. The stones/screens/plates have been effaced. No prior states of impression. No later editions from same stones/screens/plates. Not a posthumous or restrike edition". You know,

beyond any doubt, just how many prints or impressions there are in existence. Only a few of these print documentations were readily available to the author; therefore you must assume that there are a few more than 200 when you encounter that number in the listing. The current value is taken directly from the suggested retail price list furnished by Circle Gallery. The market condition will dictate actual selling prices.

Title	Edition Size	Medium	Size	Current Value
At The Barber	200	L	22x30	3000
Aviary	200	L	20x26	3200
Barbershop Quartet	200	L	24x30	2200
Big Day, The	299	L	30x22	*
Blacksmith Shop	200	L	14x30	5300
Bookseller	200	L	17x23	1700
Bookseller (Japon)	25	L	17x23	1800
Bridge, The	200	L	20x26	2100
Children At Window	200	L	20x26	1700
Circus	200	L	20x26	1700
County Agricultural Agent	200	C	24x35	2700
Critic, The	200	C	28x32	3600
Day In The Life Of A Boy	295	L	19x20	4000
Day In The Life Of A Boy (Japon)	25	L	19x20	4700
Discovery	200	C	28x32	4800
Doctor and Boy	200	L	20x26	2000
Doctor and Doll	200	C	29x35	10,000
Dressing Up (Pencil)	200	L	20x26	2700
Dressing Up (Ink)	60	L	20x26	3500
Expected and Unexpected, The	200	L	17x20	2200
Family Tree	200	L	25x30	4500
Football Mascot	200	L	20x26	1700
Freedom From Fear	200	C	29x35	4700
Freedom From Want	200	C	29x35	4700
Freedom Of Religion	200	C	29x35	4700
Freedom Of Speech	200	C	29x35	4700
Gaiety Dance Team	200	C	24x30	2800
Girl At Mirror	200	C	29x35	7000
Golden Rule	200	C	29x35	3300
Gossips	200	L	22x25	3700
Gossips (Japon)	25	L	22x25	3800
High Dive	200	C	24x30	1900
Homecoming, The	200	L	25x30	1700
House, The	200	L	20x26	1800
Ichabod Crane	200	L	20x26	5000
Inventor, The	200	L	19x19	2800
Jerry	200	L	20x26	1800
Lincoln	200	L	20x26	10,000
Lobsterman	305	L	22x29	3800
Marriage License	200	C	28x32	5500
Moving Day	200	C	24x30	2000

*Current value unavailable.
**Medium-L [Lithograph], C [Collotype] See page 11.

"The Gossips", edition 200, lithograph 22x25.

Title	Edition Size	Medium	Size	Current Value
Music Hath Charm	200	C	24x30	2800
Outward Bound (Looking Out To Sea)	200	C	29x35	6500
Prescription	200	L	24x30	3900
Prescription (Japon)	25	L	24x30	4000
Problem We All Live With, The	200	C	31x44	2600
Puppies	200	L	20x26	1800
Raleigh The Dog	200	C	29x35	2700
Rocket Ship	200	L	20x26	1700
Runaway	200	C	28x32	4600
Runaway	301*	L	20x26	2100
Safe And Sound	200	L	17x20	1700
Saturday People	200	C	24x30	1800
Saying Grace	200	C	29x35	6000
Schoolhouse, The	200	L	15x18	1500
Schoolhouse, The (Japon)	25	L	17x24	1600
See America First	200	L	17x24	4200
See America First (Japon)	25	L	17x24	4300
Settling In	200	L	20x26	1400
Shuffleton's Barber Shop	200	C	28x35	6000

*60 of this edition were printed but left un-numbered. They were retained by Rockwell.

Title	Edition Size	Medium	Size	Current Value
Spelling Bee	200	L	14x30	5500
Spring Flowers	200	C	27x33	4200
Study For A Doctor's Office, A	200	L	22x25	4800
Summer Stock	200	L	21x27	3500
Summer Stock (Japon)	25	L	21x27	3700
Teacher, The	200	L	17x23	1400
Teacher, The (Japon)	25	L	17x23	1500
Texan, The	200	C	24x30	2300
Three Farmers	200	L	20x16	1200
Ticketseller	200	L	21x27	2800
Ticketseller (Japon)	25	L	21x27	2900
Top Of The World	200	C	29x35	2100
Trumpeter	200	L	21x26	2700
Trumpeter (Japon)	25	L	21x26	2800
Welcome	200	L	20x26	1600
Wet Paint	200	C	24x30	2100
Window Washer	200	L	20x26	1700

FOLIOS by Circle Gallery

Title	Edition Size	Medium	Size	Current Value
AMERICAN FAMILY FOLIO (5)				
Debut	200	L	20x26	1800
Fido's House	200	L	20x26	1800
Save Me	200	L	20x26	1800
Teacher's Pet	200	L	20x26	1800
Two O'Clock Feeding	200	L	20x26	1800
FOUR SEASONS FOLIO (4)*				
Winter	200	L	20x21	1500
Spring	200	L	20x21	1500
Summer	200	L	20x21	1500
Autumn	200	L	20x21	1500
HUCK FINN FOLIO (8)				
Jim Got Down On His Knees	200	L	20x26	2600
Miss Mary Jane	200	L	20x26	2600
My Hand Shook	200	L	20x26	2600
Then For Three Minutes	200	L	20x26	2600
Then Miss Watson	200	L	20x26	2600
There Warn't No Harm	200	L	20x26	2600
When I Lit My Candle	200	L	20x26	2600
Your Eyes Is Lookin'	200	L	20x26	2600

There is another edition of the Four Seasons Folio on Japon. The edition is limited to 25 of each print. Add $100 to regular price for each print.

POOR RICHARD' ALMANAC FOLIO (7)

Title	Edition Size	Medium	Size	Current Value
Ben's Belles	2900	L	20x26	1900
Ben Franklin's Philadelphia	200	L	20x26	2100
The Drunkard	200	L	20x26	2100
The Golden Age	200	L	20x26	1900
The Royal Crown	200	L	20x26	1900
The Village Smithy	200	L	20x26	1900
Ye Old Print Shoppe	200	L	20x26	1900

SCHOOL DAYS FOLIO (4)

Baseball	200	L	20x26	1850
Cheering	200	L	20x26	1850
Golf	200	L	20x26	1850
Studying	200	L	20x26	1850

TOM SAWYER FOLIO (8)*

Cat	200	L	20x26	1850
Church	200	L	20x26	1850
Grotto	200	L	20x26	1850
Medicine	200	L	20x26	1850
Out The Window	200	L	20x26	1850
Smoking	200	L	20x26	1850
Spanking	200	L	20x26	1850
White Washing	200	L	20x26	3000

UNSIGNED, UN-NUMBERED COLLOTYPES FROM CIRCLE GALLERY

All retail for about $25-$35

COUNTRY AGRICULTURAL AGENT	24x35
CRITIC, THE	28x32
DANCE TEAM	24x30
DISCOVERY	28x32
DOCTOR AND DOLL	29x35
FREEDOM FROM FEAR	29x35
FREEDOM FROM WANT	29x35
FREEDOM OF SPEECH	29x35
FREEDOM OF WORSHIP	29x35
GIRL AT THE MIRROR	29x35
GOLDEN RULE	29x35

*This Folio is printed in B/W on a sepia background. There is another folio of the same prints in color. There are 7 collotypes and 1 lithograph. The edition is limited to 200 and is valued at $17,000.

*There is another edition of these four prints on Japon. Limited to 25 folios, the value is about $500 higher.

HIGH DIVE	24x30
MARRIAGE LICENSE	28x32
MOVING DAY	24x30
MUSIC HATH CHARM	24x30
OUTWARD BOUND (LOOKING OUT TO SEA)	29x35
PROBLEMS WE ALL LIVE WITH, THE	31x44
RALEIGH THE DOG	29x35
RUNAWAY	28x32
SATURDAY PEOPLE	24x30
SAYING GRACE	29x35
SHUFFLETON'S BARBER SHOP	29x35
TEXAN, THE	24x30
TOP OF THE WORLD	29x35
WET PAINT	24x30

POSTERS FROM CIRCLE GALLERY [Un-signed]

All the posters sell at $10-$15 retail. They are each photo-mechanical reproductions printed on a high-speed lithographic press.

OUTWARD BOUND (LOOKING OUT TO SEA)	28x22
MARRIAGE LICENSE	21x28
RAINED OUT	21x28
SHUFFLETON'S BARBER SHOP	21x28
SILVER SLIPPER	21x28
TATTOO ARTIST	21x28

THE CORNER HOUSE EDITIONS

As was discussed on page 11 Rockwell affixed his autograph to many reproductions as a way to aid the Old Corner House in raising funds for the cost of operation. Some editons of prints were done specially for them as well. The following is a partial list of both catagories by print title.

Audubon-Passenger Pigeon
County Agricultural Agent
Discovery-The Truth About Santa Claus
Doctor and Doll
Four Ages of Love Folio (4) Prints (4)

Four Freedoms Folio Prints (4)
Girl in The Mirror
Golden Rule
Marriage License
Moving Day
Music Hath Charms
Old Friends
Outward Bound (Looking Out to Sea)
Raleigh the Dog
The Runaway
Saturday's People
Saying Grace
Shuffleton's Barber Shop
Spring Flowers
Stockbridge in Summer
Stockbridge in Winter-(Christmas in Stockbridge)
The Texan
Three Boys Fishing
Top of the World
Wet Paint
You Gotta Be Kidding

THE ETTINGER PRINT COLLECTION

It was in 1975 that the Eleanor Ettinger Company, publishers and distributors of fine art prints began publishing Rockwell works. Although they have produced some collotypes the first several prints and many subsequent prints were printed by stone lithography (see pages 10 to 12). In all by the end of 1980 there will have been some forty prints to total. Forty of them are listed here and it is not known if the collection is complete at this writing. The editions of 295 are broken down into 200 in the regular edition, 60 artist proofs and thirty five artist's proofs numbered in Roman numerals. There are some prints that were rendered on japon paper in a deluxe edition numbering 25.

First Airplane Ride, A 12-color lithograph. The edition is limited to 260 impressions plus 35 reserved for the artist. 25 deluxe lithographs on Japon, measures 21"x26". Printed November 1976. Eleanor Ettinger Inc.

Title	Release Year	Edition	Medium	Size	Current Value
After Christmas	1979	295	L	20x26	$3100
After The Prom	*	295	L	21x27	$4000
After The Prom (Japon)	*	25	L	21x27	$4200
America Marches Ahead	1975	295	L	35x20	$1600
April Fool	1975	295	C	24x26	$5000
Back From Camp	1977	295	L	20x26	$2700
Ben Franklin	1976	295	L	20x26	$3800
Ben Franklin (Japon)	1976	25	L	20x26	$4000
Boy On Stilts	1977	295	L	24x31	$2400
Buttercup	1976	295	L	21x24	$3400
Can't Wait	1978	295	L	20x26	$3200
Catching The Big One	1978	295	L	26x34	$2900
Catching The Big One (Japon)	1978	25			
Catching The Big One (Japon)	1978	25	L	26x34	$3150
Chairwoman, The	1976	295	C	25x31	$4000
Child's Surprise	1978	295	L	20x26	$3600
Colonial Sign Painter	1975	295	L	35x23	$3900
Connoisseur, The	1980	295	L	*	$5000
Convention	1976	295	C	25x31	$2500
Dreams Of Long Ago	1977	295	L	20x26	$5500
Dreams Of Long Ago (Japon)	1977	25	L	20x26	$5700
Extra Good Boys And Girls	1976	295	L	24x31	$3300
Extra Good Boys And Girls (Japon)	1976	25	L	24x31	$3500
First Airplane Ride	1977	295	L	21x26	$3200
First Airplane Ride (Japon)	1977	25	L	21x26	$3400
Football Hero	1976	295	L	21x27	$2100
Football Hero (Japon)	1976	25			
Football Hero (Japon)	1976	25	L	21x27	$2250
Gilding The Eagle	1976	295	L	20x26	$3000
Gilding The Eagle (Japon)	1976	25	L	20x26	$3300

Records Incomplete.

173

Title	Release Year	Edition	Medium	Size	Current Value
Hayseed Critic	1977	295	L	20x26	$2550
Hayseed Critic (Japon)	1977	25	L	21x27	$2800
Horse Shoe Contest	*		C	*	$8300
Jester, The	1977	295	L	20x26	$2150
Jester, The (Japon)	1977	25	L	20x26	$2350
Law Student	1977	295	L	24x33	$3800
Law Student (Japon)	1977	25	L	24x33	$4000
Muggelton Stage Coach	1980	295	L	*	$2700
Muggelton Stage Coach (Japon)	1980	295	L	*	$2900
Racer	1976	295	L	24x29	$2300
Racer (Japon)	1976	25	L	24x29	$2400
Rejected Suitor	1977	295	L	21x26	$2550
Rejected Suitor (Japon)	1977	25	L	21x26	$2800
Rivals, The	1975	295	L	20x26	$3550
She's My Baby	1977	295	L	23x31	$2500
She's My Baby (Japon)	1977	25	L	23x31	$2700
Swing, The	1976	295	L	20x21	$3300
Swing, The (Japon)	1976	25	L	20x21	$3600
Three Boys Fishing	1975	295	C	23x33	$2350
Top Hat And Tails	1976	295	L	28x34	$6250
Voyager	1978	295	C	25x32	$6000
Wind Up, The	1978	295	L	23x29	$3200
Wind Up, The (Japon)	1978	25	L	23x29	$3600
Young Lincoln	1977	295	L	19x34	$9500
Young Lincoln (Japon)	1977	25	L	19x34	$10,000
Young Spooners	1977	295	L	20x24	$4000
Young Spooners (Japon)	1977	295	L	20x24	$4250
Puppy Love Folio* [4]	1976	295	L		$10,000

Love At First Sight
Love Pact
Love's Little Treasures
Measure Of Love

Records Incomplete

**There is another edition of these four prints on Japon. Limited to 25 folios, the value is about $500 higher.*

Puppy Love, a suite of four lithographs. 12-color lithographs, suites are limited to 260 impressions plus 35 reserved for the artist. There are 25 deluxe portfolios on Japon paper. Each measures 20"x21½", hand printed, 1975. Eleanor Ettinger Inc.

DAVE GROSSMAN DESIGNS PRINT COLLECTION

These prints are all numbered limited edition issues of 1000 copies each. They are posthumous releases hence not hand-signed by Rockwell. They are fine quality reproductions in full color. The last to be released (Holiday in Karachi) is particularly interesting in that the company reproduced the painting including the margins with Rockwells personal notations regarding some details within the work itself. The prints are listed on the following page.

On The Ice, Dave Grossman Designs.

Pals. Dave Grossman Designs.

Come On In, Dave Grossman Designs.

Title	Issue Year	Size	Source	Current Value
Pals	1978	20x27	Country Gentlemen Cover	$125
Bringing Home The Tree	1978	20x27	Country Gentlemen Cover	$125
On The Ice	1979	20x27	Country Gentlemen Cover	$100
Come On In	1979	20x27	Country Gentlemen Cover	$100
Holiday In Karachi	1980	30x24	Original painting	$125

THE HEARTHSTONE COLLECTION

Presented by the Norman Rockwell Collection of Legendary Art introduced this limited edition series through Lynell in 1980. The total edition is limited to 5000 prints. Each of the four prints in this first offering is 20"x24". They were issued at $100 the set and are still selling at about the same. The prints are:

The Toy Maker	S.E.P. Cover-Nov. 20, 1920
A Hopeless Case	S.E.P. Cover-Jan. 23, 1923
The Artist's Daughter	S.E.P. Cover-Sept. 23, 1922
The Shoe Maker	S.E.P. Cover-Apr. 30, 1921

THE JOHN F. KENNEDY PORTRAIT

In 1977 American Heritage Graphics, American Banknote Company (printers) and the owner of the original Saturday Evening Post cover painting collaborated in the production of 2550 photo-lithographic reproductions of it. The painting had appeared three separate times* as a Post cover.

238 copies of this print were sold to the Old Corner House (see page 171) and Rockwell signed each in pencil. They are not numbered. The signed prints are now selling in excess of $2500 and the remaining 2300 unsigned versions can be found for $150-$175 were signed by Rockwell are listed following: #1, #4, #6, #100 through #299 and #1900 through 1924.

THE UPJOHN PRINT COLLECTION
Medical Profession Prints

The Upjohn Company has initiated a series of Rockwell prints published in limited edition. The prints reproduce six different paintings depicting the medical profession. The originals are owned by the company. They

*First in 1960.

are limited to 950 copies further broken down into 200 printed on 100% rag paper and the remaining 750 on a slightly lower quality but still good paper. The overall size of each print is 16"x24". The release price for the deluxe edition was $200 the set and the others were released at $100 the set. Both are still selling at about the same.

Family Prescription	He's Going To Be Taller Than Dad
Getting Better	Boy Looking at His Muscles in Mirror
Doctor and Doll	Mother, Father and New Baby

SECTION X

MAGAZINE COVER
ILLUSTRATIONS

Just about anyone knows of the Rockwell illustrated covers for the Saturday Evening Post. He actually painted 321* covers from 1916 to 1963. He painted covers for dozens of other magazines also: some well known, some obscure, and most now defunct.

In the pages following is a listing of most of them. It cannot yet be said that any list is complete with the exception of the Country Gentlemen and Saturday Evening Post covers. They have each been thoroughly researched by others. The lists are growing every day and at the moment it is thought that Rockwell did work that appeared on the covers of at least eighty different magazines.

The majority of the illustrations accompanying the lists here are from the collection of Robert E. Wale. They are not complete but serve to present a good representative sampling

Robert E. Wale is the Southern Region Director for the Norman Rockwell National Convention and was instrumental in the development of The Official Norman Rockwell Convention Paper Grading Standards (ONRCPGS). They system was designed to give collectors a common method of determining conditions of Rockwell illustrations reproduced on the covers of and within magazines, etc.

It is reprinted** here in the interest of furthering the use of this needed standardization of grading.

*Some say the number is 323, but one of them was a cove that reproduced nine of his previous covers and another [December 14, 1960] was a repeat of the October 29, 1960 Kennedy portrait cover with a black perimeter.

**Copyright 1980, The Norman Rockwell National Convention, Riviera Beach, Fla. and used with their permission.

This system of grading employs five (5) classifications. The classifications are: MINT, EXCELLENT, GOOD, FAIR & POOR. Denoted when grading by a capital M, E, G, F, or P. A plus (+) symbol after the letter will indicate the grade is better than the symbol given, but does not reach the next classification.

To grade a magazine reproduction MINT (M), it must appear like a new print, absolutely no flaws.

Special note for the MINT classification. The aging of a cover, in itself will cause a slight variation in color to the cover especially the white part of the pre 1940 covers, which will gradually turn a grayish white. This will not keep the cover from being graded MINT. However, brown spotting will reduce the cover in grade. With regard to the above, the new a cover is in date, the more rigid the requirements for obtaining the MINT classification.

To grade a magazine reproduction GOOD (G), the overall appearance of the cover or illustration is very nice. There may be minor repairs to margin tears from the back of the cover, absolutely no tape on front of cover. There may be minor margin trimming, but no trimming into words, logo's or picture. There is to be no noticeable water stain or fading. There may be average brown spotting.

To grade a magazine reproduction FAIR (F), the overall appearance of the cover or illustration must be good, but there may be minor water stain or fading. There may be some restoration work done to the print. Margin trimming may be close. A cover with minor restoration may be graded good if the overall appearance of the cover from the front is excellent. A cover or illustration with major restoration must be graded not better than fair. Factors other than restoration may reduce the grade to poor.

Library stamps and mailing labels do not affect the grading system. As a collector you may or may not want covers with these. The average price, whether a magazine is complete or just the cover illustration, is about the same. Here again it is a matter of personal preference.

The values listed with each of the covers and interior illustrations are not broken down by this system. The ranges presented are for Good to Mint condition items.

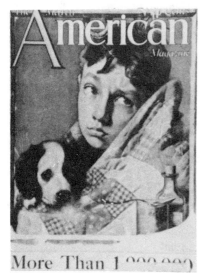

March 1923.

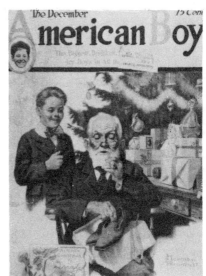

December 1917.

February 1933.

February 1932.

Magazine Name	Value Range	Cover Date
AMERICAN	$5-15.00	1918 November
		1919 April
		July
		1921 May
		October
		1922 February
		March
AMERICAN ARTIST	$4-12.00	1964 September
		1976 July
AMERICAN BOY	$10-25.00	1916 December
		1917 June
		July
		December
		1920 April
		December
AMERICAN LEGION	$2-4.00	1978 July
AMERICAN WEEKLY	$2-4.00	1951 February 25
ARGOSY	$2-3.00	1974 November

BOYS LIFE: Value range: $6 to $65.

Cover Date	Cover Date	Cover Date
1913 September	1929 February	1951 February
October	1931 February	1952 February
November	1932 February	1953 February
December	1933 February	1955 February
1914 January	1934 April	1956 February
February	1935 February	1957 June
March	July	1958 February
April	1936 February	1959 February
June	1937 February	*1960 January
December	1938 February	1961 February
1915 May	1939 February	1961 February
August	1940 February	1963 February
1919 February	1941 February	1964 February
July	1942 February	1965 February
August	1944 February	1971 March
1921 July	1947 February	
1926 February	1948 February	
1927 February	1950 February	

COLLIER'S	$6-20.00	1919 March 1
		March 29
		April 19
		June 28

This is a composite cover made up of 12 of Rockwell's previous Boy's Life covers.

182

March 1971.

April 1934.

April 19, 1919.

March 29, 1919

COUNTRY GENTLEMEN: Value range $7 to $50.

Cover Date	Cover Date
1917 August 25	1920 February 7
September 8	February 28
October 6	May 8
November 3	May 15
November 17	June 19
December 1	July 31
December 22	December 18
1918 January 19	1921 February 19
February 9	April 23
April 6	June 4
1919 April 26	June 4
May 3	July 2
June 14	October 22
June 14	November 19
June 21	December 17
August 16	1922 March 18
November 15	April 29
December 27	

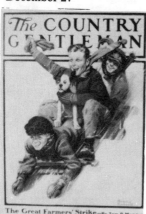

The Great Farmers' Strike—By Tom P. Morgan

December 27, 1919.

Beginning A Big Country Bank Series—By Herbert Quick

February 7, 1920.

Magazine Name	Value Range	Cover Date
ELKS	$10-20.00	1922 December
		1928 July
EVERYLAND	$3-6.00	1916 October
FAMILY CIRCLE	$5-8.00	1967 December
		1968 December
FARM AND FIRESIDE	$10-20.00	1918 May
		1919 April
		May
		October
		December
FISK CLUB NEWS	$8-15.00	1917 May
FORD TIMES	$5-7.00	1953 July
JACK AND JILL	$2-4.00	1974 December

184

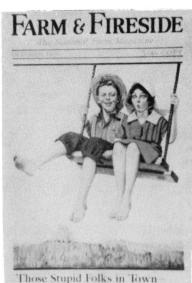

October 1919.

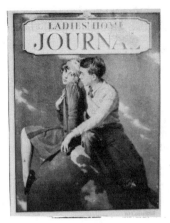

April 1928.

April 1932.

March 30, 1918.

Magazine Name	Value Range	Cover Date
JAMA (Journal of the American Medical Association)	$2-3.00	1973 August
JOURNAL OF THE AMERICAN OPTOMETRIC	$2-3.00	1972 April
JUDGE	$4-12.00	1917 January 13
		July 7
		1918 February 19
		May 25
		June 1
		August 10

Magazine Name	Value Range	Cover Date
LADIES' HOME JOURNAL	$8-15.00	1928 April
		1932 April
LESLIE'S	$10-60.00	1916 October 5
		1917 January 11
		February 1
		1918 March 30
		1919 March 22

LIFE Value range: $10 to $45.

Cover Date	Cover Date
1917 May 10	1919 March 13
August 9	April 10
November 8	1920 January 8
November 22	February 5
1918 January 31	July 1
April 18	August 12
May 30	November 11
June 13	December 16
June 27	1921 November 17
August 15	1922 March 23
September 26	June 1
November 7	1923 August 23
November 28	November 22
December 19	1924 November 26

The 2nd **Literary Digest** cover, November 9, 1918. March 26, 1921.

July 29, 1922.

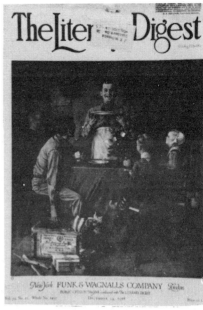

The 3rd **Literary Digest** cover, December 14, 1918.

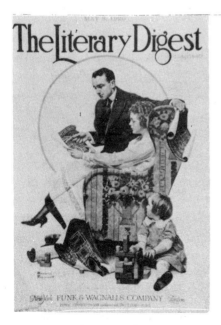

May 8, 1920.

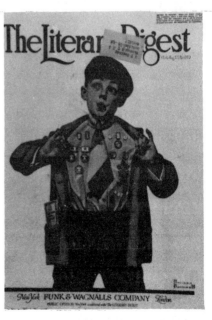

August 17, 1918: the earliest cover.

LITERARY DIGEST Value range: $8 to $25.

Cover Date	Cover Date	Cover Date
1918 August 17	1920 August 14	1922 February 25
November 9	September 4	March 25
December 14	November 6	April 15
1919 February 8	November 20	May 27
March 1	December 18	June 24
April 19	1921 January 29	July 29
June 14	February 26	September 23
July 26	March 26	October 28
September 6	April 30	December 2
September 20	May 28	1923 January 13
November 22	June 25	March 31
December 20	July 30	July 28
1920 January 17	August 27	November 17
February 21	September 24	December 22
May 8	October 22	
July 3	November 26	
	December 24	

December 18, 1920.

June 25, 1921.

Magazine Name	Value Range	Cover Date
LOOK	$3-5.00	1964 July 14
		1966 June 14
MCCALL'S	$8-10.00	1964 December
MODERN MEDICINE	$2-4.00	1976 January 1
NEWSWEEK	$2-4.00	1970 December 28
PARENTS	$5-9.00	1939 January
		1951 May

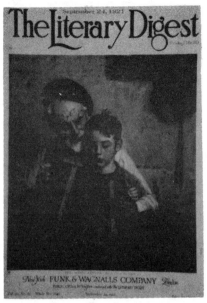

September 24, 1921.

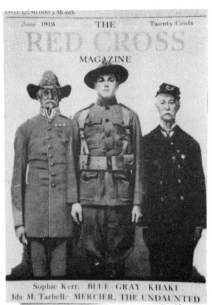

The Red Cross Magazine, June 1918.

Magazine Name	Value Range	Cover Date
THE PEOPLE'S MONTHLY	$10-20.00	1917 May
		June
		December
POPULAR SCIENCE	$10-15.00	1920 October
		1921 April
PUBLISHER'S WEEKLY	$2-3.00	1970 May 4
		1979 March 26
RAMPARTS	$8-12.00	1967 May
RECREATION	$5-10.00	1915 January
		1916 May
		1917 September
THE RED CROSS MAGAZINE	$10-20.00	1918 April
		June
		1919 July
		1920 March
ST. NICHOLAS	$15-30.00	1915 October
		November
		1916 January
		1918 August
		1919 August

SATURDAY EVENING POST

Cover Date	Value Range	Cover Date	Value Range
1916 May 20	$200-550.00	October 14	$60-90.00
June 3	$75-120.00	December 9	$60-100.00
August 5	$70-110.00	1917 January 13	$55-85.00
September 16	$75-110.00	May 12	$55-95.00

THE EMPIRE BUILDERS—By Mary Roberts Rinehart

May 20, 1916

June 3, 1916

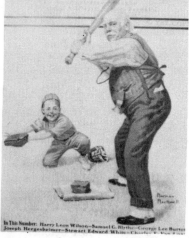

In This Number: Harry Leon Wilson—Samuel G. Blythe—George Lee Burton
Joseph Hergesheimer—Stewart Edward White—Charles J. Van Loan

August 5, 1916

Beginning
PICCADILLY JIM—By Pelham Grenville Wodehouse

September 16, 1916

Cover Date	Value Range
June 16	$50-90.00
October 27	$60-105.00
1918 January 26	$45-85.00
May 18	$40-75.00
August 10	$35-70.00
September 21	$40-80.00
1919 January 18	$45-75.00
February 22	$45-70.00

Cover Date	Value Range
March 22	$35-50.00
April 26	$35-60.00
June 14	$35-60.00
June 28	$50-85.00
August 9	$35-55.00
September 6	$30-50.00
September 20	$45-75.00
October 4	$30-65.00

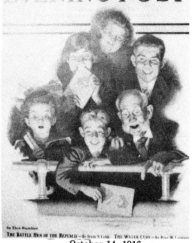

October 14, 1916

December 9, 1916

January 13, 1917

May 12, 1917

Cover Date		Value Range
	December 2	$35-60.00
1920	January 17	$40-70.00
	February 7	$30-70.00
	March 27	$20-55.00
	May 1	$25-50.00
	May 15	$40-65.00
	June 19	$30-60.00
	July 31	$25-50.00

Cover Date		Value Range
	August 28	$30-55.00
	October 9	$30-60.00
	October 23	$30-60.00
	December 4	$45-85.00
1921	January 29	$30-60.00
	March 12	$30-60.00
	June 4	$30-50.00
	July 9	$30-50.00

June 16, 1917

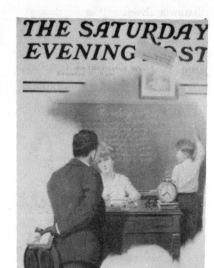

FOLLOWING THE RED CROSS—By Elizabeth Frazer

October 27, 1917

January 26, 1918

May 18, 1918

Cover Date	Value Range
August 13	$25-45.00
October 1	$30-50.00
December 3	$45-75.00
1922 January 14	$30-55.00
February 18	$40-80.00
April 8	$30-50.00
April 29	$20-50.00
May 20	$30-55.00

Cover Date	Value Range
June 10	$20-55.00
August 19	$20-45.00
September 9	$20-45.00
November 4	$15-40.00
December 2	$75-120.00
1923 February 3	$50-85.00
March 10	$40-65.00
April 28	$25-50.00

August 10, 1918

THE ZERO HOUR – By GEORGE PATTULLO

September 21, 1918

January 18, 1919

So This is Germany – By George Pattullo

February 22, 1919

Cover Date	Value Range
May 26	$45-80.00
June 23	$25-50.00
August 18	$40-65.00
September 8	$25-50.00
November 10	$25-50.00
December 8	$35-90.00
1924 March 1	$30-55.00
April 5	$25-50.00

Cover Date	Value Range
May 3	$35-75.00
June 7	$20-45.00
June 14	$25-50.00
July 19	$25-50.00
August 30	$15-40.00
September 27	$20-45.00
October 18	$55-110.00
November 8	$20-45.00

March 22, 1919

April 26, 1919

June 14, 1919

June 28, 1919

Cover Date	Value Range
December 6	$45-90.00
1925 January 31	$25-55.00
April 18	$20-45.00
May 16	$25-50.00
June 27	$20-45.00
July 11	$20-45.00
August 29	$20-45.00
September 19	$20-45.00

Cover Date	Value Range
November 21	$40-80.00
December 5	$40-90.00
1926 January 9	$40-55.00
February 6	$65-125.00
March 27	$20-45.00
April 24	$40-90.00
May 29	$30-65.00
June 26	$30-55.00

John J. Coincidence – By Irvin S. Cobb

August 9, 1919

September 6, 1919

Beginning The Peddler – By Henry C. Rowland

September 20, 1919

October 4, 1919

Cover Date	Value Range
August 14	$25-60.00
August 28	$30-65.00
October 2	$25-65.00
December 4	$25-55.00
1927 January 8	$45-80.00
February 19	$35-75.00
March 12	$25-55.00

Cover Date	Value Range
April 16	$25-60.00
June 4	$25-65.00
July 23	$25-55.00
August 13	$50-100.00
September 24	$20-45.00
October 22	$25-65.00
December 3	$20-55.00

December 2, 1919

January 17, 1920

February 7, 1920

March 27, 1920

Cover Date	Value Range
1928 January 21	$15-40.00
April 14	$30-60.00
May 5	$15-40.00
May 26	$35-65.00
June 23	$30-55.00
July 21	$20-45.00
August 18	$15-40.00

Cover Date	Value Range
September 22	$15-40.00
December 8	$25-55.00
1929 January 12	$20-45.00
February 16	$15-40.00
March 9	$200-500.00
April 20	$20-40.00
May 4	$20-40.00

May 1, 1920

May 15, 1920

June 19, 1920

July 31, 1920

Cover Date	Value Range
June 15	$15-40.00
July 13	$15-35.00
August 3	$30-60.00
September 28	$20-50.00
November 2	$25-45.00
December 7	$25-50.00
1930 January 18	$15-35.00

Cover Date	Value Range
March 22	$20-40.00
April 12	$15-35.00
May 24	$20-55.00
July 19	$25-55.00
August 23	$15-45.00
September 13	$20-45.00
November 8	$25-60.00

Saturday Evening Post continued

August 28, 1920

October 9, 1920

October 23, 1920

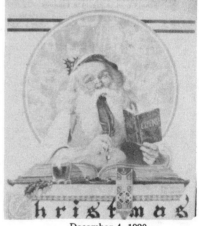

December 4, 1920

Cover Date	Value Range
December 6	$15-50.00
1931 January 31	$20-40.00
March 28	$20-45.00
April 18	$15-35.00
June 13	$20-45.00
July 25	$15-40.00
September 5	$20-55.00

Cover Date	Value Range
November 7	$10-30.00
December 12	$15-45.00
1932 January 30	$20-45.00
October 22	$20-45.00
December 10	$25-55.00
1933 April 8	$25-45.00
June 17	$15-35.00

January 29, 1921

March 12, 1921

June 4, 1921

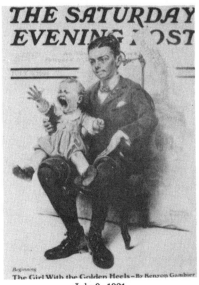

July 9, 1921

Cover Date	Value Range		Cover Date	Value Range
August 5	$15-45.00		June 30	$15-40.00
October 21	$10-35.00		September 22	$15-30.00
November 25	$20-45.00		November 20	$15-40.00
December 16	$35-75.00		December 15	$30-75.00
1934 March 17	$25-50.00		1935 February 9	$10-35.00
April 21	$15-35.00		March 9	$10-30.00
May 19	$10-30.00		April 27	$15-45.00

August 13, 1921

October 1, 1921

December 3, 1921

January 14, 1922

Cover Date	Value Range
July 13	$20-45.00
September 14	$15-35.00
November 16	$10-30.00
December 21	$30-60.00
1936 January 25	$30-85.00
March 7	$15-35.00
April 25	$15-30.00

Cover Date	Value Range
May 30	$30-60.00
July 11	$15-35.00
September 26	$20-50.00
October 24	$10-30.00
November 21	$10-30.00
December 19	$15-45.00
1937 January 23	$15-35.00

February 18, 1922

April 8, 1922

April 29, 1922

May 20, 1922

June 10, 1922

August 19, 1922

September 9, 1922

November 4, 1922

December 2, 1922

February 3, 1923

March 10, 1923

April 28, 1923

May 26, 1923

June 23, 1923

Cover Date	Value Range	Cover Date	Value Range
April 24	$15-35.00	June 4	$35-75.00
June 12	$10-30.00	October 8	$20-45.00
July 31	$20-40.00	November 19	$20-50.00
October 2	$15-30.00	December 17	$25-55.00
December 25	$15-45.00	1939 February 11	$20-50.00
1938 February 19	$15-35.00	March 18	$25-55.00
April 23	$20-50.00	April 29	$15-35.00

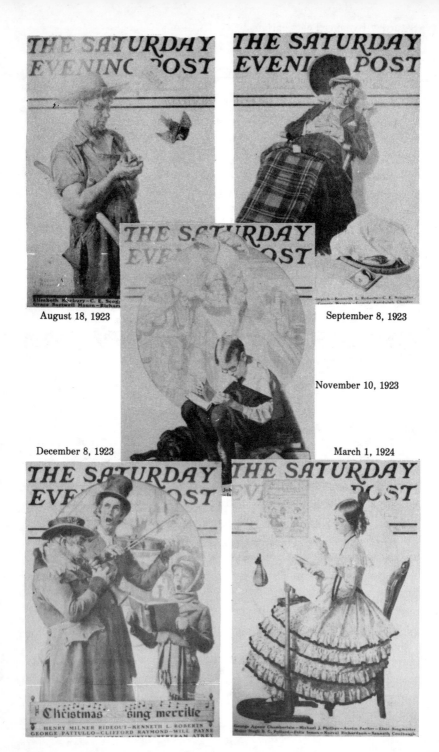

August 18, 1923

September 8, 1923

November 10, 1923

December 8, 1923

March 1, 1924

204

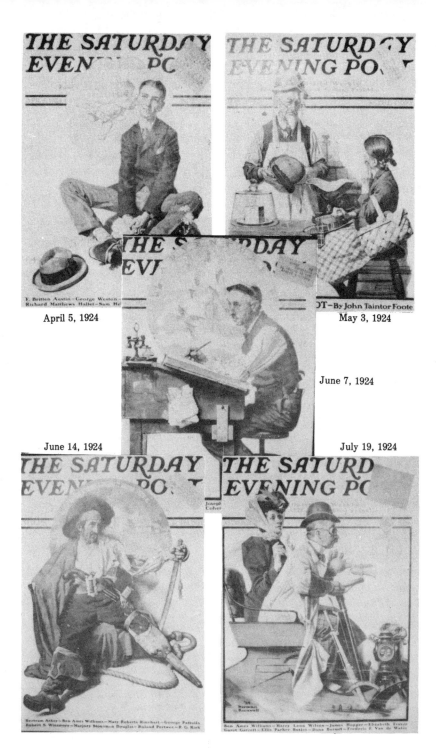

April 5, 1924

May 3, 1924

June 7, 1924

June 14, 1924

July 19, 1924

205

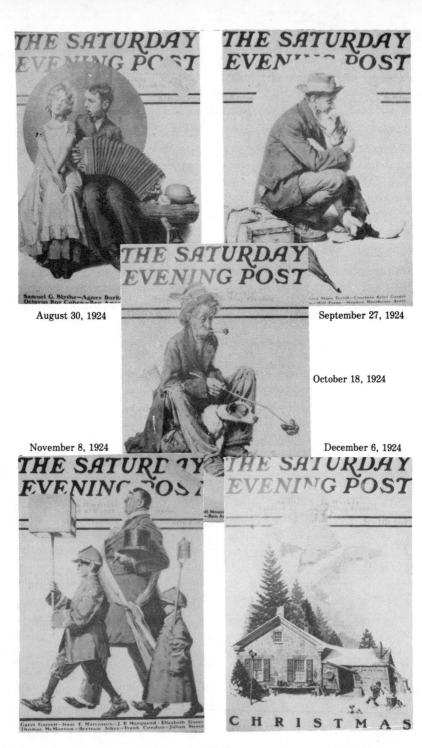

August 30, 1924

September 27, 1924

October 18, 1924

November 8, 1924

December 6, 1924

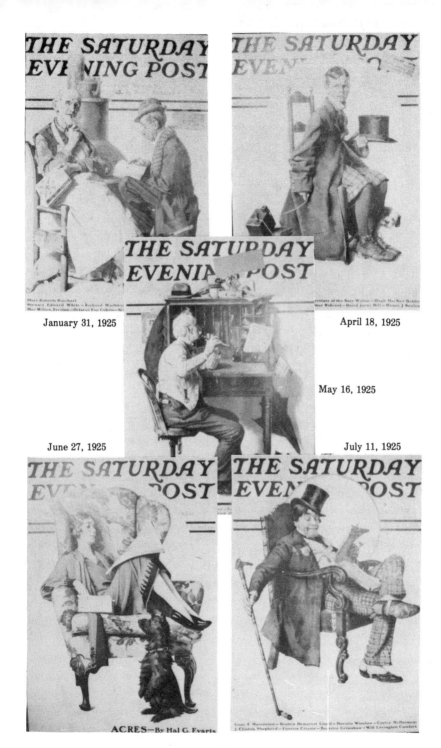

January 31, 1925

April 18, 1925

May 16, 1925

June 27, 1925

July 11, 1925

207

August 29, 1925

September 19, 1925

November 21, 1925

December 5, 1925

Cover Date	Value Range	Cover Date	Value Range
July 8	$25-65.00	July 13	$15-30.00
August 5	$20-45.00	August 24	$30-65.00
September 2	$15-45.00	November 30	$15-30.00
November 4	$15-35.00	December 28	$20-45.00
December 16	$40-90.00	1941 March 1	$40-70.00
1940 March 30	$15-25.00	May 3	$25-50.00
April 27	$15-30.00	July 26	$15-30.00
May 18	$20-45.00	October 4	$20-50.00

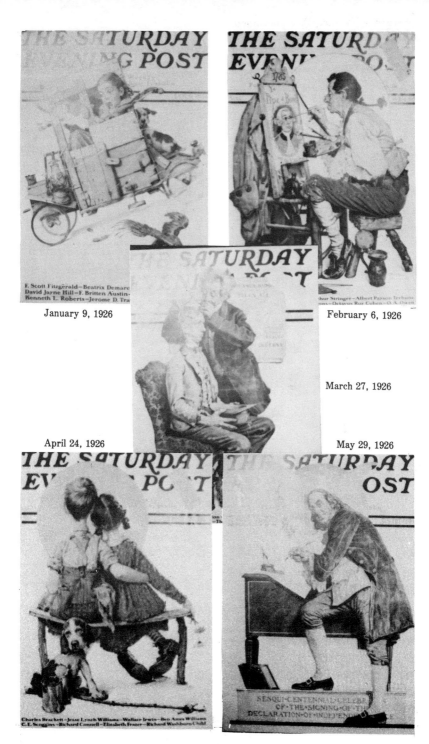

January 9, 1926

February 6, 1926

March 27, 1926

April 24, 1926

May 29, 1926

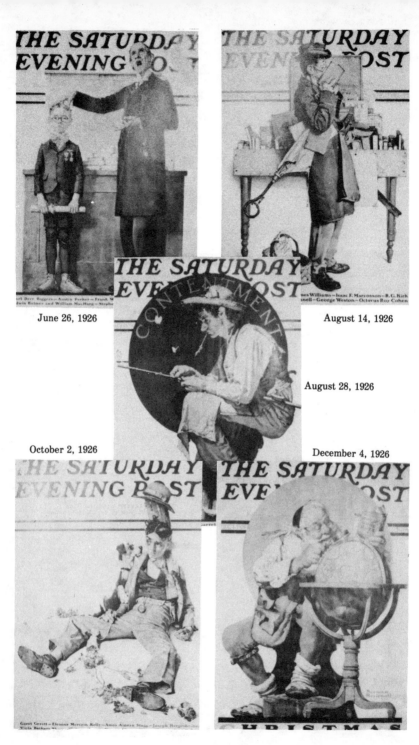

June 26, 1926

August 14, 1926

August 28, 1926

October 2, 1926

December 4, 1926

January 8, 1927

February 19, 1927

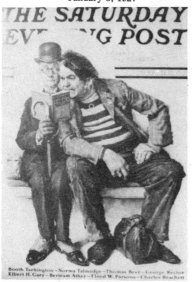

March 12, 1927

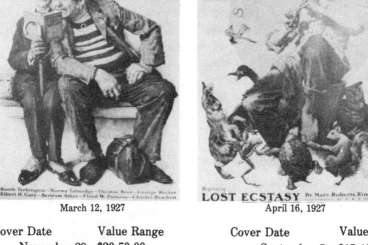

April 16, 1927

Cover Date	Value Range
November 29	$20-50.00
December 20	$15-35.00
1942 February 7	$20-50.00
March 21	$15-35.00
April 11	$20-50.00
June 27	$20-40.00
July 25	$25-55.00

Cover Date	Value Range
September 5	$15-40.00
November 28	$10-30.00
December 26	$30-60.00
1943 April 3	$30-70.00
May 29	$15-35.00
June 26	$20-45.00
September 4	$15-35.00

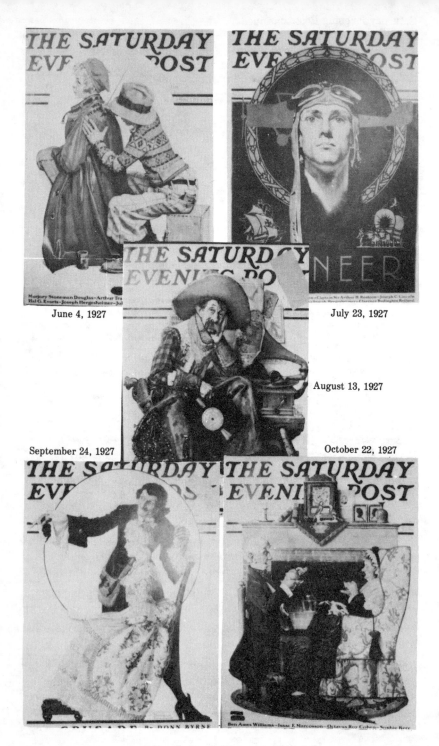

June 4, 1927

July 23, 1927

August 13, 1927

September 24, 1927

October 22, 1927

212

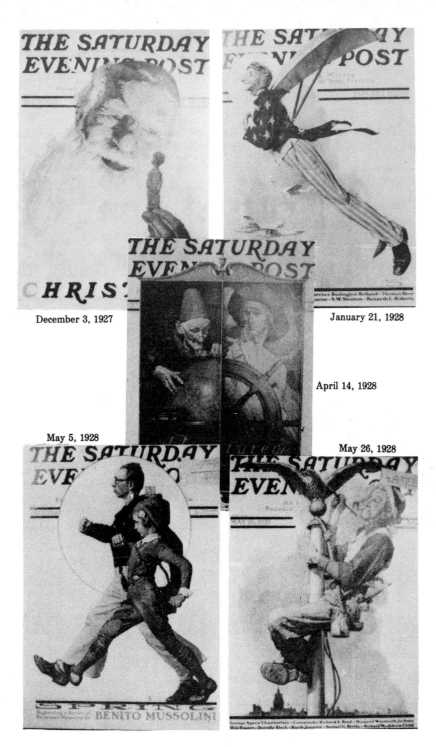

December 3, 1927

January 21, 1928

April 14, 1928

May 5, 1928

May 26, 1928

213

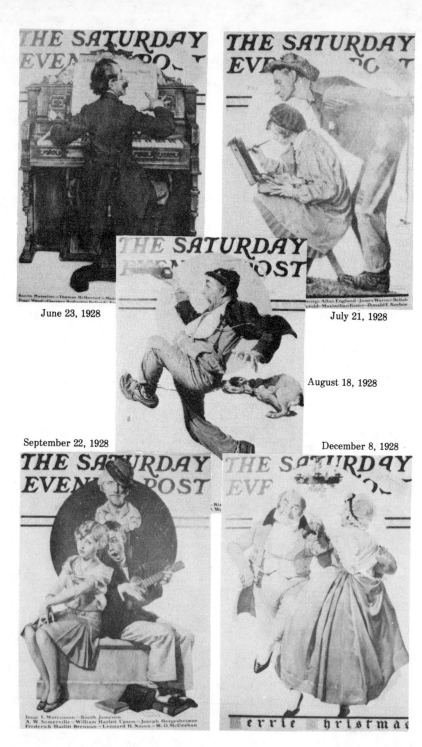

June 23, 1928

July 21, 1928

August 18, 1928

September 22, 1928

December 8, 1928

214

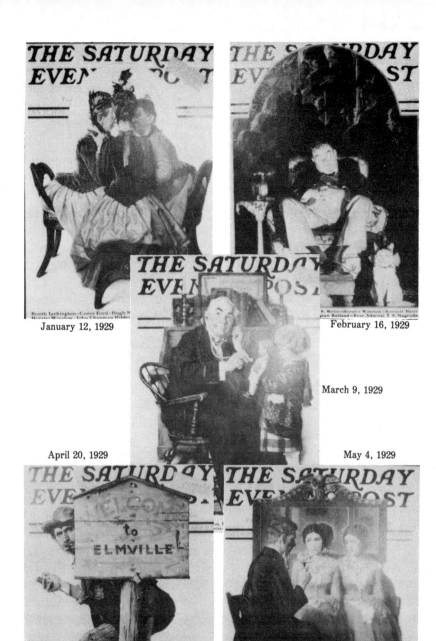

January 12, 1929

February 16, 1929

March 9, 1929

April 20, 1929

May 4, 1929

215

June 15, 1929

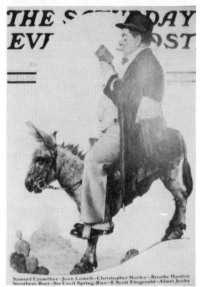

July 13, 1929

August 3, 1929

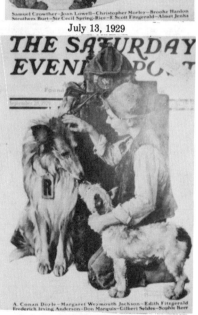

September 28, 1929

Cover Date	Value Range
November 27	$10-30.00
1944 January 1	$20-45.00
March 4	$15-35.00
April 29	$10-30.00
May 27	$10-30.00
July 1	$10-30.00
August 12	$10-30

Cover Date	Value Range
September 16	$25-55.00
November 4	$10-30.00
December 23	$15-35.00
1945 March 17	$10-30.00
March 31	$25-65.00
May 26	$50-100.00
August 11	$10-30.00

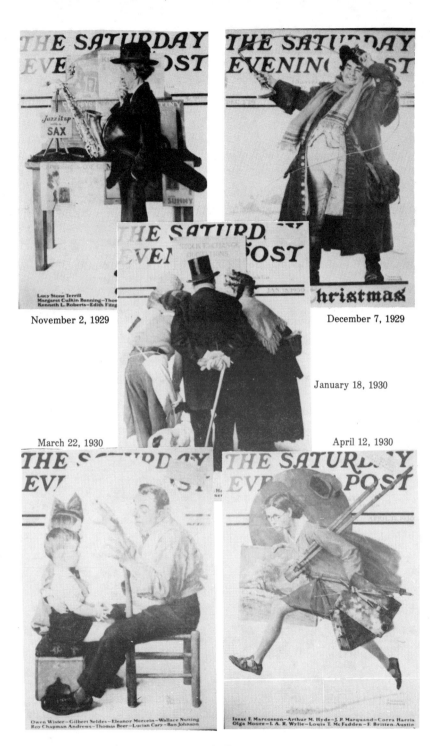

November 2, 1929

December 7, 1929

January 18, 1930

March 22, 1930

April 12, 1930

217

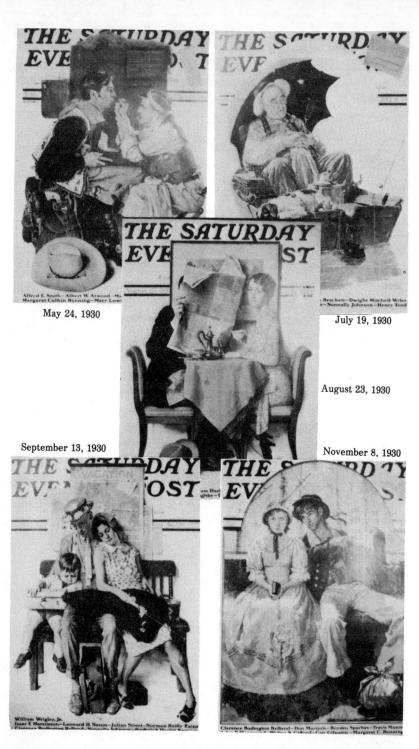

May 24, 1930

July 19, 1930

August 23, 1930

September 13, 1930

November 8, 1930

218

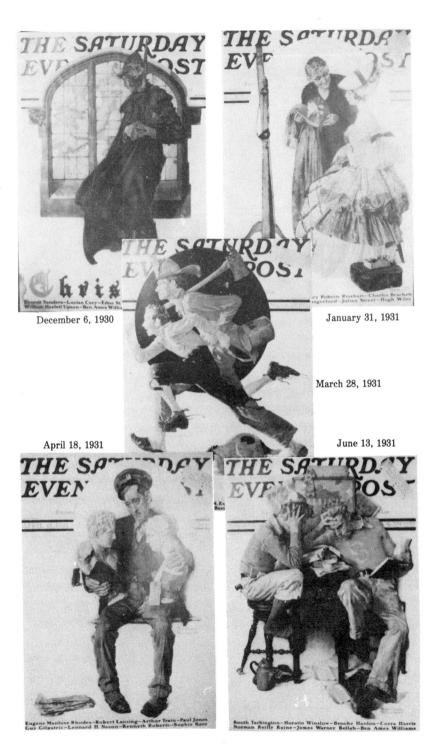

December 6, 1930

January 31, 1931

March 28, 1931

April 18, 1931

June 13, 1931

219

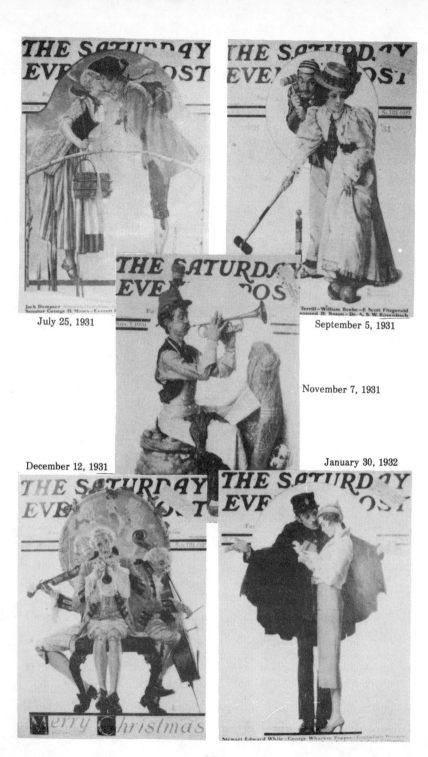

July 25, 1931

September 5, 1931

November 7, 1931

December 12, 1931

January 30, 1932

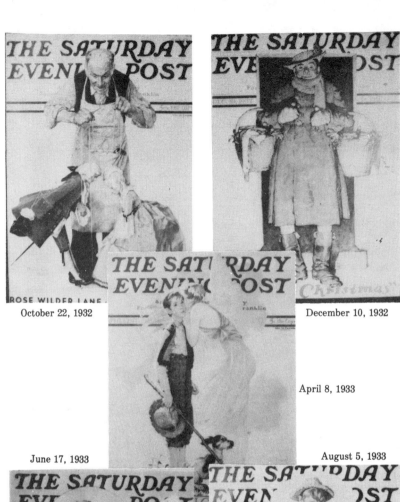

October 22, 1932

December 10, 1932

April 8, 1933

June 17, 1933

August 5, 1933

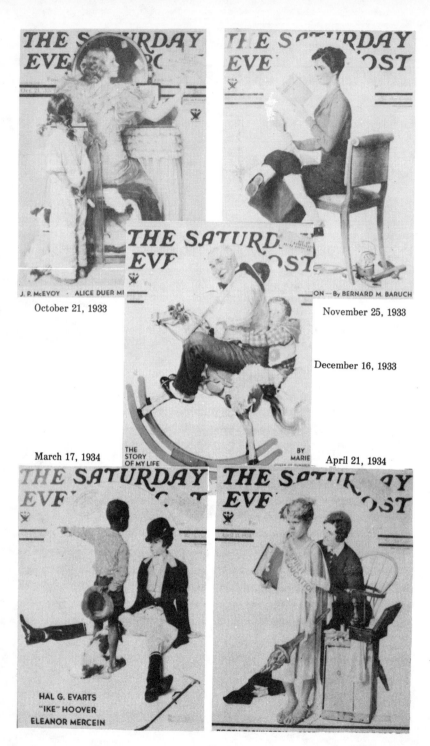

October 21, 1933

November 25, 1933

December 16, 1933

March 17, 1934

April 21, 1934

GARET GARRETT · ALICE DUER MILLER · WALTER EDMONDS

May 19, 1934

IN THIS NUMBER
GENERAL HUGH S. JOHNSON

June 30, 1934

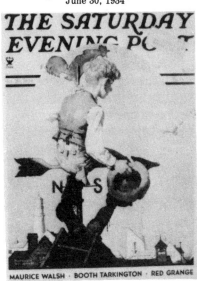

BEGINNING
IN THIS ISSUE
PITCAIRN'S
ISLAND

By JAMES NORMAN HALL AND CHARLES NORDHOFF

September 22, 1934

MAURICE WALSH · BOOTH TARKINGTON · RED GRANGE

November 20, 1934

Cover Date	Value Range	Cover Date	Value Range
September 15	$10-35.00	1946 March 2	$7-20.00
October 13	$35-70.00	April 6	$25-50.00
November 3	$10-25.00	July 6	$7-20.00
November 24	$10-25.00	August 3	$7-20.00
December 15	$10-30.00	October 5	$15-45.00
December 29	$10-25.00	November 16	$10-20.00

December 15, 1934

AGATHA CHRISTIE · JIM COLLINS · GENERAL JOHNSON

February 9, 1935

MANUEL KOMROFF · GILBERT SELDES · J. ROY STOCKTON

March 9, 1935

SPRINGTIME

JOHN TAINTOR FOOTE · GUY GILPATRIC · JOSEPH HERGESHEIMER

~ April 27, 1935

Cover Date	Value Range
December 7	$10-25.00
1947 January 11	$12-25.00
March 22	$8-20.00
May 3	$8-20.00
August 16	$8-20.00
August 30	$15-30.00

Cover Date	Value Range
November 8	$12-20.00
December 27	$12-25.00
1948 January 24	$8-15.00
March 6	$20-45.00
April 3	$25-55.00
May 15	$8-15.00

July 13, 1935

September 14, 1935

November 16, 1935

December 21, 1935

January 25, 1936

ROSE WILDER LANE

March 7, 1936

P. McEVOY · EDDIE CANTOR

April 25, 1936

May 30, 1936

July 11, 1936

September 26, 1936

JULY 11, 1936

5c. the Copy

BOOTH TARKINGTON · COREY FORD · PERCY MADEIRA

'OLLYWOOD ON THE THAMES—BY HENRY F. PRINGLE

THE DEVIL
AND DANIEL WEBSTER—BY

October 24, 1936

ES FRANCIS COE

November 21, 1936

December 19, 1936

January 23, 1937

April 24, 1937

EGINNING PADEREWSKI'S LIFE STORY

THE $47,000,000,000 BLIGHT—By SENATOR VANDENBERG

June 12, 1937

July 31, 1937

October 2, 1937

December 25, 1937

February 19, 1938

April 23, 1938

June 4, 1938

October 8, 1938

November 19, 1938

December 17, 1938

229

NOT SO FREE AIR—
February 11, 1939

March 18, 1939

April 29, 1939

July 8, 1939

August 5, 1939

BEGINNING
ESCAPE
A NOVEL OF TODAY'S REIGN OF TERROR

THE CRISIS IN CHRISTIANITY By WILL DURANT

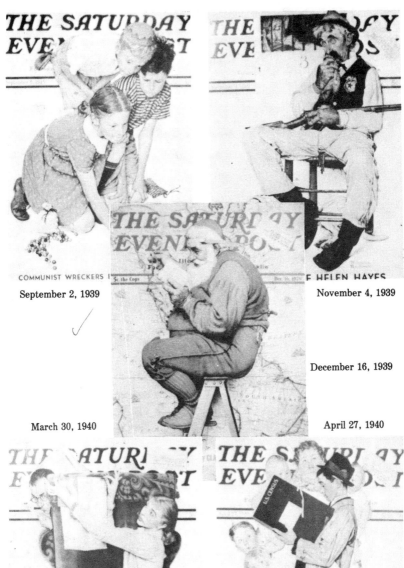

September 2, 1939

November 4, 1939

December 16, 1939

March 30, 1940

April 27, 1940

YOUNG AMES RETURNS SON By JACK ALEXANDER

May 18, 1940 July 13, 1940

August 24, 1940

November 30, 1940 December 28, 1940

March 1, 1941

May 3, 1941

July 26, 1941

October 4, 1941

Cover Date	Value Range		Cover Date	Value Range
September 4	$8-20.00		September 24	$10-20.00
October 30	$8-15.00		November 5	$10-20.00
December 25	$30-60.00		1950 April 29	$35-75.00
1949 March 19	$8-15.00		August 19	$10-20.00
April 23	$10-20.00		October 21	$10-20.00
July 9	$10-20.00		November 18	$10-25.00

November 29, 1941

December 20, 1941

February 7, 1942

March 21, 1942

April 11, 1942

234

June 27, 1942

July 25, 1942

September 5, 1942

November 28, 1942

December 26, 1942

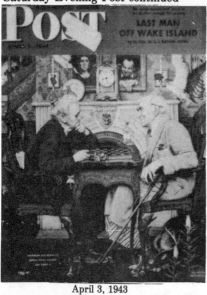

April 3, 1943

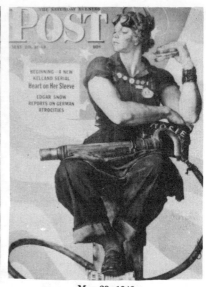

May 29, 1943

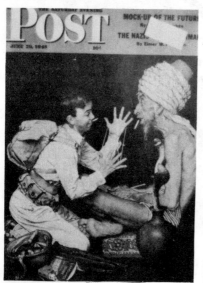

June 26, 1943

September 4, 1943

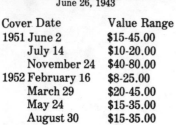

Cover Date		Value Range
1951	June 2	$15-45.00
	July 14	$10-20.00
	November 24	$40-80.00
1952	February 16	$8-25.00
	March 29	$20-45.00
	May 24	$15-35.00
	August 30	$15-35.00

Cover Date		Value Range
	October 11	$15-30.00
1953	January 3	$8-20.00
	April 4	$10-20.00
	May 23	$30-60.00
	August 22	$20-45.00
1954	January 9	$8-25.00
	February 13	$10-25.00

November 27, 1943

January 1, 1944

March 4, 1944

April 29, 1944

May 27, 1944

July 1, 1944

August 12, 1944

September 16, 1944

November 4, 1944

December 23, 1944

March 17, 1945 October 13, 1945

November 3, 1945

November 24, 1945 December 15, 1945

December 29, 1945

March 2, 1946

April 6, 1946

July 6, 1946

Cover Date	Value Range	Cover Date	Value Range
March 6	$45-90.00	August 20	$10-20.00
April 17	$8-15.00	1956 March 17	$15-30.00
August 21	$8-20.00	May 19	$12-20.00
September 25	$40-95.00	October 6	$10-20.00
1955 March 12	10-25.00	October 13	$10-20.00
April 16	$8-20.00	December 29	$25-65.00
June 11	$25-70.00	1957 March 2	$8-15.00

August 3, 1946

October 5, 1946

November 16, 1946

December 7, 1946

January 11, 1947

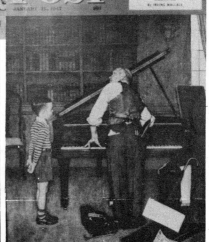

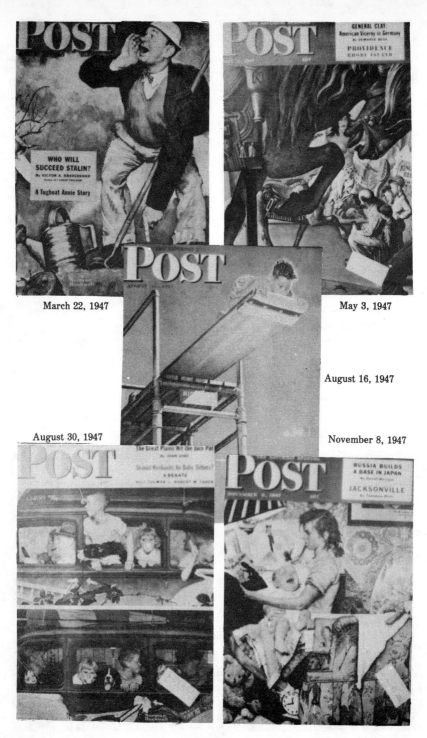

March 22, 1947

May 3, 1947

August 16, 1947

August 30, 1947

November 8, 1947

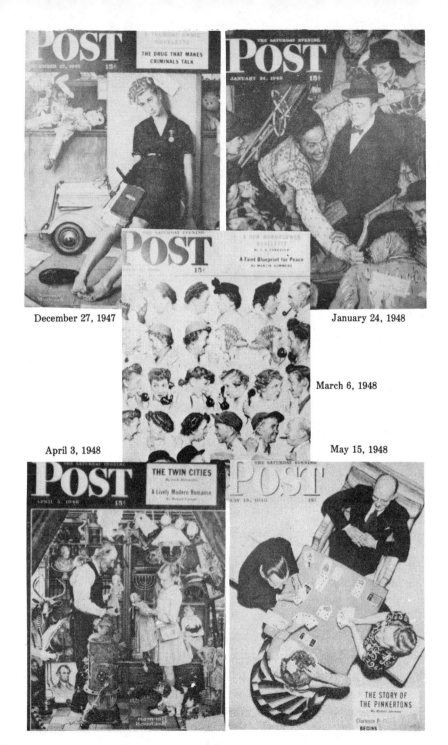

December 27, 1947

January 24, 1948

March 6, 1948

April 3, 1948

May 15, 1948

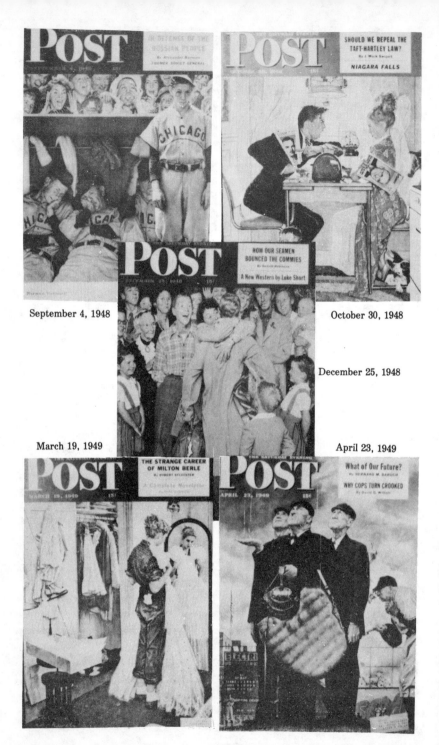

September 4, 1948

October 30, 1948

December 25, 1948

March 19, 1949

April 23, 1949

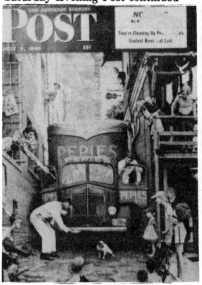

July 9, 1949

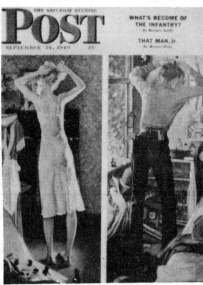

September 24, 1949

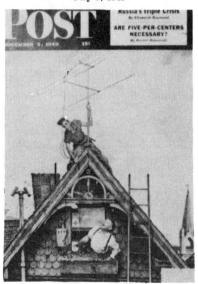

November 5, 1949

April 29, 1950

Cover Date	Value Range
May 25	$10-20.00
June 29	$15-40.00
September 7	$12-20.00
November 30	$8-15.00
1958 March 15	$20-55.00
June 28	$12-30.00
August 30	$6-12.00

Cover Date	Value Range
September 20	$15-35.00
November 8	$8-20.00
1959 February 14	$8-20.00
May 16	$12-25.00
June 6	$8-20.00
October 24	**$12-25.00**
1960 February 13	$20-55.00

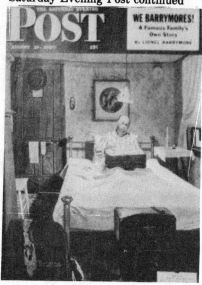

August 19, 1950

October 21, 1950

November 18, 1950

June 2, 1951

Cover Date	Value Range
April 16	$8-15.00
August 27	$6-12.00
September 17	$8-15.00
October 29	$8-20.00
November 5	$8-20.00
1961 March 1	$15-40.00
September 16	$6-12.00

Cover Date	Value Range
November 25	$8-15.00
1962 January 13	$8-15.00
November 3	$6-12.00
1963 January 19	$6-12.00
March 2	$5-12.00
April 6	$5-12.00
May 25	$4-10.00
December 14	$15-40.00

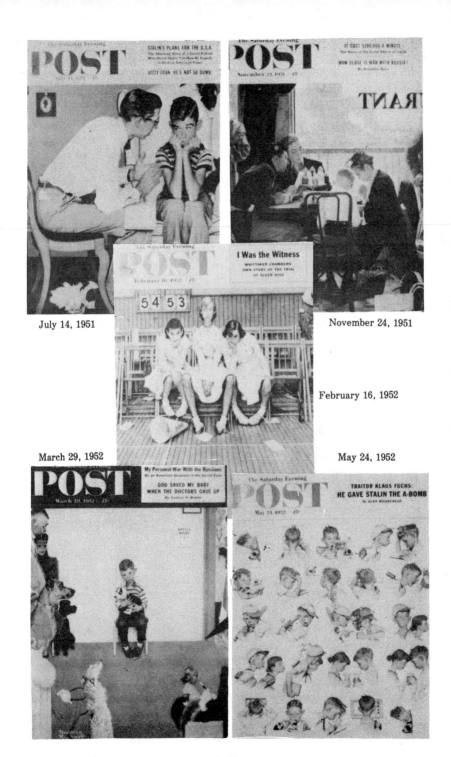

July 14, 1951

November 24, 1951

February 16, 1952

March 29, 1952

May 24, 1952

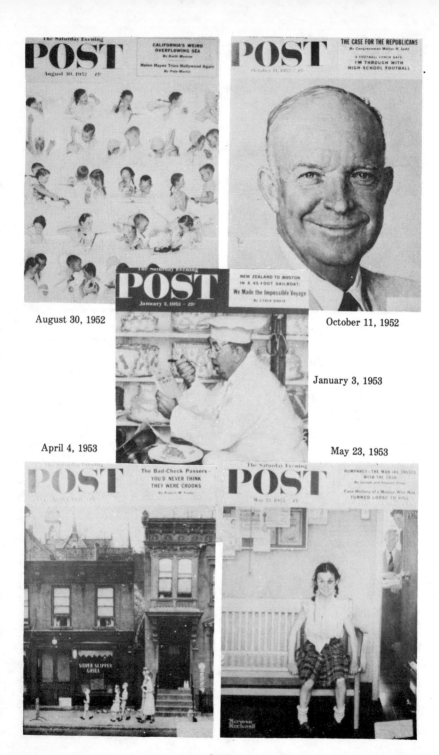

August 30, 1952

October 11, 1952

January 3, 1953

April 4, 1953

May 23, 1953

248

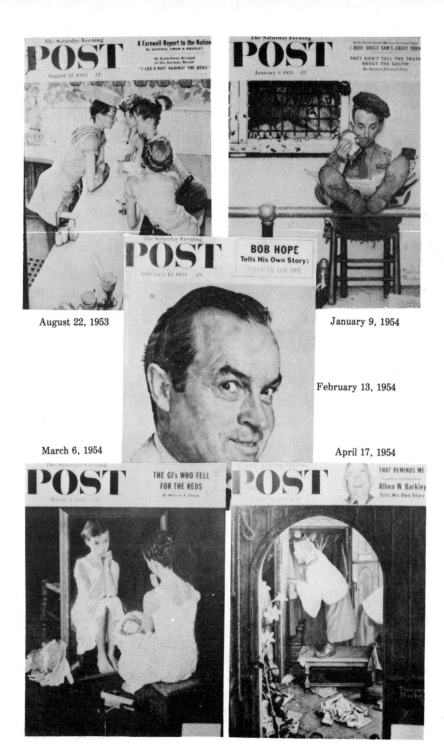

August 22, 1953

January 9, 1954

February 13, 1954

March 6, 1954

April 17, 1954

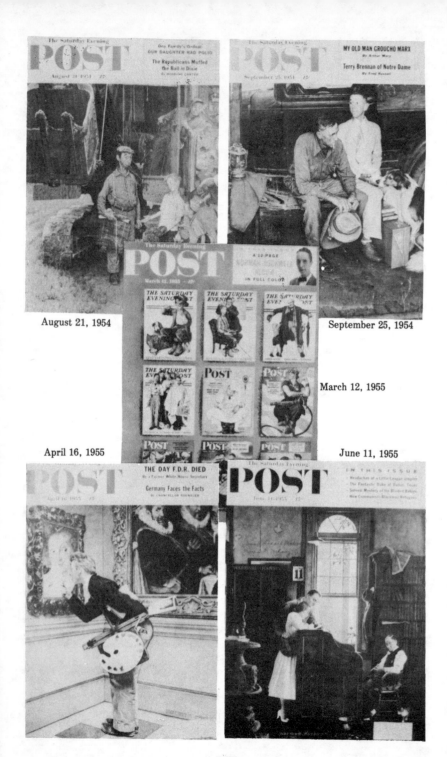

August 21, 1954

September 25, 1954

March 12, 1955

April 16, 1955

June 11, 1955

250

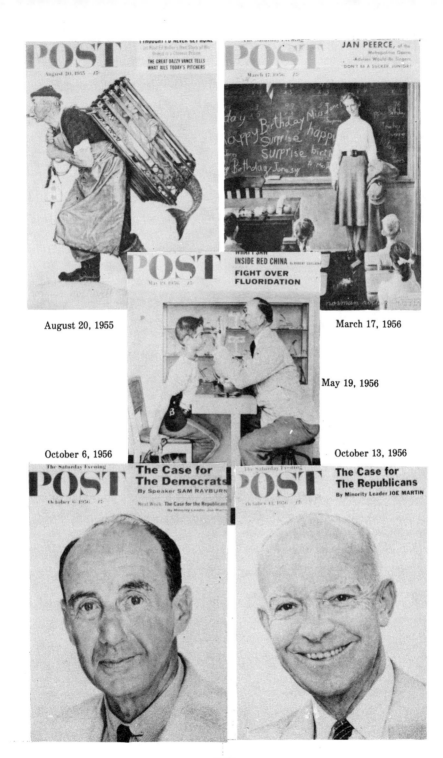

August 20, 1955

March 17, 1956

May 19, 1956

October 6, 1956

October 13, 1956

251

December 29, 1956

March 2, 1957

May 25, 1957

June 29, 1957

September 7, 1957

November 30, 1957

March 15, 1958

June 28, 1958

August 30, 1958

September 20, 1958

253

November 8, 1958

February 14, 1959

May 16, 1959

June 6, 1959

October 24, 1959

254

February 13, 1960

April 16, 1960

August 27, 1960

September 17, 1960

October 29, 1960

255

November 5, 1960

March 1, 1961

September 16, 1961

November 25, 1961

January 13, 1962

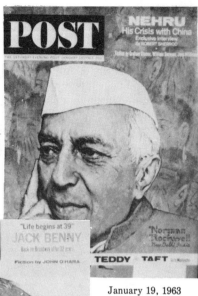

November 3, 1962

January 19, 1963

March 2, 1963

April 6, 1963

May 25, 1963

December 14, 1963

May 16, 1970

August 15, 1970

Magazine Name	Value Range	Cover Date
SCOUTING	$5-10.00	1930 May
		1934 February
		1936 January
		June
		1937 March
		1939 April
		1940 February
		1941 January
		1944 February
		December
		1948 September
		1953 October
		1959 December
		1963 February
		1967 July
		1968 February
		1969 January
THIS WEEK	$6-9.00	1935 September 1
		1936 February 23
		1937 July 18
		1947 December 27
TV GUIDE	$3-8.00	1955 January 8
		1970 May 16
		August 15

Magazine Name	Value Range	Cover Date
YANKEE	$6-8.00	1972 August
YOUTH'S COMPANION	$6-8.00	1916 February 24
		March 30
		1917 April 26
		July 26

SECTION XI

STORY, FEATURE, & ADVERTISING ILLUSTRATIONS

ILLUSTRATIONS PUBLISHED IN VARIOUS PERIODICALS

This listing is arranged alphabetically and in catagories by name of the publication. Where there is more than one issue containing an illustration they are listed chronologically. The list includes magazines, newspapers, Sunday supplements, private internal company publications, etc.

Several later issues of these publications do contain Rockwell work but they are advertisements offering various Rockwell collectibles ie., prints. They are not listed.

STORY, FEATURE, and ADVERTISIGN ILLUSTRATIONS

These are not broken down into publication type catagories for only a few were found outside this major group. They are therefore found in this first catagory in their appropriate alphabetical position.

The dates accompanying the name of the publication have no relation to the dates of the founding and demise, but rather are the inclusive dates (in present knowledge)

that Rockwell illustrations can be found in them. Also many companies used the same ad in different magazines so the list isn't quite as bad as it looks.

The value range refers to all illustrations that can be found within them. Where to place you illustration in that range is influenced by many factors. Among them are: artistic detail; size; condition; use of, or lack of color; date; condition, etc. The value range is for good to perfect condition and only a guide to get you in the ball park.

ADVERTISING ART 1933
A January 1933 advertising illustration for Listerine. Value range is $3 to $6.

AMERICAN 1918-1964
Value Range $2 to $10.

Story or Feature Illustration	Advertising Illustration	
1918 November	1921 January	U.S. Army
December	June	Lime Crush
1919 January	August	Lemon Crush
February	1922 January	Pratt and Lambert
1920 June	December	Pratt and Lambert
1921 May	1923 March	Jell-O
1934 May	December	Pratt and Lambert
1935 January	1924 May (2)	Pratt and Lambert
April		Colgate
1936 March	December	Pratt and Lambert
May	1925 June	Pratt and Lambert
June	August	Post Cereals
October	1926 July	Dutchess Trousers Co.
1937 May	October	Dutchess Trousers Co.
June	November	Dutchess Trousers Co.
July	1928 June	Coca-Cola
October	1929 December	Listerine
1938 July	1931 March	Listerine
August	1937 June	Beech-Nut
November	1939 August	General Motors
1939 April	1943 September	Listerine
July	1949 March	A.T.&T.
	1953 October	A.T.&T.

261

August	1940	May
October	1950	March
1940 February	1956	June
May	1970	Month Uknown
July	1971	December
November		
1941 January		
February		
March		
June		
September		
1942 March		
July		
December		
1947 May		
1964 September		
1964 September		

AMERICAN BOY 1916-1921
Value Range: $2 to $10.

Story or Feature Illustration	Advertising Illustrations	
1916 December*	1917 June*	Fisk
1917 February	August	Fisk
March	1918 May	Fisk
August (2)	1919 May	Fisk
1918 January	July	Fisk
February (2)	1920 April*	Goodrich
September	May	Fisk
	1921 June	Lemon Crush

AMERICAN COOKERY 1922
An October, 1922 advertising illustration for Jell-O
Value range: $3 to $5.

Also did the cover illustration for these issues.

AMERICAN HOME 1940
A December, 1940 advertising illustration for General Motors. Value range: $3 to $5.

AMERICAN LEGION 1920
A November 19, 1920 issue only. Advertising illustration for the U.S. Army. Value range: $3 to $8.

AMERICAN NEEDLEWOMAN 1923-1949
Only two illustrations are found in this magazine. They are advertising illustrations found one each in the December 1923 (Jell-O) and an issue in 1949 (A.T. and T.), month unknown. Value range: $5 to $8.

ATLANTIC MONTHLY 1923-1969
Value Range: $4 to $10.

Story or Feature Illustration	Advertising Illustration	
1969 November	1923 March	Romance Chocolates
	June	Love Brothers

BETTER HOMES AND GARDENS 1929-1974
Value range: $2 to $10.

Story or Feature Illustration	Advertising Illustration	
None found	1929 March	Anaconda
	April	Capitol Boilers
	December	Listerine
	1935 February	Listerine
	1950 December	DuMont
	1951 December	Plymouth
	1958 October	Crest
	1974 November	Crest

BETTER LIVING 1935
One issue only, March of 1935. Contains an illustration for Swift and company. Value range is from $4 to $8.
June

BOY'S LIFE 1913-1971*
Value range: $5 to $10.

Story or Feature Illustration	Advertising Illustrations	
1913 January	1917 February	Fisk
March	June	Fisk
May (2)	1918 May	Fisk
September (3)	July	Fisk
October (3)	1919 July	Fisk
November (3)	September	Fisk
December (4)	November	Kanee Shirts
1914 January (4)	1926 May	First Aid Week
February (3)	1929 January	Calendar ad.
March (3)	June	Coca-Cola
April (5)		
**May (3)		
June		
July (4)		
August (3)		
September (3)		
October (2)		
November		
December (3)		
1916 January		
February		
March (2)		
April (2)		
May		
June (2)		

CENTURY 1923
Advertising illustrations for Romance Chocolates appeared, one each in the March and April issues of 1923. Value range: $5 to $8.

*There were no advertising illustrations found in issues after 1929 or story illustrations after 1916. In the remaining years he did covers only for Boys Life although he did much other work for and about Boy Scouting.
**The first known photograph of Rockwell to be published in a magazine is in this issue also.

CHRISTIAN HERALD 1917-1924
Only advertising illustrations. Two appeared, a Fisk Rubber Co. ad in the July 4, 1917 issue and a Quaker Puffed Wheat ad in the April 19 issue. Value range: $4 to $9.

CLUES 1953
As far as is known the only illustration to appear in this magazine was for a story in the June, 1953 issue. Value range: $7 to $9.

Collier's, November 1940.

Collier's May 18, 1940.

COLLIER' 1924-1955
Value range: $4 to $10.

Story or Feature Illustration	Advertising Illustration	
Illustration	1924 March 22	Fisk
None	August 23	Fisk
	1929 August 31	Ticonderoga Pencil Co.

Also did a cover in 1937.

265

Collier's continued

1930	December 13	Brunswick
1932	July 30	Crowell
1935	May 4	Campbell Soups
1936	December 12	Cream of Kentucky
1937	January 5	Cream of Kentucky
	February 13	Cream of Kentucky
	March 13	Cream of Kentucky
	April 10	Cream of Kentucky
	May 8	Cream of Kentucky
	September 11	Cream of Kentucky
	October 9	Cream of Kentucky
	November 6	Cream of Kentucky
	December 4	Cream of Kentucky
*1938	February 5	Cream of Kentucky
	March 5	Cream of Kentucky
	April 2	Cream of Kentucky
	April 30	Cream of Kentucky
	June 25	Cream of Kentucky
	September 11	Cream of Kentucky
	October 15	Cream of Kentucky
	December 24	Cream of Kentucky
	February 25	Cream of Kentucky
	March 18	Cream of Kentucky
	April 22	Cream of Kentucky
	May 20	Cream of Kentucky
	June 17	Cream of Kentucky
1939	January 28	Cream of Kentucky
	July 22	Cream of Kentucky
	August 12	Cream of Kentucky
	September 9	Cream of Kentucky
	November 9	Cream of Kentucky
	December 2	Cream of Kentucky
	December 23	Cream of Kentucky
1940	February 24	Cream of Kentucky
	March 24	Cream of Kentucky
	April 20	Cream of Kentucky
	May 18	Cream of Kentucky
	June 15	Cream of Kentucky
	July 13	Cream of Kentucky

*1937 and 1938 may not be entirely accurate. References found were confused.

266

Collier's continued

	August 31	General Motors
	October 26	Wine Advisory Board
	November	General Motors
1941	June 14	Mobilgas
1945	October 20 (2)	Cream of Kentucky Listerine
1948	April 17	Cream of Kentucky
	June 12	Cream of Kentucky
	July 2	Cream of Kentucky
1949	March 5	A.T.&T.
1950	December 30	Plymouth
1951	December 29	Plymouth
1955	December 9	Sheaffer Pens

CORONET 1946-1955
Two illustrations have thus far been found; a story illustration in April 1946 and a Scheaffer Pen ad in December 1955. Value range: $3 to $9.

COSMOPOLITAN 1919-1937
Value range: $5 to $9.
Story or Feature
Illustration
None found

Advertising Illustration

1919	July	Post Cereal
1921	May	Orange Crush
	May	Lemon Crush
1928	June	Coca-Cola
1934	July	Budweiser
1937	May	Beech-Nut

267

COUNTRY GENTLEMEN 1917-1949
Value range: $4 to $8.

Story or Feature Illustration	Advertising Illustration	
1917 August 25	1922 March 18	Contest
1919 May 3	1923 March 3	Jell-O
1919 June 21	1925 October	Post Cereals
	November	Post Cereals
	1930 December	Goodyear
	1949 September	Watchmakers of Switzerland

COUNTRY LIFE 1924
Four Fisk Rubber Company ads have so far been found. They were in the May, July, September, and October issues of 1924. Value range: $4 to $7.

DELINEATOR 1918
One advertising illustration: Bordens condensed milk in May 1918 issue. Values are: $4 to $6.

ESQUIRE 1937-1962
Two illustrations. One Beech-Nut ad in May 1937 and a feature illustration, Nixon portrait, in January 1962. Value range: $4 to $12.

EVERYLAND 1913-1916
Value range: $5 to $12.

Story or Feature Illustration	Advertising Illustration
1913 December (2)	None found
1914 June (2)	
September	
December (2)	
1915 March (2)	
June	
September	
1916 October	
November	
December	

EVERYWOMAN'S 1956
One advertising illustration has been found in the April 1956 issue. Value range: $2 to $5.

FAMILY CIRCLE 1941-1968*
The March 21, 1941 issue had a Niblets Corn ad and the July 6, 1945 issue, a motion picture ad. Value range: $3 to $6.

FAMOUS ARTIST 1962
A 1962 issue has one ad for the Famous Artists School. Value range: $2 to $4.

FARM JOURNAL 1955
This magazine has been found to have at least one advertising illustration for the Rock of Ages memorial Stones Company. The ad has a tombstone in it with the name "Douglas". The same ad has appeared in other publications with different names on the stone. Value range: $2 to $4.

FARMER'S WIFE 1923-1927
Two advertising illustrations have been found; a Jell-O ad in the November 1923 issue and a Sun-Maid Raisin ad in the November 1927 issue. It is thought there may be

*Rockwell also did covers for them; one in 1967 and another in 1968.

another in the July 1945 issue but has not been substantiated as yet. Value range: $4 to $6.

FORBES 1972
A June 1, 1972 issue of this magazine had a story illustration. Value range: $2 to $4.

FORD LIFE 1972
A January 1972 issue featured illustrations Rockwell did for the Ford Motor Company. Value range: $2 to $4.

FORD NYT 1953
A June 1953 issue of the Ford Motor Company publication has an illustration. Value range: $2 to $5.

FORD TIMES 1963
A July, 1963 issue celebrating the Henry Ford Centennial has an illustration. Value range: $2 to $4.

Fortune, July 1934.

FORTUNE 1934-1968
Value range: $2 to $10.

Fortune continued

Story or Feature Illustrations	Advertising Illustration	
None found	1934 July	Budweiser
	December	Campbell
	1953 May	Roebling Wire
	1968 February	Sharon Steel
	March	Sharon Steel
	April	Sharon Steel
	May	Sharon Steel
	June	Sharon Steel
	July	Sharon Steel
	August	Sharon Steel
	September	Sharon Steel
	September	Sharon Steel
	October	Sharon Steel
	November	Sharon Steel
	December	Sharon Steel

GOLF 1974
The December, 1974 issue has a portrait of Arnold Palmer.

GOOD HOUSEKEEPING 1917-1977
Value range: $4 to $10.

Story or Feature Illustration	Advertising Illustration	
1924 October	1917 January	Perfection Oil Heaters
*1929 February	1923 June (2)	Lowe Brothers
1942 September		Holmes and Edwards Silver Co.
1970 December		
1975 November	1924 April	Pratt and Lambert
*1976 April	November	Pratt and Lambert
1977 November	1925 March	Edison Mazda
	May	Edison Mazda
	October	Edison Mazda
	(2)	Post Cereals
	December	Edison Mazda
	(2)	Pratt and Lambert

*Article about Rockwell.

271

Good Housekeeping continued

1926	May	Pratt and Lambert
	December	Nabisco
		Sun-Maid Raisins
1929	June	Pratt and Lambert
1940	May	Niblets Corn
1941	April	Niblets Corn
1950	December	DuMont
1953	February	Heritage Book Club
1958	September	Crest

GRAPHICS 1950
One issue, August 1950, is known to have a DuMont Laboratories advertisement. Value range: $2 to $5.

HARPER'S MONTHLY 1917-1953
Value range: $3 to $8.

Story or Feature Illustration	Advertising Illustration	
None	1917 September	Recreation Magazine
	1923 February	Jell-O
	March	Romance Chocolates
	April	Romance Chocolates
	June	Lowe Brothers
	1950 August	DuMont
	1953 February	Heritage Book Club
	July	Ford Motor Co.
	1956 October	Pan American Airways

HOUSE BEAUTIFUL 1922-1926
Value range: $5 to $7.

Story or Feature Illustration	Advertising Illustration	
None	1922 November	Pratt and Lambert
	1923 June	Lowe Brothers
	November	Pratt and Lambert
	1924 May	Pratt and Lambert
	November	Pratt and Lambert
	1925 June	Pratt and Lambert

<div style="text-align:center">

1926 June (2) Pratt and Lambert
Elgin Watches

</div>

HOUSEHOLD 1926-1931
Value range: $2 to $5.

Story or Feature Illustration	Advertising Illustration	
None found	1926 December	Nabisco
	1927 May	Sun-Maid
	October	Unknown
	November	Sun-Maid
	1928 March	Sun-Maid
	1930 January	Listerine
	1931 December	Listerine

INDUSTRY WEEK 1974-1975
Rockwell did twelve ads for the Sharon Steel Company. Ten appeared in 1974 and the other two in January 1975. There are two other ads to be found in this magazine. The same ad for Interlake, Inc. appeared twice: July 8 and September 16 of 1974. Value range: $2 to $4.

INLAND PRINTER 1928
Only one ad has been found in this magazine. It was for the Dutchess Trousers Company in the February, 1928 issue. Value range: $3 to $7.

INTERNATIONAL STUDIO 1923
One ad only. It was for Devoe Artists Materials in the February 1923 issue. Value range: $3 to $6.

JAMA [Journal of the American Medical Association] 1972
The November 20, 1972 issue of JAMA used Rockwell's "Saying Grace" along with the editorial comments. Value range: $2 to $3.

Ladies Home Journal, October 1927.

Ladies Home Journal, July 1930.

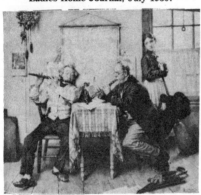

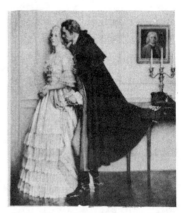

Ladies Home Journal, December 1926.

Ladies Home Journal, February 1932.

LADIES HOME JOURNAL 1918-1976
Value range: $5 to $10.

Story or Feature Illustration	Advertising Illustration	
1921 October	1918 September	Borden's
1926 December	1920 October	Fleischmann
1927 May	1922 June	Edison Mazda
July	August	Edison Mazda
October	October	Edison Mazda
December	December	Ladies Home Journal
1928 March	1923 November	Jell-O
1929 July	1924 June	Quaker Puffed Wheat

Ladies Home Journal continued

1930 July (2)	July	Colgate
December	1925 April	Edison Mazda
1931 February	September	Edison Mazda
October	October (2)	
December		Edison Mazda
1932 February	November	Edison Mazda
1933 January	1926 June	Elgin Watches
1936 November	September	Allen-A Hosiery
1938 August	December	Sun-Maid
December	1927 April	Nabisco
1939 February	May	Wallace Silver Plate
June	1928 December	Edison Mazda
August	1929 December	Listerine
1941 July	1930 December	Ladies Home Journal
1942 April	1934 January	Swift's
1943 October	1937 June	Beech-Nut
1945 January	1939 May	Niblets
1972 July	1943 September	Listerine
November	1944 January	Song of Bernadette
1973 November		Motion Picture Ad
1976 January	1956 February	Swift's
	March	Swift's
	May	Swift's
	July (2)	Famous Artists School
		Swift's
	August	Swift's
	1957 August	Crest
	October	Crest
	November	Crest
	December	Crest
	1958 February	Crest
	April	Crest
	May	Crest
	June	Crest
	July	Crest
	August	Crest
	1960 January	Famous Artists School
	1963 June	Skippy Peanut Butter

Ladies Home Journal continued

1974	October	Crest
1975	May	Crest

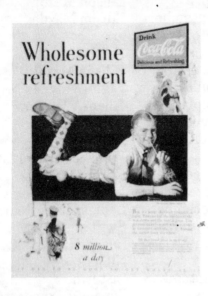

Liberty Magazine, May 26, 1928.

LIBERTY 1924-1942
Value range: $3 to $8.

Story or Feature Illustration	Advertising Illustration	
1924 November 15	1924 May 10	Fisk Rubber
	1925 February 28	Fisk Rubber
	1926 September 4	Ticonderoga Pencil Co.
	1928 May 26	Coca-Cola
	1929 September 7	Ticonderoga Pencil Co.
	1930 September 13	Ticonderoga Pencil Co.
	1937 April 10	Beech-Nut
	1938 January 22	Cream of Kentucky
	April 16	Cream of Kentucky
	1939 June 3	Cream of Kentucky
	June 10	General Motors
	October 21	Cream of Kentucky

Liberty continued

	December 23	Cream of Kentucky
1942	March 28	Cream of Kentucky

***LIFE 1937-1966**
Value range $3 to $9.

Story or Feature Illustration	Advertising Illustration	
None found	1937 to 1949	Beginning with the February 22, 1937 issue and ending with the October 31, 1949 issue, at least 30 Cream of Kentucky Bourbon Whisky ads appeared.
	1939 June 19	General Motors
	1940 August 26	General Motors
	November 4	General Motors
	November 11	General Motors
	1941 March 24	Niblets
	May 26	Mobilgas
	1942 March 23	Niblets
	1943 November 1	Upjohn
	December 3	Song of Bernadette Motion picture ad
	1945 July 2	Along Came Jones Motion picture ad
	December 3	Niblets
	December 3	Niblets
	December 17	Vim Vitamins
	1948 January 19	Aqua Velva
	June 7	Interwoven
	1949 March 14	A.T.&T.
	1950 August 7	DuMont
	1950 August 28	Watchmakers of Switzerland
	1953 January 19	Budweiser
	January 26	Ford Motor Co.

There was another earlier magazine with the same name in which some Rockwell ad illustrations appeared in the early 1920's.

Liberty continued

	February 16	Kellog's
	May 25	Aqua Velva
	June 15 (2)	
	May 25	Aqua Velva
	June 15 (2)	Aqua Velva
		Ford Motor Co.
	August 3	Ford Motor Co.
1954	August 30	Kellog's
	September 6	Watchmakers of Switzerland
	September 20	Kellog's
1955	March 7	Watchmakers of Switzerland
	December 12	Sheaffer Pens
1956	May 21	Pan American Airways
	October 29	Pan American Airways
	November 12	Pan American Airways
1960	December 12	Cinderfella, Motion picture ad
1963	September 7	Watchmakers of Switzerland
1966	April 8	Rock of Ages Corp.

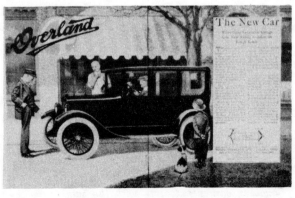

Literary Digest, November 22, 1919.

278

Literary Digest September 29, 1917.

Literary Digest November 24, 1917.

LITERARY DIGEST 1917-1929
Value range: $2 to $5.

Story or Feature Illustration	Advertising Illustration	
None found	1917 July 21	Fisk
	September 29	Perfection Oil Heaters
	November 3	Perfection Oil Heaters
	November 24	Perfection Oil Heaters
	December 8	Perfection Oil Heaters
	1918 December 7	Perfection Oil Heaters
	1919 November 22	Overland Automobiles
	December 20	Topics of the Day
	1921 June 11	Lime Crush
	July 16	Orange Crush
	1924 May 10	Colgate
	1925 November 28	Encyclopedia Britannica
	1928 May 12	Coca-Cola
	1929 December 14	Listerine

LOOK 1940-1971
Value range: $2 to $10.

Story or Feature Illustration		Advertising Illustration		
1964	January 14	1940	September 10	General Motors
	June 21*	1949	March 29 (2)	A.T.&T.
	July 14			Cream of Kentucky
	October 20	1952	September 23	Watchmakers of
1965	April 20			Switzerland
	July 27	1955	March 8	Watchmakers of
1966	January 11	1960	December 20	Cinderfella
	March 8			Motion picture ad
	June 14	1966	March 8	Stagecoach
	September 20	1966	March 8	Stagecoach
1967	January 10			Motion picture ad
	May 16	1968	August 6	Crowell Publishing
	October 3			
1968	March 5			
	April 16			
	May 14			
	June 25			
	July 9			
	July 23			
	August 20 (2)			
1969	February 4			
	July 15			
	September 9			
	December 30			
1970	December 29			
1971	October 19			

This is a most unusual illustration for an article titled "Southern Justice". It was done in a style not normally associated with Rockwell and is a very dramatic, thought-provoking work.

"Look, Mom—no cavities!"

McCall's March 1958.

"Look, Mom—no cavities!"

McCall's February 1958.

MCCALL'S 1918-1977
Value range: $5 to $12.

Story or Feature Illustration	Advertising Illustration	
1918 January	1919 July	Post Cereals
1920 April	1921 July	Post Cereals
1937 April	1924 September	Quaker Puffed Wheat
1942 July	1926 December	Sun-Maid
1964 November	1941 May	Niblets
1966 October	1957 October	Crest
1967 April	November	Crest
December	December	Crest
1966 March (2)	1958 February	Crest
*May	March	Crest
1977 December	May	Crest
	June	Crest
	September	Crest
	October	Crest
	November	Crest
	1959 January	Crest
	March	Crest

*Only known published still life by Rockwell.

McCall's continued

	March	Crest
	April	Crest
1962	January (2)	Crest
		Famous Artists School
1964	November	Famous Artists School
1965	January	Famous Artists School
1974	May	Insurance Companies of America
	September	Crest

MID-SOUTH 1978
The Sunday Supplement magazine to the Memphis, Tennessee newspaper, the **Commercial Appeal** had an article about Rockwell. The cover is a full color photo of Rockwell in his studio, November 19, 1978. Value range: $2 to $3.

MILESTONES 1918
A February, 1918 carried one story illustration. Value range: $5 to $9.

MODERN PRISCILLA 1924-1929
Value range: $5 to $6.

Story or Feature Illustration	Advertising Illustration	
None found	1924 May	Colgate
	1926 December	Sun-Maid

*MOVIE 1947
This magazine had a motion picture ad by Rockwell for "The Razors Edge". Value range: $2 to $3.

*Many Rockwell motion picture ads are to be found in other movie industry publications.

NASHUA TELEGRAPH 1974
This Nashua, New Hampshire newspaper (February 27, 1974) had an article about a local citizen sitting for a Rockwell illustration. Value range: $1 to $2.

NATION 1961
This magazine had a Rockwell illustration in the April 22, 1961 issue. Value range: $1 to $3.

NATIONAL GEOGRAPHIC 1924-1971
Value range: $2 to $8.

Story or Feature Illustration	Advertising Illustration	
None found	1924 May	Colgate
	1950 August (2)	Watchmakers of Switzerland
		DuMont Laboratories
	December (3)	Sheaffer Pens
		Plymouth
		DuMont Laboratories
	1955 May	Rock of Ages Corp.
	November	Sheaffer Pens
	1971 October	A.-T.-O. Inc.

NATIONAL SUNDAY MAGAZINE 1916
One illustration in the September 1916 issue. Value range: $4 to $8.

NEEDLECRAFT 1924-1933
Value range: $2 to $5.

Story or Feature Illustration	Advertising Illustration	
None found	1924 October	Quaker Puffed Wheat
	1926 November	Sun-Maid
	1927 April	Sun-Maid
	1929 December	Listerine
	1933 January	Listerine

NEWSWEEK 1952-1974
Value range: $2 to $3.

Story or Feature Illustration	Advertising Illustration	
1952 December 22	1952 December 22	Big Brother Week
1958 September 8	1953 January 19	Ford Motor Co.
1974 May 6	April 6	Ford Motor Co.
	June 15	Ford Motor Co.
	1957 April 29	Cotton Fiber Paper

NEW YORK SUNDAY NEWS 1970
One article in the July 26, 1970 issue. Value range: $1 to $3.

NEW YORK TIMES 1974
One article in the Sunday supplement magazine of the July 26, 1970 issue and one Ticonderoga Pencil Co. ad in the January 27, 1974 issue of the newspaper. Value range: $1 to $2.

NEW YORKER 1937-1968
Value range: $2 to $5.

Story or Feature Illustration	Advertising Illustration	
None found	1937 January	Cream of Kentucky
	1953 June	Ford Motor Co.
	1968 June	Williamsburg, Va.
	October	Williamsburg, Va.
	November	Williamsburg, Va.

NORTH LIGHT 1975
The January-February issue of this art magazine was a special Rockwell issue. Value range: $2 to $4.

PATHFINDER 1950-1953
Two Advertisements; Plymouth ad in the December 13, 1950 issue and a Ford Motor Company ad in the February 4, 1953 issue. Value range: $2 to $4.

PEOPLE'S HOME JOURNAL 1923-1927
Value range: $3 to $6.

Story or Feature Illustration	Advertising Illustration	
None found	1923 October	Jell-O
	1926 November	Sun-Maid
	December	Sun-Maid
		Nabisco
	1927 April	Sun-Maid
		Nabisco
	December	Sun-Maid

PHILADELPHIA ENQUIRER 1976
The November 14, 1976 issue contains an ad for Lancaster Turkeys. Value range: $1 to $2.

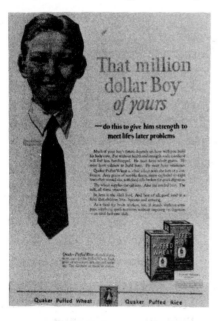

Pictorial Review, May 1924.

PICTORIAL REVIEW 1920-1929
Value range: $2 to $6.

Story or Feature Illustration	Advertising Illustration	
None found	1920 May	Four Please
		Motion picture ad

1923	April	Jell-O
1924	May	Quaker Oats
1926	December	Nabisco
1927	April	Jell-O
1929	December	Listerine

PLATE COLLECTOR
A special issue, January 1979, containing many Rockwell works. Value range:$3 to $4.

PRINTERS INK MONTHLY 1926-1941
Value range: $2 to $5.

Story or Feature Illustration	Advertising Illustration	
1941 April	1926 April	Harris Offset Presses
	December	Sun-Maid
	1927 October	Interwoven Socks
	1941 April (2)	Upjohn
		Brentwood Sportwear
	May	Upjohn

PUBLISHERS WEEKLY 1970-1979
The May 4, 1970 issue has one article and the March 26, 1979 has a two page ad for a book about Rockwell magazine covers. This latest issue has an N. R. illustration on the cover also. Value range: $2 to $3.

READER'S DIGEST 1937-1974
Value range: $2 to $4.

Story or Feature Illustration	Advertising Illustration	
1969 February	1937 November	Unknown
1971 April	1955 August	Watchmaker of Switzerland
1974 September	1957 April	Watchmaker of Switzerland
	August	Crest
	September	Crest

286

Readers Digest continued

	October	Crest
	November	Crest
	December	Crest
1958	March	Crest
	April	Crest
	June	Crest
	July	Crest
	September	Crest
	October	Crest
	November	Crest
1959	January	Crest
	February	Crest
	April	Crest
	November	Parker Pens
	December	Parker Pens
1969	December	Amway

RED CROSS* 1918-1919
Two advertisements only; November of 1918 and December of 1919. Value range: $3 to $7.

Redbook, June 1921.

REDBOOK 1921
One advertisement for Lemon Crush appeared in the June 1921 issue. Value range: $2 to $4.

*ST. NICHOLAS 1914-1925

Value range: $6 to $12.

Story or Feature Illustration		Advertising Illustration		
1914	December	1918	April	Fisk
1915	January		May	Fisk
	April (2)		June	
	May (2)		June (2)	Fisk
	June			Borden's
	July	1919	March	Fisk
	September		April	Fisk
	October		May	Fisk
	November		June	Fisk
	December		July	Fisk
1916	February		September	Jell-O
1916	February (2)		October	Jell-O
	March	1920	April	Goodrich
1917	March		June	Goodrich
	July		October	Goodrich
	August	1923	February	Jell-O
	September			
1918	March			
	April			
1919	June			
1925	December			

Saturday Evening Post, May 1, 1926.

Saturday Evening Post, April 9, 1938.

Saturday Evening Post, May 5, 1923.

Saturday Evening Post, November 10, 1956.

THE SATURDAY EVENING POST 1916-1967*
Value range: $3 to $14.

Story or Feature
Illustration

1916	July 8		1917	January 13	Fisk
	September 2			August 25	Black Cat Hosiery
1928	April 7			September 15	Perfection Oil Heaters
1934	December 22			October 6	Perfection Oil Heaters
1935	December 28			October 27	Perfection Oil Heaters
1936	February 22			December 1	Perfection Oil Heaters
1937	October 16				
	December 18		1918	January 26	Del Monte
1938	March 19			February 23	Del Monte
	December 24			August 17	Black Art History
1939	May 27		1919	April 26	Black Art History
	October 28			August 30	Bauman Clothing
1940	January 27		1920	January 3	Carnation
	May 11				
	September 21				
	October 26				

All story and advertising illustrations used after 1967 are re-use of illustrations found in the previous years.

290

Saturday Evening Post continued

	March 20 (2)	Adams Black Jack
		Edison Mazda
November 2	April 3	Paramount Pictures
1941 April 5	April 17	Edison Mazda
October 11	May 15	Edison Mazda
1942 June 6	June 12	Edison Mazda
1943 February 13	July 10	Edison Mazda
February 21*	August 7	Edison Mazda
February 27*	August 14	Goulds Pumps
March 6*	September 14	Edison Mazda
March 13*	October 2	Edison Mazda
May 8	October 30	Edison Mazda
May 15	November 27	Edison Mazda
June 5	1921 April 2	Cycle Trades of
July 17		America
November 13	July 16	Goulds Pumps
1944 January 29	December 31	Paint and Varnish
July 15		and Allied Interests
November 4	1922 Janaury 7 (2)	Edison Mazda
1945 January 27		Raybestos Co.
February 10	March 4	Raybestos Co.
1946 May 25	April 1	Raybestos Co.
July 13	August 26	Interwoven
November 2	September 9	Raybestos Co.
1947 April 12	October 7	Raybestos Co.
1948 July 24	November 11	Pratt and Lambert
1961 October 14	November 18	Interwoven
1962 February 10	1923 February 17	Valspar Varnish
1963 October 26	February 24	Romance Chocolates
1967 October 21	March 17 (2)	Willys-Overland Auto
		Romance Chocolates
	April 23	Romance Chocolates
	May 5	Lowe Brothers
	July 7	Lifebuoy Soap
	October 13	Underwood
	October 27	Valspar Varnish

*These are the famous "Four Freedoms" pictures. Value range: $40 to $50 for the set [mint].

Saturday Evening Post continued

	November 3	Pratt and Lambert
	November 24	Romance Chocolates
	December 1	Jell-O
1924	January 12	Raybestos Co.
	February 9	Allen-A Hosiery
	April 5 (3)	Fisk
		Pratt and Lambert
		Valspar Varnish
	May 17	Jell-O
	June 7	Fisk
	August 9	Interwoven
	August 23	Allen-A Hosiery
	November 1	Pratt and Lambert
1925	February 7	Fisk
	March 21	Edison Mazda
	April 18	Edison Mazda
	June 6	Pratt and Lambert
	July 4	Post Cereals
	September 12	Edison Mazda
	October 17	Edison Mazda
1926	April 3	Pratt and Lambert
	May 1	Bauer and Black
	June 5	Dutchess Trousers
	June 20	Rogers Brothers
	July 3	Dutchess Trousers
	July 17	Elgin Watches
	September 4	Allen-A Hosiery
	September 11	Dutchess Trousers
	October 9	Dutchess Trousers
1927	January 8	Dutchess Trousers
	July 2	Interwoven
1928	February 11	Interwoven
	May 5	Coca-Cola
	December 1	Parker Pen
1929	February 2	Capitol Boilers
	March 2	Capitol Boilers
	April 6	Arrow Shirts
	May 25	Tillyer Lenses
	August 17	Tillyer Lenses

292

	September 14	Tillyer Lenses
	November 9	Tillyer Lenses
	December 14	Brown and Bigelow
	(4)	Listerine
		Parker Pen
		Tillyer Lenses
1930	November 15	Goodyear
1931	January 31	Goodyear
1935	April 6	Campbells
	June 15	Interwoven
	September 28	Campbell's
	December 28	Campbell's
1936	December 26	Campbell's
1937	April 24	Beech-Nut
1938	April 9	Niblets
1939	June 17	General Motors
1940	September 14	General Motors
	November 9	General Motors
	December 14	General Motors
1941	June 14	Mobilgas
1942	April 11	U.S. Savings Bonds
1943	August 14	Listerine
	September 4	Upjohn
1945	November 17	Ipana
1946	March 16	Niblets
1948	June 12	Interwoven Socks
1949	March 5	A.T.&T.
	*September 10	Watchmakers of Switzerland
1950	February 18	Dictaphone Corp.
	August 19	DuMont
	September 2	Watchmakers of Switzerland
	December 9	DuMont
	December 23	Plymouth
1951	December 22	Plymouth

As far as is known this is the first appearance at this famous ad. The S.E.P. issue here is dated two days before the Country Gentlemen issue also containing the ad.

Saturday Evening Post continued

1952	September 13	Watchmakers of Switzerland
1953	January 17	Ford Motor Co.
	January 31	Aqua Velva
	February 7	Famous Artists School
	February 21	Aqua Velva
	March 28	Ford Motor Co.
	April 25	Aqua Velva
	June 13	Ford Motor Co.
	June 20	Aqua Velva
	September 5	Aqua Velva
	September 12	Aqua Velva
	October 3 (2)	A.T.&T.
1954	January 23	Famous Artists School
	March 13	Watchmakers of Switzerland
	September 11 (2)	Famous Artists School Watchmakers of Switzerland
	December 11	Magnavox
1955	January 1	Famous Artists School
	March 12 (2)	Famous Artists School Watchmakers of Switzerland
	March 26	Rock of Ages Corp.
	May 21	Rock of Ages Corp.
	June 18	Chase Manhatten Bank
	October 15	Niblets
1956	June 2	Pan American Airways
	October 20	Pan American Airways
	November 10	Pan American Airways
1959	May 9	Parker Pens
	October 3	Parker Pens
	November 28	Parker Pens
	December 5	Parker Pens
1961	December 23	Famous Artists School
1962	September 8	Peace Corps.
1963	March 23 (2)	Red Cross

	May 18	*Rock of Ages Corp.
	May 18	Skippy Peanut Butter
1964	March 14	Rock of Ages Corp.
	April 25	Skippy Peanut Butter
1965	April 10	Rock of Ages Corp.
1967	October 7	Purina

THEATRE 1923-1924
Two Fisk Rubber Company ads appeared in this magazine; one in each year. Value range: $4 to $7.

THIS WEEK 1940-1959
Only two Rockwell ads appeared in this magazine: Niblets Corn, March 12, 1940; Knox Gelatin, October 4, 1959. Value range: $2 to $5.

TIME, February 15, 1963.

TIME 1936-1976
Value range: $3 to $7.

continued on next page

*This is the one in which Rockwell formed the name "NORWEL" on the monument from his own name.

Time continued

Story or Feature Illustration	Advertising Illustration	
1971 June 14	1936 November 8	Cream of Kentucky
1976 *Special Edition	December 7	Cream of Kentucky
	1943 June 21	Cream of Kentucky
	1950 December 25	Plymouth
	1961 June 30	Massachusetts Mutual
	1963 February 15	Massachusetts Mutual
	1974 May 27	Insurance ad
	June 10	Insurance ad
	June 24	Insurance ad

TODAY'S HOUSEWIFE 1919
Only one ad known to have appeared. It was a Post Grape-Nuts Cereal ad in the July 1919 issue. Value range: $4 to $8.

TRUE DETECTIVE 1937
A June 1937 ad for Beech-Nut Gum. Value range: $2 to $4.

TRUE STORY 1955-1956
A series of Swift Baby Food ads appeared in June, August, September and December of 1955; and March, June, and August of 1956. Value range: $2 to $3.

VANITY FAIR 1921-1926
Value range: $3 to $9.

Story or Feature Illustration	Advertising Illustration	
None found	1921 March	Arrow Shirts
	1925 March	Fisk
	1926 November	Dutchess Trousers

VERMONT LIFE 1947
Only two issues are known to contain Rockwell works. They are the Summer 1947 and Spring 1948 issues. Value range: $2 to $4.

*Called Special Report. The American Presidents. *No Month date.*

WOMAN'S DAY 1965-1974
There is one ad and one story with Rockwell work found so far. They are: The June 1965 and Crest Toothpaste and in October 1974. Value range: $1 to $3.

WOMAN'S HOME COMPANION 1921-1955
Value range: $2 to $6.

Story or Feature Illustration	Advertising Illustration	
1933 November	1921 July	Post Cereals
1935 November	1923 March	Jell-O
1937 December	1924 July	Crest
1938 January	1926 December (2)	Sun-Maid
February (2)		Nabisco
March	1927 May	Wallace Silver
August		Plate Company
1940 August	1929 December	Listerine
1941 January	1938 August	Quaker Puffed Rice
	1945 November	Bourjois
	1955 May	Swift's
	October	Swift's

WORMAN'S WORLD 1926-1937
Two Sun-Maid Raisin ads appeared. The first was in December 1926 and the last was May of 1937. Value range: $2 to $4.

WOMAN'S WORK 1919-1923
Value range: $2 to $3.

Story or Feature Illustration	Advertising Illustration	
None found	1919 July	Post Cereals
	1923 February	Jell-O
	March	Romance Chocolates
	April	Romance Chocolates

Youth's Companion, May 22, 1924.

YOUTH'S COMPANION 1915-1926

Value range: $4 to $10.

Story or Feature Illustration		Advertising Illustration	
1915	November 4	1917 May 31	Fisk
	November 11	July 26	Fisk
1916	February 24	1918 September 12	Fisk
	March 9	(2)	Borden's
	March 23	1921 June 2	Lemon Crush
	March 30	1923 February 1	Jell-O
	August 3	June 21	Hood Shoes
1917	March 22	November	Jell-O
	April 19	1924 March 13	Quaker Puffed Rice
	April 26	May 22	Hood Shoes
	May 3	1926 April 29	Bauer and Black
	May 10		
	May 17		
	May 24		
	May 31		
	June 7		
	June 14		
	June 21		
	August 16		

INDEX

c.1

DATE DUE			